MURDER
ON THE
TABLE

A gripping Northern Irish crime mystery

LINDA HAGAN

THE
BOOK
FOLKS

Published by The Book Folks

London, 2022

ISBN 978-1-80462-050-2

www.thebookfolks.com

Murder on the Table is the sixth novel in a series of standalone murder mysteries set in Belfast and beyond.

Prologue

The noise of a phone ringing disturbed his concentration. It took him a second to realise it was his special phone.

His hand darted to retrieve it from a locked drawer in his desk. He might be eager for the news it could bring but he was still careful and checked the caller ID before answering.

'Yes?'

No friendly greetings. No names exchanged. No need for them. He knew only too well what this was about. His eyes were sparkling with a hunger to hear what would be said and his breathing quickened as he waited for the voice on the other end to speak.

'It's all sorted,' a male voice with an accent, jarring to his ears, informed him.

'You've got it?'

The man couldn't disguise his eagerness.

'No. But it's all set for Saturday night. In Belfast.'

'You're sure? Nothing can go wrong this time?'

There was an underlying sense of menace in his voice. He was a man who didn't accept failure.

'Nothing will go wrong. It's all planned.'

The caller sounded confident or at least he was trying to.

'And you'll take care of everything and everyone?'

The man emphasised the word "everyone".

The response was immediate, the words and tone designed to be reassuring.

'Yes. You don't need to worry about a thing.'

'I won't. That's down to you. That's what I'm paying you for. If it doesn't go to plan, then you'll have to start worrying. Let me know when it's done.'

'Yes, sir.'

The caller's final response went unheard as the man cut the connection and placed the phone back in the drawer. He swung round in his office chair and sank his head into its soft Italian leather. He closed his eyes and exhaled loudly. For minutes he fiddled with a heavy gold signet ring on the second finger of his right hand, twisting it round and round as he contemplated the news he had just heard.

Finally he sighed and stood up to look out of his office window. But he looked with unseeing eyes. A slow smile spread across his face and he ran his tongue over his lips anticipating his pleasures to come. His eyes weren't focusing on the iconic river far below him or the cityscape stretching out in front of him. He wasn't appreciating the view. His mind was miles away and a hundred years in the past.

Chapter 1

DCI Gawn Girvin was concentrating on the road ahead, squinting to see through the rain beating off the windscreen. The swish-click-swish of the wipers flicking backwards and forwards was almost hypnotising. The A2 was busy, like any Saturday night, the overhead lights reflecting off the black road surface and puddles lurking by the side of the carriageway to catch the unwary.

From out of the spray being thrown up by the car in front, an illuminated hotel sign loomed suddenly into view.

Gawn braked sharply. She followed the glowing taillights as the car ahead swung between a pair of tall grey stone pillars framing the outline of a baronial-style building against the black night sky and the distant twinkling lights of the County Antrim coastline across the dark expanse of Belfast Lough.

Her destination tonight was the annex at the Royal Holywood Hotel. She found a parking space and scurried across the open ground to get out of the rain. She caught a glimpse into the lighted anteroom – men in tuxedos, women in expensive dresses, standing around, drinks in hand. Immediately she felt uncomfortable and out of place. And she felt threatened like a wild animal snatched from its accustomed territory. Her natural habitat was the seedy and unsavoury, life at its most vulnerable and humans at their worst. There, she felt in control. Here, she was the vulnerable one.

The doors opened to admit a couple walking ahead of her. The strains of a string quartet playing some light classical music floated out into the night and vied with the sound of traffic from the main road just the other side of a high hedge. She heard chatter and laughter too. This was just the sort of social occasion she hated and always tried to avoid.

So why had she let herself be talked into this? Short answer? She hadn't. It had been an order. One couched in pleasant words and smiles and a gold-edged invitation, but still an order.

Gawn felt her anxiety level rising. She feared above all having a panic attack on duty. She paused to take a deep breath. Then she walked straight ahead letting the glass doors woosh open to admit her. The noise and heat hit her almost like a physical blow assaulting her senses threatening to suck the breath from her body.

'Bloody hell, Girvin, you clean up well.'

It was her boss's voice, Superintendent McDowell. He had reacted in surprise. He was used to a dour police

officer who was as tough as any man on his staff. He had probably never given much thought to the fact she was a woman. It was obvious, he was now.

Gawn felt as if she had been poured into her dress. It clung to her body accentuating her svelte outline, the result of time spent running and working out, filling her off-duty hours while her husband, Sebastian York, was in California.

McDowell seemed to be finding it difficult to take his eyes off her. He looked uncomfortable in his too-tight tuxedo. He ran his finger around the inside of his shirt collar as if his bow tie was choking him. Years of a more sedentary role had taken their toll. His face was red, probably due to the almost overpowering heat from the crush of bodies in the small space.

'Good evening, sir.'

She greeted him with what she hoped was a friendly smile. She mightn't want to be here but she would play the game. Then she spotted Paul Maxwell, her inspector, standing behind him.

'Good evening, Paul.'

Maxwell had spruced up well, in a new tuxedo. He looked very much at home.

'Good evening, boss – I mean, Gawn.'

His eyes moved down her body and paused for just a beat. Her usual attire was a formal trouser suit, invariably in some sombre colour. Tonight, her strapless red ruched minidress, with what she considered a too-low neckline and a too-high hemline, was a major image change. Sebastian had insisted on buying it for her when they'd gone shopping in LA. 'You'll knock 'em dead, babe', was what he had said but the sales assistant had needed to work hard to convince her to take it.

'Can I get you a drink, Chief Inspector?' McDowell asked brusquely.

'I'll have an orange juice please, sir. I'm driving.'

'A cheap round then.'

He headed to the bar, seeming relieved to be able to move away.

'I hope that's non-alcoholic, Paul.'

Gawn almost had to shout to make herself heard. She nodded to the glass in his hand. The black liquid with its creamy crown was unmistakable.

He moved closer to her and spoke into her ear.

'Kerri's picking me up. I'm not driving,' he answered smugly and took a quick gulp of the Guinness.

They didn't try to make conversation. It was just too noisy. Tonight was to be one of the highlights of the social calendar in Northern Ireland. Everyone who was anyone was to be here. A photographer from a local society magazine, according to her name badge, was moving through the throng snapping at random. Gawn was amused to see the women smiling exaggeratedly, the men standing up just a little straighter, sucking their stomachs in, wanting to impress. Gawn just hoped she wouldn't appear in any of the woman's pictures.

She watched her boss making his way gingerly back across the room, manoeuvring through the crowd, holding a glass carefully to avoid having his arm jostled. As he handed her the orange juice, a man's voice rang out speaking with an authority born of experience.

'My lord, ladies and gentlemen, please take your seats. Dinner is about to be served.'

Chapter 2

Everyone moved en masse towards the ballroom. Gawn caught a glimpse through the crowd. Pristine white starched tablecloths and highly polished cutlery arranged with precision were waiting for them. A trio of balloons in

pastel colours adorned with the HATP logo floated over each table.

Gawn and her two companions were here to support Assistant Chief Constable Anne Wilkinson. She was to make one of the after-dinner speeches.

They found themselves caught up in a bottleneck at the doorway as guests squeezed through the narrow entrance and stopped to search for their name on a seating plan. Gawn was not surprised to see she and her colleagues had been allocated to different tables. This would let them mix with as many people as possible. But making polite conversation with strangers all evening was not her idea of policing.

'Enjoy your meal, sir,' Maxwell called to McDowell as he headed off to the far side of the room.

Gawn was carried along with the crowd in the opposite direction.

They were all anticipating their meal. What no one realised was that, for some of the people in this crowd, this would be their last meal. They had all been invited to a murder.

Chapter 3

Gawn was first to arrive at her table. She found a place card with her name in pretty rainbow colours to match the HATP logo. A swag bag was sitting on her chair. She stowed it away under the table. She would give it to Maxwell for his daughter.

Gawn used these first moments to look around. Her army and personal protection training at the Met had ingrained a need to be in control in every situation, to have an exit strategy prepared. She had already studied a

schematic of the layout of the hotel and annex. She was being overcareful. She knew it. Hypervigilance, the medics had called it.

She noticed Wilkinson at the top table, chatting to her neighbour. Gawn recognised him. He was an ex-MP who seemed to be available to give an opinion on almost anything. "Rent-a-gub", she had heard one of her junior officers calling him after he'd made yet another TV appearance, this time giving his views on police stop-and-search tactics.

Gawn watched as an elderly man was escorted to his seat. His face was familiar too and, because Wilkinson had briefed them on the Trust whose fundraiser they were attending, she recognised him. He was Lord Ardgeen, a retired judge and Chairman of the Trust. He was too old for her to ever have given evidence before him.

Just then, the chair beside her was pulled out and a friendly voice greeted her with, 'Good evening. How are you now?'

She recognised the soft southern inflection of the words. Gawn smiled up at the newcomer and returned his greeting. The other spaces at the table were filling up too. Now her evening's work was about to begin, only it wasn't the work she, or anyone else, had anticipated.

Chapter 4

Tonight's event was the Hands Across the Pond Trust First Annual Dinner. The Trust, with its über-trendy name, had been set up less than a year ago by two American billionaire brothers, Axel and Tyrone O'Sullivan, in honour of their great grandfather. Walter O'Sullivan had been born in the little seaside town of Millisle, just a little further along the

County Down coast from where they were tonight. He was the son of an agricultural worker but, when he emigrated to New York at the beginning of the twentieth century, he had demonstrated a talent for business and making money.

O'Sullivan had managed to not only survive the Wall Street Crash but come out the other side rather rich. And his businesses had thrived. He had been the friend of presidents but he had never forgotten his humble roots and the Trust had been set up to foster educational opportunities for young people in his memory. It encouraged links between schools on both sides of the Atlantic and funded cross-community initiatives.

Anne Wilkinson's job was to make a speech, expressing appreciation of the work of the Trust and thanks for its support for the PSNI's schemes for disaffected youth.

Chapter 5

The dinner was excellent. Now, it was time for the speeches. Gawn swivelled slightly in her chair to get a better view. She watched as Lord Ardgeen stood up hesitantly. He swayed and she saw his mouth open and close but no sound came out and then, still without uttering a word, he crashed forward onto the table.

It all happened so quickly that neither of the men sitting beside him had reacted in time to break his fall and Ardgeen had made no attempt to save himself. The movement was followed by a heavy thud, which seemed to echo through the silence that had descended on the room when he had stood to speak. His body flopped over the carefully set surface followed by the sound of glasses and plates smashing on the wooden floor as they too fell, pulled off by his dead weight dragging at the tablecloth.

A gasp went round the room followed by a woman's high-pitched scream. She was hastily quietened. Almost simultaneously chairs started scraping along the floor as people stood up, trying to get a better view. There was a muttering which quickly grew in intensity. Gawn could feel a sense of uncertainty all around her.

Someone had rushed to ease Ardgeen back into his seat but Gawn could see his eyes were glassy. Then there was a noise from the far end of the top table and an elderly woman called out, 'Help me!' as the man beside her fell against her shoulder and she struggled to keep him upright.

Afterwards Gawn tried to get clear in her mind everything that happened. It was all so sudden. Unexpected. Chaotic. And everything seemed to be happening in slow motion. People were falling over all around the room. Women were crying. A man's urgent voice yelled, 'Get out! For God's sake, get out!'

There was a mass movement as people rose from their seats, trying to get away, to escape, afraid but unsure of what. Everyone was fleeing whatever danger there might be. The narrow doorway quickly formed its bottleneck again, pinching the crowd into a seething, shoving, single line. A visceral communal memory of the years of the Troubles, which most of the guests would be far too young to remember for themselves but which they would have heard about from elderly relatives, surfaced as they faced the unknown threat.

Gawn knew only too well the dangers posed by panic and crowds. She watched for what seemed like minutes but in reality was only seconds as chairs were overturned in the melee. More plates and glasses, swept aside in the rush to get out, fell smashing noisily on the floor. She saw a woman, propelled forward by the crowd, lose her balance and fall onto her hands and knees. Several people almost fell over her before a man stopped and helped her to her feet, protecting her from the surge of the crowd behind.

Gawn glanced across at McDowell. He was still in his seat, a dazed look on his face. He had made no attempt to move. Wilkinson was with Ardgeen. She couldn't see Maxwell anywhere. Someone had to do something.

Chapter 6

Maxwell had just taken his last mouthful of chocolate ganache when Ardgeen collapsed. He had been looking in the opposite direction, not really interested in the speeches. But the noise as the man's body hit the table and the plates and glasses smashed on the floor made him jerk his head round.

In that instant all hell broke loose around him. He dropped his spoon in surprise and the gooey dessert fell onto his shirt front slowly making its way down to his lap like a chunk of chocolate lava. His first thought was that Kerri would be angry. Then he realised he had more to worry about than his shirt or his wife's annoyance.

For five seconds Maxwell froze.

He had been in crowd control situations like the local football derby and an outdoor music event in Ormeau Park but he was too young to have been involved in the daily evacuations of hotels and shops and offices which had once been commonplace after yet another coded bomb warning to the local TV station. But he knew the dangers inherent in crowds and panic. Innocent people could be hurt. Or worse.

Maxwell looked around. Gawn was nowhere to be seen. He glimpsed McDowell just sitting, staring ahead. Maxwell rushed across to him struggling to make his way through the sea of bodies moving in the opposite direction towards the door. He passed the top table and saw

Wilkinson with two men working with Ardgeen. Her face was a picture of dismay.

'Sir. Sir. Are you alright?'

Maxwell grabbed McDowell by the arm but the man looked up at him, his eyes unfocused.

'Paul, help me get these people out to the main building. We need to head them away from that doorway. It's too narrow. They're being crushed. There's another exit over there behind that curtain. It leads through to the foyer.'

It was Gawn. She had appeared beside him as if by magic.

'We need to stop anyone else getting crushed. Some people have already been injured.'

'What about the boss?' he asked, turning to look at her and noting the brightness of her eyes. She was in her element.

She glanced at McDowell and made an instant decision.

'Leave him. He's not going anywhere. Go! Hurry!'

Her words displayed the urgency of the situation. She was shouting now to make herself heard over the noise of chairs being pushed over and the babel of scared voices.

The last view he had of her was her back disappearing into the seething mass of bodies, all pushing and shoving to get away from whatever was happening. No one knew what it was. That was the scariest part.

Chapter 7

Almost three hours. Three hours to ensure everyone was evacuated and the special guests were taken to safety. Gawn had worked hard to bring some semblance of calm and order; to prevent any more injuries in the crush.

When Maxwell had taken over evacuating the guests, she had concentrated on getting the injured treated by the paramedics who had arrived quickly. By then Maxwell had rounded up most of the guests and gathered them in one of the function rooms in the main hotel building. He had begun supervising initial interviews being carried out by a team of reinforcements summoned by the ACC. Gawn had briefed the CSIs and tried to give Mark Ferguson, the crime scene manager, some idea of what had happened, although she didn't know herself yet.

Now she was shivering. Her skimpy dress offered little protection from the night air. She looked down at her feet. They were bare, her painted toenails a reminder of what should have been happening here tonight. And they were icy cold. She had cast her shoes off when it had all started. Four-inch Louboutins weren't really the best for struggling through a crowd.

She had never missed her comfortable trouser suit more than she had tonight. It had seemed ludicrous to be issuing orders to incredibly young-looking police recruits hastily summoned from the nearby training centre while she was dressed like a character from *Pretty Woman*. She was glad she'd had the forethought to put her PSNI lanyard with her pass into her bag so now it hung around her neck like some avant-garde piece of jewellery. At least it had prevented her from having to explain who she was to the young men and women who had yet to hear of DCI Gawn Girvin and didn't know her reputation.

Chapter 8

'Good work, Chief Inspector.'

Wilkinson was standing by her side, surveying the scene. She sounded tired and her normally immaculately swept-back hair was dishevelled, several long strands having escaped the clasp designed to hold them in place.

'Do you have any idea what happened, ma'am?'

Gawn had spent so much time comforting people who were distressed or injured and appeasing others who were annoyed and complaining, that she hadn't got an overview of what had gone on. The glittering showpiece event would hit the headlines alright, but for all the wrong reasons. Gawn had already had to face the press standing alongside the ACC. McDowell had been in no fit state to be on public view. Gawn didn't think she was much better. She had discarded her pashmina along with her shoes when the panic had started so she had been glad of Maxwell's gallantry, offering her his jacket to drape over her shoulders to provide some protection from the cold night air outside the building and her feeling of embarrassment.

Gawn had noted her journalist nemesis, Donna Nixon, in the raucous media scrum all trying to make their voices heard. The harsh lighting of the TV camera crews was blinding in its ferocity, cutting through the blackness of the night and turning it into instant day. Wilkinson had raised her hand for silence and the journalists had quietened. She had made a brief statement but refused to answer questions, instead directing them to the Press Office for further information.

So now Gawn had plenty of questions of her own.

'Lord Ardgeen's dead,' Wilkinson said. 'But you knew that of course. There's at least one other person seriously injured and quite a few others with injuries of one kind or another. We won't really know what we're dealing with until we hear from the hospital and until Al Munroe has finished the PM. I've already spoken to him and he's getting started first thing tomorrow... or rather today.' She had looked at her watch as she named the chief pathologist. Then she paused before adding, 'I want your team to lead on this, Gawn.'

Wilkinson responded quickly to the look that crossed Gawn's face at her words.

'Is it a serious crime? That's what you're thinking, isn't it? Well, the answer is we don't know yet.' She sighed. 'It might just be a case of natural causes and hysteria but it's going to be very high profile. Apart from Ardgeen, we'd an ex-MP, a retired American senator, and a former Stormont minister here, not to mention a handful of current MLAs and a smattering of the local glitterati. All here. All panicking. It'll make all the front pages nationwide and the TV news. It already has and the pressure'll be on to get answers quickly. If it's just a dicky ticker, please God, and someone who had a few too many and can't hold his drink and a few hysterical women overreacting, then you can get it cleared up quickly.'

Wilkinson paused and then asked, 'You've no new cases on at the minute, have you?'

'Nothing major, no.'

'Let your sergeant deal with anything. She seems highly efficient. I've been watching her. She has potential.'

Gawn nodded her agreement.

'Right. Briefing at 0900. Try to get a bit of sleep. Not that there's much of the night left.'

There would be just enough time to get home but Gawn's mind was buzzing. She wasn't sure she would be able to sleep. She wanted to have everything at her fingertips for the briefing. Wilkinson would expect it and

she was hoping that it would become clear very quickly that there was no crime here to investigate.

How wrong could she be?

Chapter 9

Gawn allowed her gaze to sweep around the Serious Crimes incident room. She couldn't help smiling, proud of her team. Most of them had been at their desks before she arrived. Even though it was Sunday. Even though it was only a few weeks before Christmas and they would have had plans with their families. No one had grumbled. Except DC Billy Logan of course, but then he grumbled about everything.

The first reports, suggesting something had happened at the hotel, had featured on the midnight news bulletin, with a report from the scene by Donna Nixon. The breakfast TV programmes had carried the story and run the statement given at the scene by Wilkinson. Gawn had watched it before leaving home. She had seen herself standing beside the ACC trying to look suitably serious while blinded by the bright camera lights, looking more like a lamped rabbit.

Maxwell had already allocated detectives to teams. They were working to identify and sort the guests and confirm the seating plan. Some were collating initial statements and prioritising follow-up interviews or identifying those who would need to be contacted because they had managed to leave before reinforcements had arrived.

Before she did anything else, Gawn had taken her sergeant, Erin McKeown, aside and explained how she was to supervise their ongoing cases.

'It'll probably only be for a day or two, Erin. We should be able to clear this up quickly.'

Gawn knew McKeown would be disappointed not to be involved in such a high-profile investigation. She didn't want her to think it was some sort of indication that her work wasn't up to scratch. She explained what Wilkinson had said and McKeown had left her office beaming.

Now Gawn's gaze fell on DC Billy Logan. He was obviously waiting for a response, twiddling his pen nonchalantly through his fingers and humming tunelessly as he sat holding the phone between his chin and his shoulder.

His fellow detective constables, Jack Dee and Jamie Grant, were talking together looking over a list in Grant's hand. Gawn trusted it wasn't the latest rugby results.

Her eyes had just reached the incident board when Maxwell walked out of his office. Gawn pointed to the picture of the distinguished-looking old man whose collapse had precipitated the night's events.

'I take it we haven't got a cause of death yet, Paul?'

'Munroe's good but he's not that good. Give him a chance, boss. He was starting the PM first thing.'

'Who's this?' she asked.

Gawn was pointing to another photograph.

'That's our second victim, or our second fatality I suppose I should say,' Maxwell corrected himself. 'He died on his way to hospital. His name's Joshua Randell and he was a barrister,' Maxwell added.

'A barrister? That's a bit of a coincidence, isn't it? A judge and a barrister. Did they know each other?'

'Not that we know. Randell practised in London but maybe we'll be able to turn up some connection between them.'

'What was he doing at the dinner?' Gawn asked.

'Not sure yet. Billy's trying to find out from the Met. They were notifying Mrs Randell for us.'

'And this?'

Her finger had moved along the line of photographs and was resting now on one of a blonde-haired woman around her own age. It was slightly fuzzy from being enlarged but it was possible to make out the smiling woman leaning against the parapet of a bridge.

'That's Tracy O'Neill.'

'Is she dead too?' Gawn's voice revealed her growing surprise.

'No. She's missing.'

'Who is she?'

'All we know is that she's originally from London but married a local guy and works as an accountant at a haulage company. Her husband phoned the hotel about 3am after we'd left checking to see if she was still there. He knew she was going and he'd expected her back late but she hadn't appeared and she wasn't answering her phone. As of fifteen minutes ago, she still hasn't turned up and her car's sitting in the hotel car park.'

'Have we established any connection between her and either of our dead men?' she asked.

'No.'

Someone had pinned a seating plan on the board. Names were written on it indicating where the three had been sitting and red crosses marked the positions of some of the others who had needed treatment.

Gawn ran her finger over the plan.

'Our two "victims", for want of a better word, were both at the top table but they weren't near each other. And all these others who had to get medical treatment were sitting all over the place. If it was food poisoning, surely they wouldn't all have been affected at the same time like that and so quickly? We'd only just finished eating. And if it was a case of deliberate poisoning, it couldn't have been an accident where one person was targeted and the person next to them got the poison too. It's too widespread.'

'Is that what you think, that they were poisoned?' Maxwell asked.

'Ardgeen wasn't shot or stabbed. There was no gunshot. He had no obvious wounds. So, if it isn't natural causes, it stands to reason poison's the most likely weapon. But it seems so indiscriminate.'

She furrowed her brow as she tried to take in the implications of what she was suggesting.

'Anybody could have been killed. Could it be some kind of a vendetta against the Trust or the hotel to ruin their reputation? Or was there just one target and all the rest were some sort of collateral damage? The paramedics seemed to be treating people left, right and centre. Even the super. How is McDowell?'

'He was a bit green around the gills and still a wee bit out of it when Mrs McD came to collect him last night. I haven't seen him this morning,' Maxwell told her.

'It's so random, Paul. They're all over the place. There's even one at my table. The Dublin University professor right beside me.'

'Could have been you, boss.'

She didn't react to his comment.

'What about all these question marks on table 8? Don't we have the names yet?' Gawn asked.

'Only some of them. We're trying to sort out who was sitting there. According to witnesses Tracy O'Neill was at table 8 but we haven't been able to get the names of all the others yet.'

Her eyebrows rose in surprise.

'Why not?'

'One of the people who needed treatment is the PR girl from the Trust. She planned the event. She had all the lists and it seems table 8 had been rearranged at the last minute and the hotel didn't get an up-to-date version.

'I had a quick word with her last night. She was really upset. She said she'd pinned her version with the changes up on the noticeboard to let people know where to sit and it must have got misplaced in the crush. I have them

searching for it this morning but so far nothing's turned up.'

Chapter 10

Gawn and Maxwell heard the door opening behind them and were aware of the others standing up smartly at their desks. ACC Wilkinson walked in. She looked immaculate in her dark green uniform, not a hair out of place. Only her eyes betrayed her mood and her lack of sleep.

'Good morning. As you were, everyone. Don't let me hold you back.'

'Good morning, ma'am.' Gawn and Maxwell spoke in unison.

'What have you got so far, Chief Inspector?' Wilkinson's voice sounded as if she didn't expect to hear any good news.

'There's been a second death, ma'am. And we have a missing woman now as well,' Gawn told her.

Wilkinson listened carefully as Gawn talked her through what they knew, nodding from time to time but not interrupting. When she'd finished, Wilkinson asked, 'What's your next move then, Chief Inspector?'

'We need to hear back from Professor Munroe as soon as possible. Lord Ardgeen's death could be natural causes. But this other man, Joshua Randell, was younger and he looked healthy enough. Depending on what Professor Munroe turns up, we'll have a better idea of what we're dealing with. Getting a quick cause of death is vital.'

Wilkinson nodded in agreement.

'As for the missing woman, Tracy O'Neill, she might have wandered off feeling ill or she could be a suspect if it is murder. Forensics will go over her car and we'll need to

search the hotel in case she went off with a guest and spent the night in one of the hotel rooms.'

Wilkinson's head had come up sharply as the DCI spoke those final words.

'I don't think so, Chief Inspector,' the ACC said. 'They wouldn't like their guests disturbed. And we have no grounds for a search of the hotel.'

Gawn wasn't surprised. A lot of famous and influential people stayed at the hotel. They would have to tread carefully.

'Right, well, in the meantime then, we'll see what the CSIs turn up but any test results will take days. We'll check on everyone who needed treatment to see if they had any connection with our victims or our missing woman and I want to speak to the PR girl and get the names of the other guests at table 8. It seems a bit suspect to me that just one page went AWOL and the missing person was at that table. It could be a coincidence but I don't like coincidences.'

'Neither do I, Chief Inspector,' Wilkinson agreed. 'You have your hands full. But I'm afraid I'm going to add to it. Alistair Goodlife, the ex-MP, is convinced he was the target last night. He kept suggesting that to me at the time and he's been on the phone again already this morning. Normally, I'd stay out of your investigation but Goodlife intends flying back to London today and we should at least listen to his concerns. He's a public figure and if we aren't seen to take him seriously he'll criticise the investigation very publicly and he has friends in the media. Perhaps you could put him top of your list today?'

Wilkinson was suggesting politely but, of course, it was an order.

'Of course, ma'am, I'll speak to him myself this morning,' Gawn agreed.

'Good. Thank you. We need answers quickly. Keep me informed.'

She turned on her heel and walked out.

When the door had closed behind her, Gawn turned to Maxwell.

'What's the name of that PR person, Paul?'

'Valerie Cosgrove.'

'Do we have an address for her?' she asked.

'Yes. She lives opposite Stormont.'

'Let's go.'

Chapter 11

Gawn and Maxwell had worked together long enough for him to know she didn't chat as she drove unless she had something important to say. So, their journey to Valerie Cosgrove's apartment, only a ten-minute trip with the light Sunday go-to-church traffic, had been completed in silence.

The Upper Newtownards Road was quiet today. A major commuter route into Belfast, tomorrow it would be buzzing with cars travelling to the city centre. Tomorrow the purple glider buses would be packed with office workers and school kids. But today it was quiet.

It was only when they were walking towards the apartment building, that Maxwell ventured a comment.

'I thought you told Wilkinson you'd see Goodlife first.'

'I said this morning, Paul. I want to know if there could be any truth in his idea that he was the target. If Cosgrove tells us Goodlife was moved from his original seat, would that make it more likely or less likely? Or is it irrelevant and nothing to do with him at all? Or' – she sighed – 'is this all just a waste of our time?'

The name, Cosgrove, was handwritten on a piece of cardboard opposite the button for apartment 5. Maxwell pressed the buzzer and they waited. Nothing happened.

'Try it again, Paul,' Gawn said sharply.

'Maybe they took her to hospital. I know they were checking her over but I thought she'd gone home afterwards.'

Maxwell sounded uncertain. He had pushed the buzzer again as he was explaining, aware of how annoyed Gawn would be if they had wasted their time coming here.

Just as Gawn was about to give up, a sleepy-sounding disembodied voice came from a speaker to the side of the doorway.

'Yes. Who is it?'

She was surprised to hear Cosgrove's almost cockney accent. There was a slight slurring to her words too. Not just sleepy then. Hung-over too.

'Ms Cosgrove?'

'Yes.'

'DCI Girvin from PSNI Serious Crimes. My inspector and I would like a word with you, please. About last night.'

'Does it have to be now?' the voice asked.

The woman sounded as if she was too tired even to be irritated at their request.

'We would really appreciate it. Just a quick word. We won't keep you long.'

Gawn deliberately kept her voice friendly. She didn't want to press too hard. They needed the information this woman could provide. There was a pause, then the door buzzed and unlocked with a click.

They walked across to the lift and Gawn stabbed the call button. Nothing happened; no sign of the lift descending.

'Sod this. It must be broken. It's only two floors. It'll do us good to take the stairs.'

Gawn set off at a jog. Maxwell had no choice but to follow.

When they reached apartment 5, Maxwell knocked on the door. This time they only had a short wait. A woman dressed in pink shortie pyjamas opened the door. Only one

button was done up holding the jacket closed across her breasts leaving an expanse of tanned midriff exposed. She seemed totally unaware of her state of undress or perhaps she just didn't care.

'Come in.' She spoke carelessly in a nasal whine and turned her back to them, walking away into the lounge area. 'You'd better sit down if you've had to climb the stairs.'

Valerie Cosgrove cleared items of discarded clothing off a leather sofa with a casual swipe of her hand to make a space for them to sit. Gawn noted a pair of men's trousers among them.

Neither detective moved. The young woman went across to a bag hooked on the back of a chair beside the window and extracted a packet of cigarettes. Gawn noticed the view over the manicured grounds of the parliament building opposite. The Trust must pay well, she thought to herself. The rent on this place would not come cheap.

'Fag?' Cosgrove held out the packet, barely able to keep it steady.

'No. Thank you,' Maxwell responded politely.

Gawn shook her head.

'How long have you worked for the HATP?' Gawn began. She had no desire to prolong the interview. She just wanted some details from her before she talked to Goodlife and to get the chance to see for herself the woman who had lost the vital page of names.

'Just over a year. More or less since it started, really.'

'And before that?' Gawn asked.

'I was at university. LSE.'

Gawn thought it strange that such an important role should be given to someone so young, straight out of university with no experience, and someone with no local connections. Perhaps she was cheap labour but this apartment hadn't come cheap. She knew she was suspicious of everyone and everything at the beginning of a case. Perhaps the girl was just very good at her job.

'You lived in London?'

'Yes.'

'Did you ever come across Joshua Randell there?' Gawn asked.

'Who?' Cosgrove looked at the DCI as if she was crazy. 'Who's Joshua Randell? London's a big place you know, Chief Inspector.' The comment was made patronisingly.

It was on the tip of Gawn's tongue to say she knew that; that she had lived in London for many years herself, but she bit the comment back. She didn't want to antagonise her. Let her feel superior. If she wanted to underestimate them as culchies, so be it.

'I'm surprised the name isn't familiar. You organised last night's dinner and Mr Randell was one of the top table guests so I would have expected you to know his name even if you'd never actually met him.'

A flicker of something crossed the young woman's face. It could have been confusion or maybe fear or maybe she was just still hung-over and not thinking clearly. But it was fleeting and it was hard to define. Gawn added it to her earlier suspicions. Perhaps she was seeing things that weren't there. She mustn't rush to judgement. Just because she found the woman annoying didn't mean she was a criminal.

'I might have heard the name. Maybe. I suppose I must have if you say he was sitting at the top table. But I definitely never met him. And I never knew him in London.'

Maxwell took over the questioning. 'What about last night, did you notice anything out of the ordinary?'

'Yes. Of course. People were collapsing all around me.' This time her answer was even more sarcastic. 'And I was feeling strange too. I felt weak; as if I was going to be sick.'

'Inspector Maxwell meant before your chairman collapsed,' Gawn interrupted, becoming irked now by the woman's attitude.

'I hardly had time to breathe last night, never mind notice anything out of the ordinary. I was running around like a blue-arsed fly all evening. People were so freakin' fussy. Some stupid man was a vegan and he hadn't put that on his acceptance. Then he expected me to just magic him up a vegan meal, just like that.' She clicked her fingers before taking a deep draw at her cigarette and blowing the smoke in rings towards the ceiling.

'Someone else just couldn't sit beside that awful common woman after what she'd done.' Cosgrove spoke in an exaggerated accent and rocked her head from side to side mocking the dinner guest. 'So I had to do a whole rearrangement of a table to suit the stupid bitch.'

'What about the missing page from your seating plans?' Maxwell asked. 'You told me last night it must have fallen off the board.'

The woman looked slightly anxious and her eyes darted between the two detectives. 'It must have been ripped off in all the fuss, like I told you. It's probably just lying about somewhere.'

'Funny it was the only page ripped off. But if it was, my men will find it.' Gawn's tone as she spoke made the statement sound almost like a threat. 'But you must have a copy of the original somewhere. On your computer?' she suggested.

'Yes. Of course. But that's the table that was rearranged. I only had a handwritten version with all the changes on it. The original is in the office. Not here.'

'We'd like to check it against the hotel's list and what our witnesses have told us and see who ended up sitting there. We should be able to work that out and maybe you could look at it and write on any changes you can remember. Perhaps you could get it for us today?'

Gawn emphasised the word "today". She was asking politely but the woman couldn't fail to realise she didn't intend it as a request. She expected her to agree even though it was Sunday.

'I could go into the office later and email you a copy.' The words came grudgingly.

'Thank you.' Gawn took her business card from her pocket and smiled as she handed it over. 'Here's my email address. By the way, did you rearrange Alistair Goodlife's seat?'

'That stuffy wee man who thinks he deserves special treatment?'

Gawn couldn't help but agree with the young woman's description but all she said was, 'The ex-MP, yes.'

'No. He was always going to be at the top table. Adrian had warned me he had to be there.'

'Adrian?' Gawn asked.

'Adrian Sandford, my boss.'

'Thank you for your time, Ms Cosgrove. I'll expect to hear from you later today then.'

Chapter 12

Once outside, Maxwell commented, 'Not exactly what I would have expected from someone working at the Trust.'

'You met her last night. What did you expect?'

Gawn stopped and turned a quizzical look on him. Sometimes, she thought he could be a bit naive, but he could also be perceptive and notice things about people that she missed.

'Well, last night, it was chaos and I didn't think much about her but thinking about it now, I suppose I expected she'd be a local, so she'd know our cross-community set-up, maybe a wee bit more experienced and more serious, and I expected her to be more concerned about what happened. She's supposed to be doing PR for the Trust.

Last night won't have done very much for their reputation but she doesn't seem overly concerned, does she?'

'She's possibly too hung-over to have thought much about that yet. I think she'd just woken up, and did you notice the smell?' Gawn asked as she started walking again.

It was obvious he hadn't. He hurried to catch her up and asked, 'Smell? What smell? Was she smoking pot or something?'

'No. Aftershave. There'd been a man there. Recently. He might even have still been there in the bedroom. There was a pair of men's cargo pants on the sofa. And two used glasses on the coffee table. Didn't you notice?'

She knew he wouldn't think it was important. And she knew she often surprised him at how nosey she could be, delving into people's private lives during an investigation even if it didn't seem to have anything to do with the crime. But then sometimes, it turned out that what she discovered was important.

'If she was upset last night, she might have phoned her boyfriend or she might even be living with someone. Nothing suspicious about that,' Maxwell said.

Gawn had realised a long time ago that Maxwell always tried to give people the benefit of the doubt. She thought that was one of his Achilles' heels. She didn't. She always thought and expected the worst. Of everyone. As a result, she was seldom disappointed.

'Maybe. But why not mention it if she did have someone in the next room? And losing that one sheet of paper is definitely suspicious to me. It's too convenient. For somebody.'

'You think Valerie Cosgrove was involved in… in whatever happened last night?' he finished with a shrug of his shoulders.

'I don't know but I regard everyone who was there last night as suspect. Present company excepted of course.'

'Thank goodness for that then. I wouldn't want you to suspect me.'

Chapter 13

'What do we know about Goodlife?' Gawn asked.

She had put off contacting the ex-MP for as long as she could but she realised Wilkinson was right. They needed to speak to him while he was still in Belfast. McDowell would be furious if Goodlife was attacked and it was linked to what had happened at the dinner. And the chief constable wouldn't be pleased if Goodlife appeared on national television criticising the way the PSNI carried out its investigations.

'Not a lot, boss. I've seen him on TV but I usually switch over when there's anything like that on. Give me a wee bit of reality TV every time. I'd be more inclined to listen to what he had to say if he was munching octopus testicles or something.'

'What about when you spoke to him on the phone? What impression did you get of him?'

'Honestly?' he asked.

She nodded.

'In the words of Ms Cosgrove, he's a "stuffy wee man".'

They had arrived in Bedford Street across from their destination, one of the newest hotels in the city. It had taken its name from a once-famous Belfast landmark which had ended its days as a military barracks during the Troubles. The current building in the Linen Quarter with its seahorse symbol is a stylish conversion of a former office block. Its twenty-three floors dominate the city and its top floor bar, the highest in Ireland, provides incredible views in all directions.

Gawn knew the hotel marketed itself as "central" and "convenient for all the sights of Belfast" but that meant there was no car parking. She pulled tightly into the kerb directly in front of the revolving door and beckoned to the hotel commissionaire in his smart blue overcoat and top hat. She took out her ID.

'Police business. We'll only be here a few minutes. If you need to move it, you can.'

She handed him her car keys.

Inside the concierge called up to Goodlife's room and then informed them he was expecting them.

* * *

'Chief Inspector, I was beginning to think the PSNI was ignoring my fears.'

Goodlife's words were said in the guise of a joke and accompanied by a half-smile but Gawn knew it was a joke with a barb.

'Your fears, sir?'

She could play games too.

'Surely your assistant chief constable told you about the threats that have been made against me?'

'The ACC mentioned you had some concerns, sir. She didn't go into any details. She knows we have procedures to follow. She wouldn't want to jeopardise an ongoing investigation,' Gawn explained.

She looked at the little man in front of her, a good six inches shorter than she was. His hair was thinning so there was a shine off his scalp when the light caught a thinner spot and reflected off it.

Goodlife was dressed in a pair of dark grey pinstripe trousers and a rose-pink shirt. A matching suit jacket was lying across the top of an open suitcase on the bed. A tuxedo in its protective cover, but not yet zipped up, lay over a chair. He was preparing to leave. Gawn noticed a book sitting out ready to be packed away. She recognised

the cover. A heavy tome by Simon Sebag Montefiore. Hardly light bedtime reading. She had read it too.

'Of course, of course. I realise you have your own ways of doing things. I wasn't trying to suggest I deserved any kind of special treatment, Chief Inspector, but I would have thought someone who had been receiving death threats would be a priority for you.'

He couldn't prevent annoyance sounding in his voice, although he had been backtracking.

'Perhaps you could give us some details of these threats, sir.'

Given the opening, Goodlife spoke at length. He explained that, like any major public figure, he was used to criticism and the occasional unpleasant letter or phone call. Gawn noted with some amusement, which she managed to conceal, how he elongated the word "major".

'You've reported all this to the Met, sir?' she asked.

'Of course. Many times. They offered me advice about protecting myself and my home.' He snorted in disdain.

'Have they identified anyone who might have targeted you? Any group or individual?' she asked.

'No.' The answer had come reluctantly.

'And no actual attacks have taken place?'

'No. But they shouldn't wait until someone blows me up or shoots me before they do something about it,' he almost whined.

'We may need to see the letters you've received, sir,' Gawn said.

'I've already passed them to the police in London.'

'Then we'll liaise with them and get the details. Now, about last night. Did you notice anything out of the ordinary before Lord Ardgeen collapsed?'

He took a moment to respond and Gawn realised he was trying to think of something he could tell them. Then, reluctantly, he admitted, 'No. I was busy chatting with your assistant chief constable. I was facing towards Ms Wilkinson so my back was turned to the other end of the

table away from where the judge was sitting. I was thinking more about when the speeches would be over so I could nip out and smoke my cigar.'

He gave a dry laugh.

'And when Lord Ardgeen collapsed?'

'I went to his aid, of course. But I'm afraid there was nothing anyone could have done for him. Then that silly woman started shouting. She'd been sitting near me. It could have been me. It was meant for me, I'm sure.'

His voice had taken on a whining timbre again. He wanted sympathy, Gawn realised. But she also realised everyone in the room, herself included, could say what he had just said. With the evidence, or lack of it, they had at the minute, the attacks seemed random and indiscriminate. Those who had succumbed to poison – or whatever it was – were from tables all around the room.

'Had you spoken to Mr Randell at any time during the evening?' she asked.

'Randell?'

'The man who collapsed near where you were sitting,' she explained.

'Oh him. Just to say hello.'

'So, you didn't know him?' she asked.

'No.' Goodlife's answer was accompanied by a shake of his head.

'And you didn't notice anything suspicious, anyone putting something into his food or drink?'

'I think I would have mentioned that.'

His sarcastic reply closed off that avenue of questions. She changed tack.

'So, how did you come to be at the dinner, Mr Goodlife? Do you have connections with the HATP?'

The Trust didn't seem the kind of organisation that he would support. Granted it was based in Northern Ireland, not Great Britain, so maybe he thought that made a difference.

'In a way, I suppose. My sister invited me. She thought it would be good for me to hear about all their good work.' Gawn could hear the sarcasm in his voice.

'Your sister, sir?'

'Veronica.'

When he saw the name didn't mean anything to her, he added, 'Lady Ardgeen.'

Chapter 14

It looked like a scene from the aftermath of an earthquake in some Hollywood disaster epic. Chairs and tables lay where they had been overturned in the rush to get out. No one had been allowed into the room to tidy up. The CSIs were busy at their work.

Plates and dishes, some in pieces, some intact, lay scattered over the polished wooden floor, their former gooey contents spread out beside them. Yellow plastic markers littered the area showing where evidence had been found and photographed. Some discarded plates of half-eaten desserts sat forlornly on tables reminiscent of the fate of the *Mary Celeste*. Of course, here the empty spaces didn't indicate people who had disappeared never to be seen again except for Tracy O'Neill, and Gawn was still hopeful she would turn up somewhere with a simple explanation for her disappearance.

A neat pile of discarded bags and shoes sat off to the side, their owners not yet identified. That job would come later. There was just so much to do and returning a handbag was low priority. Gawn had managed to retrieve her own shoes last night, now she spotted her pashmina lying in the pile.

A group of white-suited androgynous figures, only their eyes visible between their masks and hoods, wandered, what looked like randomly, around the room. But Gawn knew there would be nothing random about these searches. Mark Ferguson was methodical. She watched as one of the figures paused and bent over to examine something on the floor more closely. There was a whirr and a flash as a photograph was taken and a sample was bagged and labelled.

Gawn and Maxwell had paused outside the building to don their own protective coverings. Now she spotted Mark Ferguson, the CSM, and made straight for him.

'Good morning, Mark. Hard at it, I see.'

'Morning. Yes, ma'am. It's not quite as bad as a bomb but there's still a hell of a lot. I'm just thankful we're not searching through body parts this time. You have no idea if we should be looking for a murder weapon, do you?'

Gawn shook her head.

'Sorry, Mark. No. The PM results aren't in yet but I would guess it's probably poison, if it is murder.' She added, 'But what poison and how it was delivered to the victims, I haven't a clue. I'm hoping you'll be able to provide the answer to that one.'

Gawn scanned the room. Her eyes paused at the table where she'd been sitting.

'You got the seating plan from Grant?' she asked.

'Yes. Thanks. That was helpful but we have to go over everything anyway. If it was murder and it was poison, there may have been another intended victim or more than one who didn't eat whatever it was or drink whatever it was, and it'll still be sitting here or somewhere in the kitchen.' He extended his arm and made an expansive gesture. 'Somewhere.'

'But nothing at all out of the ordinary has turned up?' she asked.

'The only thing I can tell you is that both your dead men and your missing woman had the chocolate ganache for dessert, if that's any help.'

'Not really, Mark. Paul had that too.'

Chapter 15

Before they left the hotel, Gawn decided they should speak to DC Jo Hill and DS Walter Pepper who were interviewing the staff who had worked on Saturday afternoon preparing the ballroom. The two would need to check up on the evening serving staff whenever they came back on duty later and chase up any casual staff employed for the event.

'Anything?' Gawn asked.

'Not yet, ma'am. It was a busy night. That's what they've all been telling us. They were a bit short-staffed. Everyone was kept on the go. And the heating system was playing up so it was very hot in the kitchen. One of the wee waitresses fainted. She had to go home early which made them even more short-staffed. But they're all denying seeing anything out of the ordinary until' – Pepper read from his notebook – '"that old guy took a header into the trifle". The sympathy of youth, ma'am.' He tutted and shook his head.

'Indeed, Walter. You'll need to speak to that waitress. The one who fainted. She may have gone home early but she could still have noticed something before she left or she could have been involved in some way.'

Gawn couldn't say anything more for she didn't know what the woman might have been involved in. None of them did. She had never had a case like this before where they weren't even sure yet what they were investigating and

they had no idea about a weapon or a motive or any suspect.

'Keep at it and let me know if anyone comes up with something to help us.' She turned to Maxwell. 'I think we'll have a word with the manager.'

Maybe he could provide some new information. Gawn didn't really think that but they needed something. Her instincts were on alert. She sensed something major had gone on here, but she just didn't know what or why.

Chapter 16

Maximilian de Grosse was Swiss but he had lived in Northern Ireland for over a decade and his English was impeccable with only the faintest suggestion of an accent. Long experience in the hotel trade all over the world had given him the ability to appear unflappable in any situation. Appear. Not actually be in control.

Gawn and Maxwell found him in his office sitting at his desk looking out over the hotel's manicured lawn which swept gently down to the edge of the lough. Gawn glimpsed, across the expanse of water, the Norman castle near her home in Carrickfergus. De Grosse was absent-mindedly cradling a demitasse in his hand and his immediate reaction to their appearance was to set it down on his desk and offer hospitality.

'May I get you some coffee or tea perhaps?' the immaculately dressed man asked, unable to relinquish his role as host even in these unusual circumstances.

Normally Gawn would have refused but with her lack of sleep she thought an espresso might help keep her going. Maxwell declined the offer. She settled herself into a leather wingback armchair, one of a pair facing the

manager's desk. Maxwell sat beside her, holding his notebook at the ready as unobtrusively as possible. The intense aroma of the Puerto Rican blend of coffee wafting from the cup in Gawn's hand perked her up even before she had tasted it.

'Were you here last night, sir?' Gawn asked. She hadn't seen him but then she had been concentrating on the people in the annex.

'Yes. I have an apartment in the hotel. I'm not quite on duty twenty-four hours a day but I do need to be available if there's any emergency and, when there's an important event, like the Trust dinner, I'm always around to make sure everything runs smoothly.'

'So, before Lord Ardgeen collapsed, was everything running smoothly?' she asked and took a sip of the scalding liquid, savouring the flavour as it burned her tongue while she waited for his reply.

'I'm sure you're aware of the famous image of the swan, Chief Inspector?'

He paused. She nodded and smiled.

'A cliché, I know, but true even so. Running a hotel, and especially a big event, is rather like that. Our aim is that the guests will see nothing but calm and everything will run smoothly and on time, no hitches but, of course, in reality, everything is going crazy behind the scenes. The kitchen is usually bedlam. That is just the way it is. I wouldn't say last night was any different.'

She waited, hoping he would add something more to help them if she didn't jump in with another question.

'We were maybe a little short-staffed,' he reluctantly conceded.

'Yes. A few of your staff did mention that to my officers,' Gawn said.

'It can be difficult to get the extra experienced silver service staff needed for a special occasion. We don't keep a full complement of waiting staff. It wouldn't pay. No hotel does except possibly the Ritz.' He smiled at his own touch

of self-deprecating humour. 'We use casual staff as the need arises. And sometimes that can leave us a little short-handed but it was not a problem and nothing was done that in any way affected the guests or compromised the quality of the food.'

'Mr de Grosse, we suspect that Lord Ardgeen died of natural causes. It probably had nothing to do with the hotel. It could have happened at any time at his age,' she finished with what she hoped was a reassuring smile.

'And the other man?' the manager asked.

News of Randell's death had obviously reached the hotel. It was probably already on the news reports, she realised.

'We haven't had the results of his post-mortem yet,' Gawn had to admit.

'It doesn't look good with all the others collapsing like that, does it? I've never seen anything like it,' the manager added.

'Me neither, sir,' agreed Maxwell.

Gawn threw him an annoyed look.

She stood up and set her now empty cup and saucer down on the desk.

'If you think of anything that could help our enquiries, please get in touch. And thank you for the coffee, sir. It was delicious.'

She handed de Grosse her card.

'My pleasure and of course I will contact you if I think of anything.'

He hesitated, as if making up his mind how to frame his next comment.

'I don't wish to appear insensitive but I wondered when we would get our venue back. We don't have an event scheduled today but we do have a conference booked in for tomorrow afternoon and we would need to set the room up tomorrow morning.' His voice trailed off apologetically.

'I'm afraid that's out of my hands, sir. The forensics people are in charge until they've decided they've done everything they need to. Even I can't go in without their permission. I would suggest you might want to think of an alternative venue?'

He nodded sadly as if he understood.

'Do you think he will?' Maxwell asked her as soon as they had stepped outside the hotel building.

'What? Get an alternative venue or contact us if he thinks of something?'

'Contact us.'

'Maybe not if he suspects it reflects badly on the hotel. That's what I'm afraid of. If he remembers something out of the ordinary, he may filter it through what's best for the hotel first rather than thinking of our case.'

'Where to now, boss?'

'We need to speak to someone higher up the pecking order at the Trust than Cosgrove. She's PR and Ardgeen was the chairman but that's pretty much a figurehead role. There must be someone actually running the show.'

'Adrian Sandford.'

'Was he at the dinner?' she asked.

'Yes. Sitting at the top table beside Ardgeen.'

'Then why hasn't he been beating a path to our door demanding action, like Goodlife? That's what I would have expected. Do we have a home address for him?' Gawn asked.

'He lives in Killinchy.'

'Do we have a phone number?'

'Yes.'

'Ring him and tell him we're on our way.'

Chapter 17

Killinchy is only a thirty-minute drive from Belfast past the market town of Comber yet it manages to appear deep in the countryside. Its fertile land would yield the famous early Comber potatoes but not for months yet.

Gawn had programmed her satnav to take them directly to Sandford's home. It was up a narrow laneway which opened out to reveal a stone and white-rendered bungalow enjoying a secluded location with a distant view of Strangford Lough. There was a sweeping driveway leading to the front of the property and a turning circle for cars. A black Range Rover with tinted windows was parked out front.

Before they had the chance to knock, the front door opened and a man in chinos and a white polo shirt with the HATP logo on the breast pocket stepped out and greeted them. He looked like an entertainment organiser at a holiday camp. His cheery smile revealed a row of straight white teeth sparkling enough to grace any toothpaste ad and his hair was slicked back framing his tanned face. Before he had even spoken, something about his manner grated on Gawn. She was suspicious of him, one of her famous instant reactions.

'Chief Inspector Girvin, I presume.' His voice was light and cheery as if he was greeting an old friend.

She thought Sandford was too upbeat, too charming. The chairman of the Trust had died last night. So had another man although he may not know that yet. His job could be on the line. There was nothing to be cheery about but she realised he was a man used to charming women and probably men too to promote the charity. That would

be his forte and she expected he was good at parting donors from their money.

Sandford turned to Maxwell.

'And Inspector Maxwell. Welcome. Please come in. We're in the conservatory.'

Sandford led them down a broad hallway. Their feet sank into the deep-pile carpet and when they walked into a huge kitchen Gawn was not surprised to see the ubiquitous Aga. This was an expensive home.

Sandford led them into a bright conservatory with views over the fields and Strangford Lough just visible on the horizon. He had obviously been working here before they had arrived, for a laptop sat open on a circular glass table and papers were scattered haphazardly around.

'Please, have a seat,' Sandford said and shut the lid on his computer with a snap.

'I'm very surprised you haven't been in touch with us, sir,' Gawn began and waited, letting her comment hang between them, wanting to hear how he would explain himself.

'Last night was a bit of a blur. You can't imagine what it was like, Chief Inspector.'

'I was there.'

That was all she said but she had obviously surprised him. He mustn't have seen her or at least not recognised her in her formal suit today as the redhead in the little red dress of last night.

'Oh, right. Yes, of course you were. I remember seeing your name on the guest list. Well, then you do know how crazy it all was. One minute everything was fine and the next everything went to blazes. Out of nowhere. I tried to help Lord Ardgeen and then, when your people had finished with me, I went to see his wife. Then I had telephone calls to make.

'I didn't get to bed until just a couple of hours ago and then there were more calls to make once I was awake

again. I had to speak to the family in the US. They're obviously very concerned about the turn of events.'

That was one way to describe it, Gawn thought to herself.

'Tyrone O'Sullivan wants to come over if he can rearrange his schedule but he's in the middle of important takeover negotiations at the minute.'

Gawn had wondered why neither of the brothers had been at the dinner. What about the other brother? Surely, if this was their pet project to honour their forbear, one of them would have wanted to attend the first fundraising dinner.

'Let's go back to last night, sir. Who decided on the seating allocation?' she asked.

His response was immediate.

'That would be Val, Valerie Cosgrove. I mean I gave her certain parameters and special requirements to follow. We had some very important supporters who needed to be at specific tables and the top table had to be the main dignitaries and the speakers, of course. Your assistant chief constable was there and a couple of other people who were due to speak as well. Some of the tables had been purchased by companies and their people had to be seated together, but for anyone who had only bought one or two individual tickets I simply told Val to make sure we had a good mix of people and a good gender mix. Basic things like that.'

He had almost been gabbling but then he seemed to run out of ideas and his voice trailed off. Gawn wondered if he was worried about something, something more than the death of their chairman. He seemed edgy to her although he was trying to hide it. But perhaps it was just the circumstances. He would be under pressure. He must realise his job could be on the line.

'Joshua Randell was sitting at the top table. Who decided that? Why was he there? Was he going to make a speech?' she asked.

'No. Mr Randell has done some work for the family in the past. He's a personal friend of theirs. Neither of the O'Sullivans could be there last night so they suggested inviting Randell but he wasn't making a speech.'

'The O'Sullivans couldn't be there,' she repeated, keen to hear the reason why.

'That's right. We'd changed the original date. It was all due to happen a couple of weeks ago. But Axel has just moved to Japan and Tyrone is up to his eyes with this takeover, as I said. They were both most disappointed they couldn't be there.'

'I see. But Mr Randell had no involvement with the Trust?'

'No,' Sandford said and shook his head to emphasise his answer.

'But he was important enough to merit sitting at the top table?'

Gawn's tone of voice suggested she was surprised. It seemed strange to her a man like Randell, whom Sandford didn't know, should be given such a prominent position. She wondered if it had some significance.

'Not important. No. We needed another single male for the table to even up the numbers and, as I told you, he's a friend of the family so I thought it would be a good idea. He was on his own. He didn't know anyone so it was as good a place for him to sit as anywhere.'

'So it was you who arranged for him to sit there?'

'I suppose so. Technically, yes,' he conceded rather unwillingly, she thought.

'Had you met him before last night at all?'

'No. He's based in London. We'd spoken on the phone once. That's all.'

It was obvious Sandford hadn't heard of Randell's death.

'I'm afraid Mr Randell died on his way to hospital, sir.'

She watched Sandford's face closely as he took in her news.

'He's dead?'

He seemed stunned and that surprised her. If he didn't know the man, hadn't met him or had any dealings with him before, she was surprised that he seemed so upset. He had turned deathly pale.

'That's terrible.'

Gawn was keen to move on.

'What about Tracy O'Neill? Did you know her?' Gawn asked.

'I'm afraid the name's not familiar to me, Chief Inspector. Was she injured last night too? She's not dead too, is she? I suppose there'll be a lot of claims and the hotel will try to get off the hook.'

'You think the hotel's to blame, sir?' Maxwell interrupted, looking up from his notes.

'Who else? You sit down to a nice meal and people start dropping like flies. Must have been the food, mustn't it? Or maybe the wine,' Sandford added.

This time neither of the detectives responded. Gawn wasn't going to give away any information about the case nor offer him any reassurance. Instead she asked, 'Can you think of anyone who would want to damage the Trust's reputation?'

Sandford seemed shocked at her suggestion.

'You think this was done deliberately? That it was aimed at us?'

'It's one line of inquiry we're following. We can't rule anything out at the minute.'

'We're a charitable trust. We help young people. Why would anyone take objection to that?' Sandford's voice had grown louder and he was becoming agitated.

'You'd be amazed at what people can take objection to, sir. If not the Trust, then what about Lord Ardgeen? How did everyone get on with him? Did he have any enemies?' she asked.

'In the Trust?'

'Yes.'

'He was our chairman. It was an honorary position. The only time we saw him was for the trustees' meetings and I took him to dinner a couple of times when we were getting everything off the ground.'

'How many staff do you have?' Maxwell interrupted, ready to jot down more details in his notebook. He knew Gawn liked him to write a lot. She had told him when he first began working with her that it made witnesses nervous. If necessary, he was just to scribble anything. He never did that, of course, aware his notebook could be required in evidence but, if anyone checked, his notes were always very detailed and wordy and he was careful to write slowly.

'There's only the five of us. We're not a big operation. There's Valerie, then an admin clerk, Aine, our receptionist, Pauline, and a finance officer, Declan Burns. We're a small tight ship. We use the money we get for the benefit of the young people. Not on admin.'

Gawn immediately thought of Sandford's Range Rover and his expensive bungalow and Cosgrove's prime apartment. Even if they were only rented, they would still have been expensive. The Trust obviously had money and paid well. Sandford must be good at his job.

'Were all the staff there last night?' Maxwell asked.

'Yes.'

'And how much money does the Trust get in donations?' Gawn asked, picking up on Sandford's comment about the Trust's finances.

He seemed annoyed at the question.

'I couldn't really give you that information.'

She looked at him, surprised.

'For a start we haven't had the first year's accounts audited yet so I'm not even sure myself but many of our contributions are anonymous.'

'You mean you don't know who gives you money?' Maxwell asked disingenuously.

'No, of course not. I mean some of our donors don't wish to be named. They prefer anonymity. They want their donations kept private so we don't give out that information.'

'Any particular reason why they would want anonymity, Mr Sandford?' asked Gawn.

Sandford was getting more than a little annoyed at this line of questioning and he couldn't conceal it. He had lost some of his confidence and some of his bonhomie towards them.

'You would have to ask them that, Chief Inspector. Now I really can't see how our finances have anything to do with what happened last night.'

There was an edge to his voice. He wasn't a great actor and he shouldn't try playing poker, Gawn decided. He couldn't hide his discomfort.

'Until we know for sure exactly what did happen last night and why then we can't know what's relevant to our investigation,' Gawn explained.

Adrian Sandford stood up, keen to bring the interview to an end now.

'If there's nothing else I can help you with, I really need to be getting back to work. There's a lot of important people to be contacted.'

'One last question. Did Lord Ardgeen have any problems with anyone outside the Trust? Maybe from his work as a judge?' Gawn suggested.

'I know nothing about his work as a judge. I didn't know him then. I would suggest you speak to his wife or perhaps his son would be the person to ask. Lady Ardgeen will hardly be in a fit state to answer questions,' he said with obvious relief that he could point them in someone else's direction. 'But his son was arriving this morning.'

'Thank you for your help, Mr Sandford.' Gawn held out her business card as she spoke. 'If you think of anything that might help our inquiries, please get in touch.'

Sandford took it but said nothing.

When the front door had closed behind them and they were walking to the car, Maxwell looked at Gawn.

'When he talked about "the family", I couldn't help thinking of the Mafia. That's what it sounded like,' Maxwell said.

He laughed.

She didn't.

'I know big companies have their in-house legal teams,' she said, 'but it seems a bit strange that the O'Sullivans keep a criminal barrister in the UK and they wanted him at the dinner. Why? And why on earth would he want to come unless he was being well paid of course? It's hardly a fun night out attending a dinner where you know no one and have no connections and flying all the way from London to do it.' Gawn paused and then added, 'I don't think the O'Sullivans have any business interests here on this side of the pond, as they call it, but it would be worthwhile checking up on them and on the donations to the Trust. Anonymous donations. It could be a conduit for money laundering. Follow the money, isn't that what they say?'

Gawn was jumping to another conclusion. She was sure that was what Maxwell would think but he had worked with her long enough to follow her lead.

'I'll get someone started checking as soon as we get back. I miss Erin for this sort of thing. I wonder how she's getting on,' he said.

'I'm sure she's fine. By the way, did you notice Sandford's trousers?'

'His trousers?' he asked.

'Chinos.'

She stared at him.

Suddenly he reacted. 'Like in Ms Cosgrove's?'

'Exactly. Maybe the reason he didn't get home until the early hours was because he was spending the night with her.'

'They're a fairly common type of trousers, boss. I have a pair myself.'

She knew Maxwell was trying to curb her suspicions.

'But if they were his,' she continued, 'it would mean he was there when we were questioning her. And that begs the question, why wouldn't he have joined us? Could he have more to hide than a bit of a romp with an employee?'

She saw the expression on Maxwell's face and said, 'I know. I know. It's a big leap from a pair of trousers to an office romance but check into him as well. We need background on all the main players, including Ms Cosgrove.'

Maxwell didn't challenge her. He had experience of her hunches of old. She could trust him to have someone check into the HATP and its finances and into Adrian Sandford's and Valerie Cosgrove's backgrounds too. Just in case she was right this time.

Chapter 18

Before they could finish their day of preliminary interviews, Gawn decided there was one more person she needed to speak to. Ardgeen's widow. She knew she needed to pay the PSNI's respects to the family and assure them they would be doing their utmost to find out what had happened to the judge. Talking to grieving relatives was her least favourite part of the job. She was glad Maxwell was with her.

The Ardgeen home was an imposing detached red-brick residence in an avenue of imposing detached red-brick residences just off Malone Road, an area synonymous with money and influence. The house was set behind a high hedge, only its upper storeys visible from the

street. A set of six-foot-tall double iron gates was shut but a pedestrian access gate was unlocked. Gawn parked in the street behind a white Mercedes. She noticed a battered silver Fiat further up the street just pulling away. She recognised it. Donna Nixon's car. So, the press had been sniffing around.

They approached the double-fronted house up a winding gravel driveway, their feet crunching at every step. The solid pre-war building befitted an ex-High Court judge. Gawn noticed the blinds were pulled down, a custom she hadn't seen for years. A house of mourning.

The front door opened as they approached. Someone had been alerted by their footsteps or perhaps they had been on the lookout.

'Good afternoon. I hope you're the officers from the PSNI and not more journalists. I'm Nigel Ardgeen.'

A stick-thin man in his late fifties with greying hair spilling down over his forehead in a surprisingly haphazard manner extended a hand in greeting. There was something almost boyish about him. Gawn shook the proffered hand and was struck by its flabby moist texture. She had expected the smooth sensitive hands of a surgeon, not chubby fingers which immediately made her think of half a pound of sausages.

When they had introduced themselves, Ardgeen said, 'Please, come in. My mother's resting but she hopes to join us.'

His voice was deep, with an accent which reflected his mainland boarding school education and his career as a surgeon in a top London hospital.

'We're very sorry for your loss, sir. If you're being bothered by the press I'll arrange for an officer to be on duty outside the house for the next few days.'

'Thank you, Chief Inspector,' Ardgeen said and stepped back to let them enter the hallway.

'I know this is a very difficult time but we're trying to understand what happened last night. There was another

fatality at the event. We don't know yet whether the two deaths are linked and if something untoward was involved in either or both of them. Your father's death may have been due to natural causes, of course. I'm sure, as a doctor, you'll be well aware of the state of your father's health. However, the other death is more surprising and we need to know if the two were connected; if your father and Joshua Randell knew each other.'

While she had been speaking, Ardgeen had only nodded. Now he turned and gestured to them to follow him into a large formal drawing room before replying. He had not reacted to the mention of Randell's name.

The atmosphere in this room reflected the gravitas of the man who had lived here. There was a chill in the air. The room was unheated and the drawn blinds prevented any light or heat from the dregs of the weak winter sun permeating inside to offer any warmth. A tall black marble and mahogany fireplace dominated the room. Above it hung an ornate gilded mirror which reflected the image of their three figures, almost ghostlike, back at them as they walked in. The room was in semi-darkness and oppressive in its stillness, except for the loud tick of a grandfather clock in the corner.

The furniture was old-fashioned but not in any attempt to be trendy, not shabby chic. Heavy, mahogany side tables and two dark brown leather sofas sitting at right angles to each other did little to lighten the mood. The place reminded Gawn of a gentleman's club.

Ardgeen turned on lamps either side of the empty fireplace before responding.

'Please, sit down. If there's anything we can do to help, we'll do it. Of course. That goes without saying. If something criminal went on last night, well, my father valued the law. He dedicated his life to it. He would expect us to help.'

'Your father hadn't been in good health, had he?'

Gawn knew this already from a quick phone call with Munroe. She felt this was a good way to get Nigel Ardgeen talking. He was a doctor. He would be on solid ground discussing illnesses and death.

'He was eighty-five. He'd had a heart condition for a long time. He kept remarkably well really, considering. That was his way. He said he wasn't going to check out sitting in a chair with a blanket over his knees if he could help it. He wanted to keep busy, feel he was still doing something worthwhile for society. That's why he got involved with the HATP.'

'How did that come about, sir? Do you know?' she asked.

'Only in very general terms, I'm afraid. I think he was contacted by some mutual friend of his and the O'Sullivans. They wanted a figurehead, a name with a reputation. He had lots of contacts who could be worth tapping into for them and he was looking for something to do. He'd had to give up his beloved golf. It had got too much for him and the Trust fitted the bill.'

'Do you know who the friend was?'

'I don't. My mother may know. Sorry.'

'And what did his involvement with the Trust entail? We've been told he only attended a couple of meetings a year and that was about it.'

Nigel Ardgeen was sitting back comfortably across from the two detectives. Slowly he crossed his legs and then reached into his pocket and took out a brilliantly white handkerchief, clear fold lines showing it had been meticulously ironed. He blew his nose noisily before answering. With a suspicious mind developed from years of questioning suspects and witnesses who were trying to hide something, Gawn wondered if this was a ploy to delay answering. Then she rejected the thought. The doctor was a respected figure. He hadn't been there last night. He had nothing to do with the Trust and he had just lost his father.

'Well, yes. So far, the Trust has only been in existence for about a year so there wasn't a lot for him to do. He had his first trustee meeting about nine months ago, if I remember correctly, and then one about three months back. The big one was coming up in a few weeks. And he was looking forward to meeting some of the young people who had been given internships when they get back from the States.'

'The big one, sir?' Maxwell queried, picking up on the doctor's comment.

'Yes. Their first two meetings had been pretty dry, legal-type meetings to do with the setting up of the Trust. Pa did talk to me about them when we spoke on the phone but that sort of stuff is a closed book to me. He loved it. But it wasn't for me so I didn't listen very closely. Usually we just chatted about cricket or golf when I phoned.'

He gave a rueful smile as if regretting his admission.

'If you want more details about the Trust and what my father did you should speak to Adrian Sandford, the chief administrator. He'd be able to tell you and give you the minutes of any meetings, I'm sure.'

'Yes. We've already spoken to Mr Sandford and I'm sure we'll be talking to him again. But, to take you back to what you were saying, what about the big one, as you called it?' Gawn asked.

'That's the AGM when they sign off the accounts for the year. Pa was looking forward to meeting up with Oscar MacFarland, their auditor. He was an old friend.'

'Could MacFarland have been the mutual friend who got your father involved?' Gawn asked.

'I don't know. It's possible, I suppose. I don't think my father ever mentioned who it was.'

'Had your father been worried about anything recently, sir?' Maxwell asked.

'About the Trust?'

The doctor seemed puzzled by the question.

'About it or about anything really. We're just trying to get an idea if he was under any pressure,' Maxwell explained.

'Pa was used to pressure, Inspector.' A smile crossed the man's lips. 'He had lived through the Troubles with all that entailed for a member of the judiciary. I remember the panic buttons, the police guards at our house, the officers checking under the car every morning before we set out for school but I didn't know the half of it, of course.'

Gawn knew the lifestyle Ardgeen was talking about all too well. As the daughter of a serving police officer, that had been her childhood too until her father had been caught out.

'Ma and Pa kept it from us as much as they could.'

'But there was nothing recently he was concerned about?' Maxwell probed.

'Not that I know but I wouldn't have expected to be told if there had been. Pa played his cards very close to his chest all his life. He could be secretive and he wouldn't have wanted to worry anyone else in the family. And of course I don't live here. I'm based in London. I just flew in, so there could have been something that I didn't know about. And my sister lives in Dubai so it's unlikely she'd know anything either.'

The three looked round at the sound of the door handle turning and watched as the door slowly opened and an elderly lady walked in. "Lady" thought Gawn, not woman. She had the deportment and grace of a debutante, her back ramrod straight, her head held high, dignity oozing from every pore. She carried a crumpled handkerchief but her eyes were dry. Only her slightly flushed complexion betrayed her earlier tears.

They all stood respectfully and Ardgeen moved across to his mother. He took her by the elbow and guided her across the room although she seemed perfectly capable of walking by herself.

'This is the police, Ma. DCI Girvin and DI Maxwell. I told you they were coming.'

Lady Ardgeen cast a disparaging look on her son.

'Nigel seems to think I'm decrepit.'

Gawn and Maxwell smiled dutifully as if any suggestion that the octogenarian widow might be in need of support was ludicrous.

'I'm perfectly capable of remembering a simple detail that you only told me an hour ago, my dear. I'm not senile yet.'

She extended her look to Gawn and Maxwell. Her eyes passed over them and Gawn had the distinct impression they were being judged. She wasn't quite sure what the test was and whether they would pass.

'I hope he's told you everything you need to know. If something untoward took place last night my husband would want it uncovered and dealt with.'

From the look on Lady Ardgeen's face and the sternness of her tone, Gawn surmised Lord Ardgeen might not have been the fiercest member of this family.

'He's been most helpful, My Lady. May I offer our condolences on your loss. If I can ask just one question and then we'll leave you in peace. Do you know who recruited your husband as Chairman of the Trust?'

'Recruited. What a strange word to use, Chief Inspector. He was invited to take on the role by a colleague, Joshua Randell.'

They had their link.

Chapter 19

It had been a busy day and a very long one, starting early. The events of Saturday night seemed a lifetime ago and the interviews so far had produced little. The most interesting fact was a connection between the two dead men, but exactly what it was, was unclear. Lady Ardgeen had only

been able to tell them that Randell had worked with her husband briefly at some time in the past on a committee in London. She didn't know any details.

'Right. Update,' Maxwell announced as he positioned himself in front of the incident board facing a room full of detectives, some of them looking very tired. They had been at the hotel last night until late and back on duty this morning too.

Gawn had chosen to stay at the back of the room, leaning against a filing cabinet in the corner.

'Anything from Forensics yet?' Maxwell asked.

'No. Nothing new. Just complaining how much evidence they've collected and how long it's all going to take,' Logan answered.

'Anything from Munroe, Jo?' Maxwell turned to the young officer sitting in front of him.

'Just the prelim reports. Lord Ardgeen's COD is natural causes but Randell, he's classifying as unexplained at the minute. He has more tests to run. He's promised the full report on the judge by tomorrow.'

Gawn sighed loudly at Hill's response. Now she spoke up. 'No wounds on Randell?'

'No, ma'am. No stab wounds or gunshot wounds or anything like that and he says it'll take a while for the toxicology results to come back.'

Gawn sighed again. They still didn't know if they had a murder to investigate but she was becoming more certain that, if they had, it was poisoning.

Maxwell knew she would be annoyed at the delay.

'Walter, did you get anything useful from the staff at the hotel?' he asked, hurrying on.

'Afraid not, sir. Just more of the same.'

Now it was Maxwell's turn to look impatient.

'Well, have we made any progress on Tracy O'Neill? Has she turned up yet?' he asked.

No one responded.

'Right. We've got the CCTV from the hotel.' Maxwell's voice betrayed his growing exasperation. 'Tomorrow we need to see if we can get any sightings of O'Neill leaving. Some of the witnesses will need to be questioned again too.'

Gawn spoke up from the back of the room.

'And we need to find out exactly how Ardgeen and Randell were connected. What was this committee Lady Ardgeen mentioned? Jack, phone Randell's chambers tomorrow and see if they can shed any light on it. By the way, did anything come in from Valerie Cosgrove for me?'

Her face showed she had just remembered that the woman was supposed to send her a copy of the missing page.

'Oh yes, ma'am.' It was Grant who spoke, sounding as if he had just remembered. 'She phoned. She went into the office to get the list for you but she found there'd been a break-in. Her computer's been stolen.'

Chapter 20

Gawn listened to the satisfying glug-glug as she poured herself a large glass of red wine. She thought she'd earned it. She had been on the go nonstop since early morning after what little sleep she had managed. Now it was almost ten o'clock, the time she looked forward to, when she and Sebastian caught up on their week. The time since he had left for California was passing but very slowly. The days she could fill with work and busyness but the nights were long and lonely.

As she waited, her thoughts were on the case. They had a missing person, but murder? Ardgeen had died of natural

causes. Randell's cause of death? Well, Munroe was being characteristically cautious.

Tracy O'Neill was missing but they'd found no indication of foul play and people went missing all the time for all kinds of reasons. Her car was at the PSNI's forensic facility being checked over but there'd been no update. Dee and Grant had spoken to her husband but Gawn decided she would need to see him herself if the woman hadn't turned up by tomorrow morning.

Everything about what had happened on Saturday night was so amorphous. She felt as if she was fighting her way through a bag of cotton candy to see if there was anything of substance there at all. There were too many coincidences and she didn't like the latest news that the Trust's offices had been burgled just when everything was happening at the dinner.

At ten o'clock sharp, she was settled in front of the fire, her laptop on her knee. She opened the lid. The connection to California was speedy. She thought fleetingly of a time, not so very long ago, when communication between the two continents would have been much more difficult. She thought even further back to the time before Walter O'Sullivan had made his Atlantic crossing. Then it had been almost like a death, the famous Irish living wake, when families expected never to see their loved ones again. As far as she knew, O'Sullivan Snr had never made it back to the "oul countree" and her fear that Seb wouldn't want to come back resurfaced briefly.

'Hi, babe.'

Her husband's cheery greeting along with his familiar cheeky grin filling the screen immediately lifted her spirits. She gazed into his vivid blue eyes, sparkling with fun, the crinkles at their corners formed from his frequent laughter and good humour. How she missed that smile. That and so much more about him.

'Hello, darling. You look in a very good mood,' she responded, smiling back at him.

'I am. I had a fabulous brunch with some friends at a new restaurant in Santa Monica and I've arranged to go surfing with them.'

He sounded pumped up, excited, and her fears of him deciding his life lay in California rather than Belfast resurfaced. She wondered who the new friends were and if any were female.

'Hey, babe, I really liked your wee red dress last night. See, you do listen to me sometimes.'

'How did you…' she began.

He had enjoyed spoiling her with that expensive dress she didn't realise she would ever have occasion to wear. And she had enjoyed pleasing him by letting him buy it for her.

'The internet, babe. You can't hide from me, you know. Big Brother is everywhere. God, you looked smokin' hot standing there. Those legs. And bare feet. Be still my beating heart! No wonder some old guy had a heart attack. I nearly had one myself.' He teased her and laughed.

'Sebastian, it's not a laughing matter. Lord Ardgeen was a fine old gentleman. It's very sad. Anyway, it had nothing to do with my dress. The poor man had a heart condition.'

'If you say so, babe, but I bet you set a lot of men's hearts racing at that dinner.' When he saw her stern expression, he hurried on. 'So, you've no murder to investigate then. You'll be disappointed.' He pouted, exaggeratedly.

Would she? Did she really enjoy her work so much even when it meant people were being killed? It made her sound emotionless. Cold. And she knew that had once been her reputation; her nickname, the Ice Queen.

'Is that how you think of me?' she asked, hurt that he thought she was so unfeeling.

Then his face fell into a serious look.

'No. Sorry. No. Of course not, darling. I was only joking. I know you always want to get justice for the victims. Oops, sorry. That sounded really cheesy didn't it,

like something I would write in one of my scripts for *Lieutenant Darrow Investigates*?'

'Sorry. I know you care, Gawn. The problem is you care too much sometimes. And that's what makes you a good cop. No, that's what makes you a great cop. I'm proud of you, babe, and what you do. You know that.

'Now can we please talk about something else? Please? Pretty please? Something fun? How about what was under that wee red number you were wearing last night?'

'You're incorrigible, Sebastian York!'

But a smile spread across her face and she laughed.

Chapter 21

Monday. A new day and Gawn was at her desk reading through Munroe's report of Ardgeen's post-mortem. The pathologist had spoken with the judge's doctor. Ardgeen had suffered from heart failure and high blood pressure and his doctor had expressed no surprise that he had eventually succumbed, suffering an acute intracerebral haemorrhagic stroke which had resulted in myocardial injury and cardiac arrhythmia leading to sudden death. So, no foul play, no suspicious aspects to his death other than its synchronicity with Randell's death and Tracy O'Neill's disappearance.

The preliminary report on Randell was much less satisfactory. The findings were inconclusive. Munroe couldn't or wouldn't give a cause of death. The man had been only forty-four years old. He had an enlarged liver but Munroe was waiting for the results of toxicology tests before he would commit to anything more.

There was a timid knock on her door.

'Come.'

Erin McKeown walked in.

'Sorry to disturb you, ma'am. I wanted to run something past you if you have a minute to spare.'

McKeown's voice was hesitant.

'What is it, Erin?'

'Sergeant Cunningham phoned me.'

Gawn hadn't had anything to do with the infamous Sergeant Garth Cunningham but she had heard of him.

'What did he want, Erin?'

'He has a missing persons case, a Jaxon Arnold. He thought I might be interested in taking it on.'

'Any particular reason why he would think that?' Gawn asked, her famous left eyebrow rising in surprise.

'Garth didn't say exactly. He just suggested it would be good experience for me.'

Gawn noted her sergeant's use of the policeman's first name.

'How do you feel about it, Erin?' Gawn asked.

The young woman didn't respond right away. She seemed to be choosing her words carefully.

'I'd really like to take it on, ma'am. It's a young man. I know the statistics about young men and suicide. It happened to a family down my street last year. I knew him. We'd grown up together. His family was so grateful for some closure when they got his body and had a grave to visit. I'm sure the Arnold family must be frantic. I'd like to have a go at it. If it's left to Sergeant Cunningham, I don't fancy their chances of ever finding out what happened to their son.'

Gawn could hear a touch of the zealot in her sergeant's voice.

'You do know why Cunningham is suggesting this, don't you, Erin?'

'I know he wouldn't have suggested it to you or Inspector Maxwell, ma'am. I'm not a fool. But it's only been a few days since Arnold was last seen. There's still a chance he can be found. But they've no leads and it'll

probably come to nothing. A nineteen-year-old with a bit of a record for petty crimes doesn't have the same appeal as some pretty teenage girl to attract the media and get the public involved.'

McKeown's cynical assessment pleased her boss. She realised what she would face if she took it on.

'I'd like to give it a go, ma'am,' McKeown said and then paused waiting for a response.

Gawn could see herself, her younger self, gazing back at her expectantly.

'It's your decision, Erin. If everything else is covered and you can do it without using anyone I need for the HATP case, then it's up to you.'

'Right, ma'am.' McKeown bounced to her feet, eager to get started. 'Thank you.'

Gawn watched as she left the room. Cunningham had no right to pass on cases he didn't want to spend time on. She just hoped McKeown didn't get bogged down in it and take a knock to her confidence when she didn't find Arnold.

Chapter 22

Gawn had reluctantly returned to the pile of reports when there was a muffled thud against her door. Before she had time to respond, the door swung open and Maxwell backed into the room with a mug in each hand and a newspaper under his arm.

'Morning, boss. Coffee?'

He proffered a cup.

'When did you ever know me to refuse coffee?'

'You might fancy something a wee bit stronger when you see this morning's paper,' Maxwell said.

He extracted the paper from under his armpit and dropped it down on the desk in front of her. 'You haven't seen it yet, have you?'

'I didn't bother buying a paper this morning. We don't have anything new so they won't have anything unless Donna and her cronies are making stuff up again.'

Gawn was referring to Donna Nixon. She had spotted her yesterday outside the Ardgeen home.

'Not her and nothing new about the case,' Maxwell said and waited.

She was relieved but when she looked at him she knew there was something more.

'Well, what is it then?'

'Front page. See for yourself.'

She turned the paper over and saw a large photograph of herself, kneeling beside a distressed elderly lady who had cut her head in the scrum to get out of the ballroom. Gawn was holding a handkerchief to the woman's forehead trying to keep her calm while she waited for a paramedic to take over. Gawn's hands were covered in blood. The angle from which the photograph had been taken accentuated her long legs and short dress. The caption was "Lady in Red" and the article commented about how different she looked out of uniform.

Gawn flung the paper down in disgust.

'They obviously didn't have anything better to write about so they're filling up with this guff. I suppose that was the photographer who was there on Saturday night doing the publicity shots for the magazine.'

'You look very well, boss. I'm sure upstairs will be pleased, you being heroic and all,' Maxwell teased her.

'You think? I look like...' She seemed lost for words. 'Well, not like a senior police officer anyway.'

'It'll be a one-day wonder. Something will break in the case or some other case will come along and this'll be forgotten.'

She knew he was trying to console her. He would realise she was genuinely upset. Other female officers might have been flattered at the attention. Not her.

'Let's hope so. I had enough of all that. I had to put up with some right dinosaurs when I started at the Met. How I look has nothing to do with how I do my job.'

Maxwell seemed to hesitate before adding, 'I should tell you…'

'What?'

'There's been a bit of chat already. In the canteen. I overheard a couple of constables saying something about not minding seeing you out of your uniform.'

She had wondered why she'd got some funny looks when she'd arrived this morning. Now she understood. They had seen the photograph. It would be all round the place.

Damn the newspapers.

Chapter 23

DC Jo Hill had organised a Family Liaison Officer to go with her to meet Hermione Randell at George Best City Airport and accompany her to the mortuary to identify her husband's body but Gawn wanted to talk to the widow herself afterwards. She was waiting for them now to arrive.

There was a light tap on her door and Maxwell appeared.

'I've just had an interesting phone call, boss,' he announced.

She was still annoyed about the photograph in the newspaper and snapped back at him, 'Are you going to tell me who from or do I have to play twenty bloody questions?'

'The Met.'

'The Met?'

'Yes. I phoned them about Goodlife. Their opinion of him is pretty much the same as ours. He's got the odd letter but they're sure it's nothing; just cranks. But when I told them about our investigation they told me something very interesting.'

He paused.

She waited.

'Randell was on their radar. He had connections with an OCG.'

'He was a criminal barrister. Of course he had connections with criminals.'

Gawn sounded dismissive.

'Yesss.' He elongated the word. 'But they hinted that he was a wee bit more than just professionally connected. One gang and one case in particular.'

She sat forward in her chair.

'What sort of a case?'

'A big jewel heist. And a smuggling operation out of Tilbury docks.'

'What was his part in it?' Gawn asked.

'Just what you would expect. Up to now. He'd represented some of them in court and got them out of a few scrapes. He'd managed to find discrepancies in how the Major Crimes team had gone about some searches. He had evidence disallowed which totally stalled their case. They suspected he might have a vested interest; more than just a cheque for legal services rendered. And now they think he might have got sucked in. They didn't like him but I couldn't get anything more out of them and' – Maxwell looked at Gawn directly before adding – 'look, it might just have been my imagination, but when I told them who was heading up the investigation here–'

'Me, you mean?'

'Yes. They clammed up. Wouldn't say anything more.'

Gawn sat back in her seat.

'So Randell might not have been Mr Squeaky Clean. Which begs the question, what was his association with our judge and with the HATP and the O'Sullivans? Get Walter or Billy, they might have some old friends who've transferred to the Met, get them to have an off-the-books chat with someone from Major Crime Command and see if they can get any more out of them.'

'What about you?' Maxwell asked.

'I don't think I'm their flavour of the month.'

'OK. Will do. Here's Mrs Randell, by the way.'

He had been looking out the window and spotted Hill arriving in the car park.

'Do you want me in with you for the interview?' he asked.

'No. Let Jo do it.'

Chapter 24

Hermione Randell looked as if she'd just stepped off the cover of the latest Mills and Boon novel to hit the shelves of the local supermarket and catch the eye of busy housewives craving some vicarious romance. At least that was Gawn's uncharitable reaction as she watched the woman climb out of the car and walk into the building. It was another one of her instant reactions and she chided herself for it. This was a woman who had just lost her husband.

Hill had escorted the widow to a more informal interview room with a tired-looking sofa and a couple of overstuffed armchairs. The walls were a sludgy yellow colour. A row of sepia prints arranged along one wall was an attempt to brighten the place up. As if a tacky picture of a yacht sailing off the White Rocks could make any difference when you'd just been molested or you'd witnessed a murder.

Hermione Randell was sitting looking calm and unconcerned. She glanced at her watch. Maybe she had somewhere to be.

'Good morning, Mrs Randell. I'm DCI Gawn Girvin. You've already met DC Hill. I'm very sorry for your loss. We're doing all we can to discover the circumstances of your husband's death.'

Gawn was aware that her words sounded cold and formulaic. She locked eyes with the woman for an instant before the other looked down, unable or unwilling to hold her gaze.

'Thank you. I appreciate you've a job to do.'

'I hope you feel up to answering a few questions to help us with some background information for our investigation,' Gawn said.

'Investigation? What investigation?' The woman's head jerked up and she sounded surprised, as if she hadn't realised they had anything to investigate. 'My husband dropped dead. I assumed coming here was some sort of formality, that I'd have forms to sign to get his body brought back to London. He had a heart attack, didn't he? What are you investigating?'

There was a frown on the widow's face.

'Our pathologist hasn't determined the cause of death yet, so I'm afraid we have to treat it as unexplained. Suspicious,' Gawn said.

The woman's eyes opened wider. Her voice was low but controlled. She was displaying what Gawn regarded as an almost impossible level of composure. She sat dry-eyed, looking straight ahead, focusing on a ripped crime prevention poster on the wall rather than meeting Gawn's eyes. But then Gawn glanced down and saw the woman's hands tightly clenched on her lap, her knuckles white with the pressure she was exerting, as if her life depended on it. She realised that what she had interpreted as indifference or coolness was probably the widow's strategy to get through the interview without breaking down in front of strangers.

When Hermione Randell spoke again, her voice seemed to be coming from somewhere far away. It was tiny.

'You really think Josh could have been murdered?'

'We can't be sure of anything until we get the final report from the pathologist but it's a possibility we have to consider. Had your husband any health issues? Had he consulted a doctor recently?'

'Josh was as fit as a fiddle. He played squash at least once a week. I'm not aware of him seeing a doctor except when he hurt his back in a cycling accident. But that was over six months ago. He was knocked off his bike in the street near our home. But it was all cleared up. He was fine.'

'Was he under any particular stress that you know of?' Gawn asked.

'He had a stressful job. He was a criminal barrister. People's freedom depended on him getting them the right outcome in court and he felt the responsibility of that. And he was good at his job. But that meant he had to mix with some rather unsavoury types.' These last two words were enunciated very carefully as if the very feel of them in her mouth was sullying.

'Did he mention anyone in particular who might have been causing him some concern; someone he might have been frightened of?' Gawn persisted although she could imagine Maxwell fidgeting, watching the interview from Comms. She knew he would be protective of the attractive widow. She was glad she had brought Hill with her instead.

'Frightened? No. But he didn't discuss his work with me. At all. A lot of it was confidential and I didn't really want to hear about it. I preferred he didn't bring any of that home. But he never told me he had any problems with anyone. Or that he was frightened. I'm sure if he'd thought there might be any danger to the children or to me, he would have told me.'

'What about any problems outside work? I'm sorry to have to ask, but do you have any money problems?'

'No. Everything's fine.' The response came quickly and the voice was dismissive.

'And your relationship?'

Gawn waited.

'What are you asking?'

This time the woman's voice was harder, almost confrontational in tone.

Gawn's thoughts turned to Tracy O'Neill, the missing woman. Could she and Randell have known each other? Could they have been in a relationship? It might explain why he had agreed to travel all the way to Belfast to attend a dinner for an organisation he seemed to have known little about. She knew she had absolutely no evidence to suspect anything like that but she decided to ask her question and gauge the Englishwoman's reaction.

'There's no easy way to ask this, Mrs Randell. Could your husband have been having an affair?'

The widow gave Gawn a look of utter contempt akin to the look she might have given to some dirt she had picked up on the sole of her shoe in the street. Her nostrils flared and she practically spat her response through gritted teeth.

'I wouldn't know anything about that and neither would my husband. Not everyone you're dealing with lives in a sewer, Chief Inspector.'

Her anger seemed to subside as quickly as it had arisen, as if the effort to defend her marriage had been too much and her voice had broken as she finished off. 'My husband and I were very happy. He was not having an affair and we had no problems in our marriage.'

She had spoken very definitely, emphasising each word. Then she stood up abruptly pushing the armchair back, scraping it off the tiled floor with a noise that reminded Gawn of the panic in the hotel on Saturday evening.

'I'm tired. It's been a very difficult time and I'm flying back to London this afternoon. I don't want to be away from the children too long.'

Gawn and Hill stood up too.

'Of course, Mrs Randell. I understand. Just one final question, please, before you go. How did you husband know Lord Ardgeen?'

'Lord Ardgeen?'

Hermione Randell sounded as if she had never heard the name before but Gawn caught just the merest flicker of something in the woman's eyes. She couldn't pin it down. It could just be surprise at a name new to her but it could be something else.

'Josh never mentioned any Lord Ardgeen. Was he one of his clients?'

'Never mind. We have further inquiries to make. But we may need to speak with you again. The Family Liaison Officer will see you back to the airport and once again, I'm very sorry for your loss.'

Hermione Randell swept out of the room. There was no other word to describe her exit in Gawn's mind. She felt like they were all in an Oscar Wilde play and some grande dame of the theatre had swished her elegant ballgown as she flounced disdainfully off stage. Gawn wondered if the woman had been playing a part and she wondered too if denying any connection between her husband and Ardgeen had been part of that act.

Chapter 25

'Jo's found something.'

Maxwell greeted Gawn with the news as she walked into the incident room after lunch. She had had coffee and a sandwich at her desk while finishing her review of the interviews the team had carried out.

It had not made encouraging reading. The detectives had asked all the right questions. They had been thorough

but she still didn't have a clue what this was all about. No one had noticed anyone around Randell slipping anything into his food or drink. No one could remember when Tracy O'Neill had left the table or where she had gone.

The one new piece of information had come from DC Jack Dee. He had discovered from a telephone call to Randell's chambers that the two lawyers had met when Randell was involved with an anti-drugs strategy. He had met Ardgeen and their friendship had continued after the judge's role on a committee on prospective changes to drug misuse legislation had finished its report.

Now Gawn was faced with Hill holding out a photograph, waiting for a reaction.

'We were going through all the pictures taken by that magazine photographer, ma'am, and we noticed this,' Hill said.

Gawn took the picture from Hill's hand and looked at it. At first she saw only Randell walking through the automatic doors to the annex and then she noticed the incongruity of the image.

'You see it, ma'am?' Grant asked. 'Here it is again.'

He stood up eagerly and reached her another picture.

'Yes. Of course I do.'

Randell, dressed for his formal night out, was carrying a briefcase as if he was off to the office or a business meeting.

Grant handed her a third, more formal photo of Ardgeen, Randell, Goodlife and Sandford posing in front of an HATP banner. The briefcase could be seen sitting off to the side, just in shot. Randell must have set it down to take his place in the line-up.

'Who brings a briefcase to a dinner? Well, we thought it was a bit strange anyway,' Dee finished a little lamely.

'It is. You're right, Jack. I suppose if he'd been one of the after-dinner speakers he might be carrying a copy of his speech but he wasn't. And anyway you could fit a few pages of a speech into a pocket. You wouldn't need a

whole briefcase. It's an anomaly. I'm not sure exactly what it means but well spotted.'

She wondered what could have been in the case. She speculated, without saying anything to the others, that perhaps it was documents and the money needed to run away and start a new life with O'Neill. That would fit in with her suspicions of a possible relationship but she hadn't shared her speculations about that with anyone yet. Not even Maxwell. They had no connection between Randell and O'Neill. Yet.

'Did they find a briefcase?'

She had directed her question to Maxwell.

'No briefcase.'

'Right. It's unlikely the photographer was hanging about to take pictures of anyone leaving and she certainly wouldn't have been able to get any pictures when everyone was flooding out in a panic so our best chance of seeing where this briefcase went is the hotel CCTV.'

'Walter's made a start looking for O'Neill,' Maxwell told her.

'You three, help him. Not just the annex. All the footage. That briefcase is missing. It could be important.'

She thought it was.

'Anyone who took it could have left through the main hotel by that doorway we used to evacuate the guests or even through the kitchens, I suppose, although you'd think someone would have noticed and said something. And check for anything suspicious in the car park too.'

Gawn was visualising the top table and its position in relation to the kitchen. There had been constant comings and goings all evening. Could someone have walked out through the kitchen with the briefcase? And would this have been before or after all the chaos? Her immediate thought was it was more likely just before or during, using the panic as cover, which meant it could all have been planned.

'Randell brought something with him to the dinner but someone else left with it,' Gawn said.

'What about O'Neill?' Maxwell asked. 'Could she have taken it?'

'She wasn't sitting anywhere near the top table but Randell could have handed it to her before he sat down. We're already looking for her anyway. We should ask Wilkinson. She may have noticed the case when Randell was sitting beside her,' Gawn said.

They had been marking time, not even sure what they should be investigating. Now, at last, it seemed they had something to follow up. Randell had brought something with him, Randell had died and that something was missing and so was Tracy O'Neill.

'And he may not have handed it over. It could have been stolen from him in all the fuss after he collapsed. There would have been lots of people around him then. Any one of them could have taken it,' Maxwell suggested.

'You're right. We need to find out what was in that briefcase and how it left the hotel.'

Chapter 26

'Well, anything?'

Gawn looked up hopefully as Maxwell appeared at her door. A look at his face gave her his answer.

'The lady who was sitting beside Randell says she saw nothing out of the ordinary. She'd had a few drinks and she was a bit merry, as she put it, but so was Randell apparently. In fact she said she thought he'd been drinking quite a bit before the dinner. But she's certain no one put anything into his drink or his food at the table.'

He saw her expression and added, 'As far as she noticed. But I don't know if we can rely on that. She was on a night out. She wasn't being super vigilant.'

'Like me, you mean?' Gawn asked.

'I didn't notice anything either.'

'And neither did Wilkinson. I phoned her. She noticed nothing out of the ordinary. And she didn't see a briefcase. Who searched Randell's hotel room?' Gawn asked, changing the subject.

'Billy and Jack. He was staying at the Titanic.'

'Not at the Royal Holywood? I wonder why.'

'Maybe it was all booked up. Or it could be something to do with the fact he came over by ferry so he was near the docks anyway,' Maxwell suggested. 'He arrived from Liverpool about five o'clock and basically checked in to the Titanic and got ready for the dinner. He was travelling light. Just an overnight bag for his tux and PJs. Nothing suspicious. He was due to fly back to London on Sunday morning.'

'So he came over by ferry but he was flying back. Why?' she asked.

'Jack checked when he was talking with the clerk at his chambers. He'd been meeting a client in Liverpool. I suppose it was just easier to come over from there than go back to London first,' Maxwell suggested.

'Yes, but he could have flown from Liverpool. They do have an airport there too, you know,' Gawn said and immediately realised how sarcastic she sounded. She was taking out her frustrations on Maxwell.

'Maybe the plane was booked up. It happens.'

Gawn was thinking. 'There could be another reason. Security isn't quite as tight on the ferries for foot passengers. I don't think they X-ray everything. Just a quick look through. If he wanted to bring something into Belfast it might be easier on the ferry,' she said.

'What sort of a something?' he asked.

'That's the question, isn't it? What was in that briefcase?'

Maxwell seemed to have a sudden thought.

'Could the papers for his Liverpool meeting have been in it? If he had an important meeting with a client he must have had notes and maybe documents. Maybe he didn't want to leave them lying around. They would have been confidential.'

Gawn considered what he had said.

'There would have been a safe in his hotel room, Paul. They can't have been so important that it was safer to carry them to a dinner and leave them sitting under a table all night rather than locking them away. It wasn't the nuclear codes he was carrying with him.'

She paused and then added, 'Sorry. It's not your fault. It's just there are so many gaps in what we know. Get someone to check with his chambers again. They won't give out any details about his meeting but they might give us a heads-up if it was something he'd be extra careful about.'

'OK, boss.'

She lifted the photograph Grant had given her of the four men in front of the HATP banner and looked at it closely.

'Damn! Look.'

She flung the photo across the desk to Maxwell. He picked it up and looked at it but his face showed he didn't know what he was supposed to be seeing.

'What did Goodlife tell us? He'd only said hello to Randell when he was at the table? So how come here they are side by side before the dinner?'

'The photographer probably posed them like that. It doesn't mean they'd talked, boss.'

'And Cosgrove denied ever meeting him but she must have arranged this photograph.'

'Not necessarily, boss. That photographer could just have picked a couple of extra people to stand with

Ardgeen and Sandford. But Sandford denied meeting Randell too, didn't he?'

'They've all been lying through their teeth to us, Paul. Randell could have passed the briefcase to any of them before the dinner,' Gawn suggested. 'I want to talk to Goodlife again. It doesn't really merit anyone flying over to London. Yet. He'll probably claim he forgot or he didn't realise that was Randell or something. We'll arrange an online chat. But if I still think he's lying to us we'll need a formal interview. Get it set up, Paul. And we'll need to get Sandford in here for an interview too. Put a bit of pressure on him. And Cosgrove too but we'll speak to Sandford first.'

'Right, boss.'

She seemed to make a sudden decision.

'In the meantime CCTV is our best chance of turning up something to help. But let's leave Randell for now. Until we have his cause of death and we've spoken to Goodlife. We could be wasting our time. We don't know if anything criminal happened to him. Or if this briefcase is important at all. But we do know Tracy O'Neill is missing.'

Gawn sprang up out of her seat. She needed to be doing something; anything. She would speak to Gary O'Neill. His wife had been missing for nearly forty-eight hours. Officers had been out to see him several times since his phone call in the early hours of Sunday morning reporting her missing. An FLO was in the house waiting with him in case she showed up or made contact but now Gawn felt they needed to step their investigation up a notch.

Chapter 27

'What do you think, Paul? Has O'Neill's vanishing act got anything to do with Randell?'

She was driving along Shore Road in North Belfast. Maxwell had been gazing out of the car window watching the passing streets, daydreaming, not expecting her to ask him anything. There was no view of the sea or the shore here in spite of the road's name. Just rows of back-to-back terraced houses. They passed a fortified police station, a reminder that everything still wasn't back to normal for police officers in Northern Ireland, even after more than twenty years of the Good Friday Agreement.

Maxwell looked across at her as he answered.

'I suppose it depends.'

'On what?'

'On the woman herself. We don't know much about her. We know she and her husband have no children and she works as an accountant in a business down at the docks. She might have been having an affair and arranged to go off with her lover or she could be in an abusive relationship and decided to take the opportunity to escape from her husband. Or she could have murdered Randell and be on the run. Or she could have been abducted by wee green men in a spaceship.'

'OK, OK, Paul.'

Gawn held up a hand to stop his flow of words.

'I get your point. I'm guessing. We don't know enough about her to form any kind of valid opinion. It's all just speculation. But sarcasm does not become you, Inspector.

'One thing I am pretty sure of is she didn't kill Randell. If anybody did and we don't even know that yet.' She

sighed loudly. 'She wasn't near the top table or Wilkinson would have noticed. No one places her anywhere but at table 8. No one saw her moving from her seat during the meal and no one seems to have noticed when and where she went. She's like the disappearing woman.'

'At least no one we've found so far,' Maxwell said. 'Although, did you read the report where someone said they thought she had already left the table before Ardgeen collapsed?'

'Yes. But they weren't sure, were they? They only thought she might have left. They couldn't remember seeing her after he collapsed but that doesn't mean a lot. It was chaotic.'

'Anyway, she didn't have to have done anything to Randell after Ardgeen collapsed. She could have slipped him something in the crush before we all sat down, something slow-acting,' Maxwell said.

'But when did she take the briefcase then?' Gawn asked.

'If it was her who took it,' Maxwell added.

'It's like pin the tail on a donkey. We could be miles off and wasting our time. Have they found her phone yet?'

'It wasn't in her car or anywhere in the annex so she must have taken it with her but it's been switched off since about just after lunch on Saturday.'

'So we don't even know where she was on Saturday afternoon before the dinner?' Gawn asked.

'No.'

She steered the car up Fortwilliam Park, a wide steep avenue, heading away from the lough towards Cavehill and Belfast Castle. Two ungated sandstone archways stood on either side of the road like sentinels from some superhero movie ready to spring into life, remnants of a grand past when this area had been part of a large demesne. The houses here were larger with gardens and driveways. Gawn stopped the car in front of one of them.

When they got out she realised they had a view over the rows of little streets below, over the land reclaimed from the sea which now housed businesses and a flourishing film studio and across to the shoreline, the docks and the port of Belfast. Gawn noticed that one of the huge cruise liners which were becoming ever more frequent visitors to the city was in port today.

The O'Neills' house was on a corner site. There was a smallish mature garden, well-kept and well-stocked with shrubs and small trees. A trio of bright red tubs, providing a dash of colour, stood in a row under the front window. They were empty, only bare soil ready for new planting or perhaps they were already filled with dormant bulbs hiding, waiting to come to life in Spring. Was Tracy O'Neill hiding somewhere waiting? But where and for what?

Maxwell rang the bell and after a short wait the door was opened by the Family Liaison Officer, Sergeant Mandy Bell.

'Sergeant Bell?'

'Yes, ma'am.' She'd been expecting them. 'Mr O'Neill is in the living room, ma'am.'

'How is he?' Maxwell asked.

'Very quiet, sir. I think at first he thought it was some mistake. Maybe she'd been taken to hospital and was suffering from amnesia or something but he's got to the point now where he's expecting the worst. He's just sitting there staring into space. I couldn't even get him talking. Usually they want to talk and tell you all about their missing loved one.'

'Does he have any family with him?' he asked.

'His sister was here for a while this morning.'

Bell led the way into the living room and spoke gently to a man sitting slumped in an armchair in front of an unlit fire.

'Gary, here's the officers I was telling you about.'

O'Neill turned an ashen face towards them. He looked dreadful, much older than his forty years.

'Have you any news about Tracy? Have you found her?' he asked hopefully, his face coming alive for a second.

'No, sir, I'm afraid not.'

It was Maxwell who had answered him and walked forward, pulled up a chair and sat down beside him.

'I'm Paul and this is my boss, DCI Girvin.'

At his words Gary O'Neill looked up at her but she wasn't sure his eyes were even focusing. She signalled to the FLO to come with her and backed out of the room.

'We'll leave Inspector Maxwell to talk to Mr O'Neill. Have you had a look around?' She kept her voice low.

'No, ma'am.'

'Let's take a look now.'

'What are we looking for, ma'am?'

'I don't know,' Gawn admitted. 'Anything that seems unusual; that could give us a clue about where Tracy might have gone or why. I can't be more definite than that. Look. Don't touch. If you see something which seems out of place or unexpected, call me.'

They climbed the stairs and she pointed Bell to one room while she went into what was obviously the master bedroom. The bed had not been made. The bedclothes were tangled as if someone had been tossing and turning, unable to settle. She noted a photograph of the couple on a bedside cabinet. Alongside it was a copy of a romantic novel with a female on the front cover who reminded her of Hermione Randell. On the table on the other side of the bed was an empty glass. Gawn picked it up and sniffed. She recognised the whiff of whisky. Self-medicating, she thought.

A dressing table was covered with items of make-up, left behind when Tracy had been getting ready for her big night out and rushing, not taking the time to tidy up. There was a hairbrush too. They could get DNA if they needed to identify a body.

Although she had told Bell to touch nothing, Gawn opened the wardrobe. A man's suit and a handful of shirts hung to one side. The other side was packed with women's clothes – dresses, skirts, coats. Some still had their labels on, never worn. Gawn looked at one or two of the labels and her eyebrows rose in surprise. These were expensive designer clothes. She should know. She had some by the same designers. Where would Tracy O'Neill get the money for this? Then she realised the labels weren't quite right. These were fakes. Good fakes but fakes all the same.

Gawn spotted a piece of paper peeking out of the pocket of one of the jackets. She was already wearing forensics gloves. She never went anywhere without a pair. Seb teased her when they inevitably fell out of her pocket at some embarrassing moment when she was trying to find a hankie or some change in a restaurant or at the cinema. Gingerly she lifted the piece of paper. It was a business card. Her eyes widened as she read the name on it, Joshua Randell. She turned it over and saw a phone number written on the back in green ink. She took her phone and snapped a quick picture of it.

At Maxwell's call from downstairs she hastily pushed the card back into the jacket, ripped her gloves off and stuffed them into her pocket and walked out trying to look as if she had found nothing.

Chapter 28

'Did you learn anything useful from Mr O'Neill?' Gawn asked.

'Not really,' Maxwell sniffed. 'The poor man doesn't know whether he's coming or going. He doesn't have any idea where his wife could have gone. He says they're just a

normal couple. They mind their own business. They don't have a lot of money so there'd be no point in anybody kidnapping her. They've never had any trouble with the neighbours or the paramilitaries. They steer clear of them. I think he didn't want to say it but I'm sure he believes she was grabbed and murdered.'

Gawn didn't react to his suggestion. Instead she asked, 'Have we checked if either of them has a criminal record?'

'No. We're checking Sandford's and Cosgrove's backgrounds and Walter was going to look into the Trust's finances as you asked. But they're going through the CCTV footage too. We're stretched, boss.'

'Get someone to do it, Paul. If need be pull someone off the CCTV search. O'Neill mightn't know everything about his wife's life before they met. She could have a record. How long have they been together?'

'A couple of years, I think.'

'Not that long, really. What age is our missing woman?' she asked.

'Thirty-six.'

'She could have got up to all kinds of things before they met.'

Gawn thought of all the life experiences she'd had before she'd met Sebastian. She had shared some of them with him but not all. And she thought of the fake expensive clothes in O'Neill's wardrobe. All was not as it seemed with this woman.

'We've been concentrating so much on our two dead men that we've dropped the ball on this one. So now we need to know more about her. Let's start with where she works. Remember the Met said Randell was involved with a gang at Tilbury Docks and O'Neill works at the docks in Belfast, doesn't she?'

'But we have no connection between our missing woman and Randell.'

Gawn hesitated as she debated with herself if this was the time to tell him what she had found in the bedroom.

Sometimes she felt he thought she went too far and pushed the boundaries. Once or twice in the past he had criticised her actions. She hadn't asked to search the house, didn't have a search warrant, but she thought O'Neill wouldn't have raised any objections if it helped to find his wife.

'I had a bit of a look around upstairs while you were talking to O'Neill.'

'That's what I thought you were doing.' A knowing smile played on his lips. 'Was I just a diversion?'

'No. Of course not. Questions needed to be asked and I knew I could depend on you to get us the answers. It just didn't need me to be standing at your shoulder. And it was too good an opportunity to miss,' she added.

'So, what did you find?'

'Tracy has expensive taste in clothes.'

'How expensive?' he asked.

'Very. I recognised a skirt which I know costs almost four figures.'

'For a skirt?' Maxwell could barely get the words out.

'However… I'm pretty sure it was a fake. The label wasn't quite right. It was a good quality knock-off.'

'Do you think it could have anything to do with her disappearance?'

'I don't know. High fashion fakes can be big business I suppose. We probably need to have a word with Organised Crime and see if we have any counterfeit clothes rings operating here or maybe over the border. But it's just something to suggest our misper could be more than an innocent accountant.'

Gawn had reached the dock area and was turning towards the Westlink away from Police HQ.

'Where are we going now, boss?' Maxwell asked.

'I want to talk to Munroe. We need to know Randell's cause of death. Now. I want to pressure him a bit.'

'Good luck with that.'

'If it's natural causes we can concentrate on O'Neill and leave it to Ferguson to find out what was happening to everyone on Saturday. If not, I think we need to look for a connection between his death and her disappearance.'

Gawn was holding back to allow one of the massive container lorries making its way from the docks filter into the line of traffic heading onto the M1, dwarfing her Audi.

'Find anything else?' Maxwell asked.

'She had Randell's business card in her pocket.'

'You went through her pockets?'

She knew he wasn't really surprised although he was trying to sound it. Very little she would do to get at the truth surprised him now, she knew.

'It was sticking up. Practically falling out. Anyhow I saw it.'

'She is connected to Randell then. Shouldn't we have questioned her husband about that?' Maxwell asked.

'Not yet. If he doesn't know about her association with Randell then he'd have nothing to tell us. If there is something going on, he could be involved too and we'd have tipped them off that we know.'

'Maybe someone gave her Randell's card. She didn't necessarily know him herself. Or maybe she and Randell were old friends. It could be innocent,' he argued.

'You don't usually give an old friend your business card with a telephone number on the back of it. Unless they're in some sort of trouble and you're going to help them or you're planning something with them.'

'You think they were going off together, don't you, boss?'

'I think it's a possibility. We need to trace the number on the card. It was a landline number, London area. I'm beginning to think she was the one meeting Randell at the dinner.'

'And maybe she was the one who left with the briefcase.'

Maxwell finished her sentence for her.

Chapter 29

Munroe was surprised to see them but since she had helped him out of an embarrassing situation on a case she knew he felt he owed her his reputation and his career too. Now he always tried to help her if he could.

'Good afternoon, professor. I hope you don't mind us dropping in like this. We were in the vicinity and I was hoping you might have an update.'

The chief pathologist was dressed in his green scrubs, still pristine. Gawn knew Maxwell had never grown used to their visits here. But at least he'd never fainted as one of her sergeants had almost done.

'It's been a busy day, Chief Inspector. I was just about to start on another poor soul.' Munroe smiled at her. 'But I can always spare a minute or two for you.'

Gawn thought his Scottish accent was even more pronounced than usual today. They were in his office, sitting across the desk from him.

'Joshua Randell,' Gawn said and stopped. She didn't need to ask a question.

'You're looking for a cause of death?'

'Yes.'

'Then you're in luck. I think your ACC must have put a bit of pressure on the lab. They were quick. The first toxicology results are just back. I was going to send them over as soon as I'd finished.'

Munroe clicked an icon on his computer and obviously checking details on the screen. 'Cocaine. Not surprising. It seems to be the recreational drug of choice these days. I'd already noted the condition of Randell's liver in my prelim. He was a heavy drinker and there's

evidence of painkiller use too. Fentanyl. I contacted his doctor. He'd hurt his back about six months ago and been prescribed painkillers at the time but not fentanyl and his doctor hadn't renewed the original prescription. There's a danger of addiction with the long-term use of these opioids, as you know, and fentanyl is only available on prescription so Randell must have found himself another source.'

Gawn realised the lawyer had either kept his addiction from his wife or she had lied to them. Had she been lying about anything else? And if Randell had become addicted to the pills, it would have made him vulnerable to blackmail or pressure to get his supply, she thought. It was a constant fear she had once faced herself.

Munroe's voice pulled her out of her thoughts.

'I take it you're familiar with spice?' he asked with a slight grin.

'And I take it you're not referring to my culinary skills,' she replied.

She was prepared to indulge his sense of humour a little, go along with his almost-flirting, if it got her what she needed.

'He was mixing his alcohol with cocaine. But more important from your point of view he was using spice or K2 as well. The "zombie drug", they call it. It can more or less instantly reduce users to a semi-comatose state and that sounds rather like what happened to the people at your event, doesn't it? And Randell had taken a very potent mix of K2. Any polydrug use is dangerous and the effects can be unpredictable to say the least.'

'My understanding is spice is normally smoked,' Gawn said, her brow furrowed.

'Yes. Either conventionally in a joint or e-cigarette but it can be taken in a capsule or made into a drink so maybe he had his sprinkled as a liquid over his food?' he suggested tentatively.

'But all the food at the hotel has tested negative for any suspicious substances so far and nobody was smoking in the room.'

'Maybe he excused himself during the meal and went out and had a crafty smoke,' Maxwell suggested.

'I didn't notice anyone leaving the top table during the meal. Did you?'

'Well, no, but I wasn't really watching. I was too busy enjoying my dinner,' he replied.

Maxwell might have missed it but Gawn was confident she wouldn't have. It was the kind of action she would have registered even if only subliminally.

'We can check with Wilkinson and with his neighbour,' Gawn said.

'Dr Maven,' Maxwell added.

'She's a doctor! I'm surprised she was so easily upset when he collapsed,' Gawn said.

'She isn't that sort of doctor. Not a medic. She's a PhD. Specialises in drama in education or something.'

'Well, she got plenty of drama on Saturday night,' Munroe said and grinned.

Gawn realised he was trying to be funny but her patience was wearing thin now. She wanted answers.

Munroe noticed her expression and hurried on. 'It wouldn't necessarily have killed him straight off. But it would have had an effect. He would have been acting strangely for a while before he collapsed.'

'So, what killed him, professor?'

'Take your pick, Chief Inspector. People think K2 or spice is harmless. But it can be up to hundreds of times more powerful than cannabis. Even just a single puff can end up in an overdose.

'The chemicals in it aren't regulated or standardised so there's no way to know how many synthetic cannabinoids can end up in just a single batch when you buy it. It can result in paranoia, anxiety, panic attacks, convulsions, tachycardia, spikes in blood pressure, seizures, organ

damage. You get the idea. And it can cause swelling on the brain. With Randell it was his blood pressure. A massive stroke.'

The irony that both men had died from a stroke did not escape Gawn.

'But we still don't know how it got into his system,' she said.

'I do have a wee suggestion about that, Chief Inspector.'

Gawn was surprised. Munroe didn't usually involve himself in investigations, keeping to his area of expertise and leaving everything else to the police.

'It can be vaporised to be used in e-cigarettes rather than smoking in the traditional way.'

'But I told you no one was smoking, even e-cigarettes.'

'Yes. You did. But could he have been using an inhaler? His medical notes said he suffered from allergies and had been prescribed an inhaler. If he habitually used spice, he could have carried an inhaler with some in it when he knew he wouldn't have the opportunity to smoke.'

'Is it even possible to take an inhaler apart like that? Aren't they pressurised or something?' Gawn asked.

'I'm no expert on any of that, I'm afraid. You'd have to ask someone else but I would think it could be done. Most things can be, especially if it's something to do with drugs and money. People are ingenious when it comes to ways of killing themselves.'

'Was an inhaler found with his possessions and clothing?' Gawn asked the pathologist.

'No. We sent everything that came with the body to Forensics. There was no inhaler,' Munroe stated.

'And no inhaler was found in his hotel room, was it?' she asked Maxwell.

'No, ma'am.'

'So if Ferguson's people can find an inhaler then it can be tested for spice and checked for fingerprints. Only Randell's should be on it. If we find another set and there

was spice in it then we'll need to start thinking about who could have got access to it. Thank you, professor.'

Chapter 30

Gawn and Maxwell were sitting side by side in her car still outside the mortuary. Traffic was passing on the narrow roadway in front of them, carrying visitors from the main hospital wards. The light had already faded. Evening was setting in. Most of the team would have gone home.

Gawn had inserted her key into the ignition but not yet started the engine. She made no move to leave. Maxwell looked across at her, a puzzled expression on his face. Eventually he spoke.

'An inhaler doesn't explain what was happening with everybody else on Saturday night.'

'I know. It can't have been what caused everyone's reaction.' Then she added slowly, 'But an airborne substance is not something we've considered.'

'You mean like something pumped through the air conditioning system?' Maxwell looked sceptical. 'That's a bit James Bond-ish, isn't it?'

'The whole thing's a bit James Bond-ish, Paul. But that still wouldn't explain why some people were affected and some weren't, would it? You weren't. I wasn't. But we were breathing the same air as everyone else in the room.'

She sounded irritated now. She had begun to think they were getting somewhere, now she wasn't sure.

'Maybe it only had an effect combined with alcohol and other substances like in Randell's case,' Maxwell suggested.

'I was on the soft stuff but you were drinking alcohol, Paul.'

'Not much. A couple of pints of Guinness and a glass or two of wine with the meal. No cocaine, for sure.'

'You think McDowell and that little old lady they had to stretcher out had been snorting a couple of lines of coke before the dinner?' she asked sarcastically. 'No. It had to be something more specific. But random at the same time. The people affected were sitting all over the place. We need to find out if there's anything to connect those people to each other and to Randell in case it wasn't as random as it seems. Get hold of Jack. Now. I want that information ready for the briefing first thing tomorrow morning.'

Chapter 31

The team was gathered for the briefing on Tuesday morning. Even McKeown had joined them. When Gawn saw her, she thought again that she should ask the young detective how her case was going.

'OK, Jack. What have you got for us?' Gawn asked.

Dee scanned his notes.

'Only four people were taken to hospital in the end, not counting Ardgeen and Randell, of course, ma'am. One had chest pains. She was having' – he looked down at his notes – 'an episode of tachycardia.'

'That must have been the lady stretchered out,' Maxwell said.

Gawn nodded. 'Go on, Jack.'

'Two others were complaining of nausea and severe breathlessness.'

'Were they together?' Maxwell interrupted him.

'No, sir. They don't know each other and they were sitting at different tables. The only one more seriously

injured was that lady you were pictured with in the paper, boss. Hilary Johnstone.'

His voice had changed when he mentioned the photograph, rushing over it, trying not to get a reaction from her. Maxwell had already warned them it was a touchy subject.

'She'd banged her head when she fell. She needed fourteen stitches. They kept her in overnight for observation in case she had concussion. Everyone else was just treated at the scene. The paramedics we talked to all said it was mostly just distress, some bumps and bruises from the crowd and a touch of hysteria and some mild nausea. They suggested most of it was probably overactive imaginations and panic plus too much alcohol and the heat in the place.'

Gawn remembered how hot the room had been.

'The four people who needed hospital treatment, they don't have any connection to each other?' Gawn asked again.

'No, boss,' Dee answered.

'Sure?' she asked.

'Yes. I double-checked.'

'Any connection to Randell?' she persisted.

'No,' Dee repeated and shook his head.

Gawn was disappointed but her eyes lit up as she spotted Ferguson walking in.

'Mark, thanks for coming in this morning. Anything new from the hotel?'

'We've still got a lot to process. The manager's practically sitting on my shoulder now trying to hurry us up. He wants his venue back but I'm paying him no attention. We'll work on until we're finished. We've collected a massive amount of material and they've already started looking at it back at the labs.'

'Did you find an inhaler anywhere near where Randell was sitting?' Maxwell asked.

'An inhaler? No. Nothing like that.'

'Nowhere in the room? Maybe it got kicked away across the room or under a table,' Gawn suggested.

'No inhalers, ma'am. Definitely. I'm sure. We did find a pair of dentures.'

A titter of laughter spread across the room.

'There goes that good idea then,' Maxwell said, shrugging his shoulders.

'Professor Munroe says Randell had inhaled K2. I was wondering if it could have been filtered into the room in some way. The difficulty of course is that not everyone was affected,' Gawn explained.

'We haven't looked at the air conditioning system yet,' Ferguson said. 'As soon as I get back we'll have a look.'

'Thank you, Mark. OK. You've all got work to do. I'm still waiting for the background info on Sandford and Cosgrove someone was supposed to be getting for me. And what about the check on the O'Neills? Let's get on it, everyone. We've wasted too much time already.'

No one met her eye.

Maxwell headed into his office to answer his phone while the rest turned back to their desks. Gawn had sounded despondent. She had run out of good ideas. She was sitting now at McKeown's empty desk, her index finger tapping restlessly on the desktop.

'By the way, ma'am, here's your wrap and your swag bag.' Ferguson walked across and handed her the pashmina and the colourful bag with the HATP logo and her name on the tag.

'Thanks, Mark. I wouldn't like to lose the pashmina but I'd intended to give Maxwell the freebies for his daughter anyway. I'm sure there's something she'd like in it.'

The office was clearing quickly. None of the detectives wanted to risk her asking them something they didn't have an answer to. While she waited for Maxwell to finish on the phone, Gawn sifted casually through the bag.

Gawn had been to events in the past where the giveaways had been impressive. She thought of a red

carpet event she had attended in Leicester Square while on close protection duties with a cabinet minister. And Seb had taken her to a movie premiere in LA for a sci-fi film made at the studio where he was working. That night the loot had included some slightly risqué items. Well, risqué for a fourteen-year-old girl which is what Maxwell's daughter was. Kerri would never let her hear the end of it, if she sent the girl something inappropriate.

A new local gin distillery had sponsored part of Saturday's event. They might have provided something for the gift bags too. She couldn't pass alcohol on to a minor.

As she trawled through the bag she became more and more certain it would be fine. A pen with the HATP logo and a little notebook. A glossy leaflet advertising the work of the Trust. A book of raffle tickets for the draw which had been due to take place after the meal and a code for a free download of a song from an up-and-coming local group called The Fat Slippers. They had been helped by the Trust and were giving all the proceeds back to it according to the blurb on the voucher.

Digging down towards the bottom of the bag, she lifted out a bar of ethically sourced chocolate from a local company, a box of Belfast teabags, a tube of gel hand sanitiser, a soy candle from a company which proudly proclaimed itself to be one of HATP's success stories and another voucher for 10% off at the restaurant in the hotel. She pocketed the voucher. She and Sebastian could use it next time he was home.

The last item she lifted out was a little clear plastic spray bottle of aqua skin freshener with the HATP logo on the front. As she held it in her hand and watched the colourless liquid splosh backwards and forwards, she had a flash of memory of the university professor beside her complaining about how hot the room was and spraying something on his face. She remembered glancing across at McDowell too just before the speeches started and he had

been using his spray. She had thought nothing of it at the time. Now her mind was fizzing.

When Maxwell walked out of his office, she was holding up the bottle to him almost like a trophy.

'We might have our murder weapon,' she announced.

Chapter 32

Ferguson had his team collecting all the spray bottles at the hotel. He also had men checking the air conditioning system in case Gawn's theory about the bottles was wrong. Maxwell had dispatched officers to collect any bottles taken home by the other diners.

'It'll take days to get all the bottles collected and tested, ma'am, and we probably won't get them all. Some people will have thrown them away or passed them on.' Ferguson had warned the DCI when she had chased him down the corridor and told him her theory.

Now Gawn and Maxwell were sitting in her office. Her second cup of coffee, half drunk and getting cold, was on the desk in front of her. He was on his first cup of tea. She was fingering the little bottle, watching the clear liquid inside moving rhythmically backwards and forwards. It seemed to be having an almost mesmerising effect on her.

'We only have to find one bottle with K2 in it to prove my theory. Just one.'

'You should get that one sent to the lab too then,' Maxwell said.

'I was considering trying a wee experiment, Paul.'

His face showed he knew what she was thinking without her putting it into words.

'For God's sake, Gawn, no. No way. It's too dangerous.'

'No, it's not. I haven't been drinking. I haven't been snorting coke. If there is spice in this spray and I inhale just a tiny amount there should be some mild effect so we know we're on the right track but it shouldn't be enough to be dangerous. Munroe said it was polydrug use that was dangerous.'

'No. What he actually said was it was a very potent mix of K2 Randell had smoked or sniffed or whatever and even a single puff could end up in an overdose,' Maxwell stated solemnly.

He looked straight at her, maintaining eye contact.

'It could be dangerous. You don't know for sure that it isn't. And risking yourself is unnecessary. They know it's a rush job. They've already started testing the first ones we sent to them. It's what you said. We only have to get one positive result to know you're right. You don't need to take the risk.'

Alone in her office before Maxwell had arrived bringing his cup of tea, she had almost inhaled some. It could be a shortcut to know what they were dealing with.

'You don't need to play guinea pig.' The concern in Maxwell's voice was clear. He knew she'd taken risks in the past and he knew she was frustrated with their lack of progress.

There was a pause. Neither spoke. Then she broke the tension between them.

'OK. I suppose you're right.'

She set the spray down on her desk and saw Maxwell relax where he had been leaning forward tensed in his seat. She wondered if he would have physically prevented her from using the spray. She suspected he would.

'Right. While we wait let's see what anyone's turned up on our misper,' Gawn said as she walked out of the office. She didn't notice Maxwell lifting the bottle from her desk and putting it into his pocket as he followed her out.

Only Pepper and Hill were still there.

'Have we anything new on O'Neill?' Gawn asked.

'No, ma'am. I've looked at the CCTV footage until I'm cross-eyed. Unless she hid for two days before trying to leave, she didn't walk out of the hotel or the annex any time on Saturday night or Sunday morning,' Pepper stated, disappointment sounding in his voice.

Gawn remembered how Wilkinson had been so concerned that they cooperated with the hotel and ruffled as few feathers as possible. But if they couldn't find some evidence that Tracy O'Neill had left the premises either dead or alive, they would need to carry out a full search. She didn't look forward to having to suggest that.

'And she still hasn't contacted her husband?' Gawn asked.

'No, ma'am,' Hill responded.

'She works for an import-export company. I think it'd be worth paying them a visit. Did they sponsor her ticket on Saturday night?'

'Don't know, ma'am.' Hill shook her head.

'We can ask when we're there.'

This comment was directed towards Maxwell. Gawn didn't really expect to learn anything useful but she needed to be doing something. Waiting around for results from the lab and the CSIs at the hotel and having no clear motive or suspect for Randell's murder, if that was what it was, was stressing her out. They couldn't even be sure he hadn't done something himself which led to his own death.

She thought back to a time when she would have resorted to one of her own little pills in a situation like this. Sebastian had changed that. He had helped her see she was strong enough to face her demons without drugs.

She didn't want to go back there now.

Chapter 33

McKinty Logistics was a local success story. Started as a family concern only six years ago, it had quickly gathered important local and national clients. Its matt black lorries with gold McK logo were a familiar sight on the roads around Belfast and Larne ports.

Maxwell provided Gawn with background information about the business as they took the exit off the M2 signposted to the docks. They followed Dargan Road unto West Bank Road, huge hangar-like buildings lining the dusty roadway, many with containers sitting in rows stacked two, three and four high in their car parks ready for shipment all over the globe. Just as they were about to reach the entrance to the ferry terminal linking Belfast and Scotland they saw the signage for McKinty.

'I've been thinking, Paul. The Met told you Randell was involved with a gang which uses Tilbury to move stolen goods. What if they use Belfast too or they're starting to use Belfast?' Gawn asked.

'That's a bit of a leap, isn't it? We have no evidence and no connection between McKinty and any criminal group. We were told Randell was just the OCG's brief. It's a bit of a jump from standing up in court defending some scumbags to smuggling stolen goods for them.'

'But humour me, Paul. What Munroe told us about Randell's drug habit means he could have been susceptible to blackmail. He was getting his supplies from someone. If it was this OCG he could have brought something with him on Saturday night in that briefcase for them, couldn't he? Something that was going to be smuggled out of the country? And, if so, the person he was going to pass it to

must have been at the dinner or in the hotel or maybe he was going to meet up with him somewhere afterwards to do the handover.'

'That's possible, I suppose.' Maxwell didn't sound convinced.

She had pulled her car into the car park. Two lanes of containers, three high, towered over them. The containers formed a narrow alleyway, their high sides casting shadows so although it was a bright winter's day, they were in semi-darkness as they stepped out of the car.

Gawn turned and faced Maxwell.

'O'Neill works for McKinty. We know, from what I found in her wardrobe, that, one, she wasn't averse to handling the odd fake which must have been smuggled in. Two, she had Randell's business card in her pocket so there was some connection between them. Three, she disappeared from the dinner in all the chaos and four, Randell's briefcase went missing then too.' As she had spoken Gawn had counted the ideas off on her fingers.

'But I checked with Organised Crime. They have no intel on any fake fashion ring operating either side of the border. She might just have her own personal source for knock-off clothes. But if you suspect something illegal is going on here, shouldn't we have contacted the Harbour Police before we came?' Maxwell asked.

'The key word is *suspect*, Paul. We have no evidence. At all. We do have a missing persons case which we're investigating, which is nothing to do with the Harbour Police. She didn't disappear from here so we have every right to come and question the staff to see what we can find out. Maybe she confided in one of her colleagues that she intended going off for the weekend with someone and they can tell us where she is and it will all be perfectly innocent.'

Gawn didn't believe that of course. She just didn't want to have to involve anyone else. She always liked to keep tight control of her investigations.

'If we find a definite link to criminal activities then we'll let the Harbour Police know. Of course. And we'll need to let Organised Crime know then too. But let's see for ourselves first before we go running off to anyone else. It's just a thought. I could be wrong.'

Maxwell wasn't totally convinced about Gawn's theory.

Chapter 34

'We'd like to speak to the manager, please.'

Maxwell held up his ID as he spoke to a pretty young blonde receptionist who smiled shyly back at him through a Perspex screen dividing off the reception area from an open office space behind. Half a dozen staff sat at desks working at computer terminals. Several of them had turned to watch what was happening.

After a quick phone call, the woman escorted them between the desks, through a fire door and up a set of stairs at the back of the building. A double-height window illuminated the stairwell and offered a view over the waterside. Maxwell caught a glimpse across to Queen's Island, the iconic yellow cranes and the familiar shape of the Titanic Museum glinting in the low winter sun.

She led them to an office which overlooked the passenger ferry terminal to one side and the berths for container and merchant ships to the other. It was a busy port and getting busier every year. From the wrap-around windows they could see a ship docked alongside the building and containers being loaded onto it. A huge crane was painstakingly manoeuvring onc into a space not much bigger than itself, like a massive mechanical hand threading a needle.

A man stood up from behind his desk and smiled in welcome.

'I presume you're here about Tracy. Mrs O'Neill,' he corrected himself. 'I'm Donald Gunning, the manager.'

Gawn was surprised at his accent, a mixture of London and New York with its distinctive vowel sounds.

'I'm DCI Girvin. This is DI Maxwell. We're from the Serious Crimes Unit. We're looking into Mrs O'Neill's disappearance. We wondered if she had been acting out of character in any way recently or if she'd said anything to any of her co-workers here about any plans to run off.'

'Is that what you think happened? Tracy's a very sensible, down-to-earth sort of woman. Very dependable. I would never have thought she'd be likely to run off and leave her husband. They seemed very close.'

'Do you know her well, sir?' Maxwell asked.

The question seemed to surprise Gunning and he hesitated before answering.

'I don't want to give you the wrong impression, officer, that we were close or anything. We worked together. That was all. We weren't really friends. I've only been in this job for a few months. She was the company accountant. I'm the CEO. Her office is just next door. We saw each other every day, spoke every day but she was quite a private person in many ways. She didn't share any confidences with me.'

'Who was she friendly with then, sir? Who would she have been likely to talk to about her private life?' asked Gawn.

'The only person I can think of is my PA, Sylvia. Sylvia Newton. They eat lunch together most days. She would be the one most likely to know what Tracy might have been planning. If she was planning anything,' Gunning said.

'May we speak with Ms Newton?' Gawn asked.

'Of course. I'll get her.' He reached out to lift the phone to summon his assistant.

'Perhaps we could go to her,' Gawn suggested. She didn't want to be speaking to the woman in front of Gunning. Gawn thought she mightn't be so forthcoming if her boss was listening to her every word.

'Of course. She's just next door. Go ahead, Chief Inspector.'

'One more question before we speak to Ms Newton. Did McKinty buy Mrs O'Neill's ticket to the HATP dinner on Saturday night?'

'No. No way.' He seemed almost horrified at the suggestion. 'We don't have a budget for junkets like that. I didn't even know she was going. She must have paid for it herself or someone else must have. It wasn't us.'

And with that very definite response, they left Gunning standing behind his desk watching them.

Chapter 35

Gawn knocked and a woman's voice sounded telling them to 'Come ahead.'

'Ms Newton?' Gawn said putting her head around the door.

The woman, who had glanced up from the papers she had been perusing, looked surprised at their appearance. She was older-looking than Tracy O'Neill with touches of grey showing through her short mousy brown hair.

'Sorry. I thought you were someone else. I'm expecting some customs documents to be delivered. Come in. How can I help you?'

'We're from the police.'

Gawn introduced herself and Maxwell and tried to gauge the woman's reaction to their arrival.

Sylvia Newton looked a little uneasy. Gawn had long ago realised that innocent people, who had never had any dealings with the police, could appear uncertain when put in the position of being questioned, even just as witnesses. It didn't necessarily mean they had something to hide or were guilty of anything.

'This is about Tracy, isn't it? I was expecting someone to turn up sometime. I thought you might have been here sooner.'

Gawn felt a twinge of guilt. They had been concentrating so much on the two dead men that the missing woman hadn't received the attention she should have.

'How can I help you?'

Sylvia Newton had removed her glasses and was massaging her forehead as if she was trying to forestall an incipient headache. She cast a slightly myopic look at them.

'The IRS. You don't want to fall into their hands. Tracy usually deals with this. It's something new with us just expanding into the American market.' She smiled as she explained.

'You know Tracy well.' Gawn stated the fact anticipating agreement.

'Well, yes and no. I know her better than anyone else here I think, but I wouldn't say I know her well. We eat lunch together most days. We're in a minority here.' She smiled. 'The boys aren't interested in listening to our chat about the latest soaps or what new dress we bought at the weekend and we're not interested in hearing anything more about Liverpool or Man U. We both get enough of that at home. And the young women in the office are full of gossip about reality TV shows and their sex lives. So Tracy usually comes in here and we just sit and chat while we eat our lunch.'

'Does she talk much about her home life?'

'She talks about Gary, her husband, and how lucky she is to have met him. They're only married a couple of years

and I think she's still a bit in the honeymoon stage. I've been married nearly twenty so I'm well past that.' The woman laughed.

'So, you don't suspect any problems in her marriage then?'

'No. Is that what you think? That she's left Gary?'

'We wondered if she could have started another relationship,' Gawn said.

'Are you asking me if she was having an affair?' Sylvia Newton's voice had risen slightly in surprise. 'No. Never. Well, I mean it's not impossible.' The woman contradicted herself. 'I only saw her here at work. I don't know what she does outside the office other than what she told me but I can't believe she has a fancy man.'

'What about clothes?'

The woman seemed surprised at Gawn's change of direction.

'You mentioned that you discussed clothes; what you'd bought. Does Tracy like clothes? Does she buy a lot?'

'She certainly likes clothes. Before she moved here to Belfast, she'd worked in the fashion industry. She'd been used to getting clothes at discount prices and some of her contacts in London still send her stuff. She's always well dressed. Very fashionable and she gave me a few bits and pieces they'd sent her that she didn't want.'

'They send her clothes?' Gawn asked.

'Yes. One of the crew on one of the ships brings them over.'

'Do you know his name?' Maxwell asked.

'Greg something. I don't know his last name. Sorry. I only heard her talking about Greg.'

'Do you know which ship?'

'Sorry. No.'

'Thank you, anyway, Ms Newton. You've been most helpful.'

Gawn and Maxwell exchanged a look. It seemed at least part of Gawn's idea might be right.

Chapter 36

They had learned a little more about Tracy O'Neill from her co-worker but now Gawn was keen to get back to hear if any of the others had progress to report.

'We need to know more about O'Neill's background,' she said as Maxwell climbed into the car beside her and slammed the door shut. 'If she worked in London, she could have known Randell there. Maybe he was an old flame and they'd planned to get together at the dinner.'

'That might explain why she had his business card, boss, and that was probably his number on the back.'

'Have you traced that number yet, Paul?'

He looked sheepish. He had got sidetracked and had forgotten all about it.

'I'll get onto it as soon as we get back.'

He expected a reaction but none came. Her thoughts were too concerned with speculation about their missing woman to think of berating him.

'If we find out who it belongs to, we may find Tracy or at least some way to find out where she's gone. And we need as much background information on both her and her husband as we can get. If she's been involved in smuggling goods, like the stuff in her wardrobe, then who knows what else she's been up to and if her husband is involved too.'

'It's a bit of a jump to go from accepting the odd skirt from old mates, counterfeit or not, to fencing stolen property for some big-time gang in London and maybe being involved in murdering Randell. That is what you're thinking, isn't it? That the two cases are linked?' Maxwell asked.

'Yes. If she took the briefcase, then the events at the hotel would have been a perfect cover to let her get away. She may not have intended for Randell to die. She probably just thought he'd collapse like the others so he wouldn't be able to cause a fuss about his case going missing. She probably didn't have any way of knowing about his drug habit.'

'But if it was an inhaler that was tampered with, how did she get access to it? He had to have doctored that himself. And if it was the face spray, how could she be sure he'd use it?' Maxwell asked.

'Maybe she met him earlier. We haven't traced her movements before the dinner. We've really let this one slide, Paul. Big time. But anyway, I'm inclined to go with the face spray rather than the inhaler,' Gawn responded as she drove up Castlereagh Road.

'Same problem, boss. How could she be sure he'd use the spray or anybody would use it? And how did she get access to a whole lot of sprays so there'd be multiple victims to cover her tracks?' he asked.

'I haven't worked out all the details yet, Paul. But I'm getting there. Maybe she didn't need Randell to be affected. Maybe it was enough that some people were so there'd be a commotion to let her escape. His death mightn't have been part of the plan.'

'But, if what you think is right, she would have needed access to the bags to tamper with the sprays.'

'Yes. So we need to speak to Valerie Cosgrove again. Who chose the items for the bags and who put them together? Did she supervise it? It could even have been O'Neill herself if she was a volunteer with the Trust or something. And what was in that briefcase that made it worth going to all this trouble? There's too much we don't know, Paul. Let's find out.'

Chapter 37

After her visit to the McKinty offices, Gawn thought she was beginning to see some daylight in all the murk of the two cases and she was convinced now there was a link between them. But there were still so many gaps, so many things she didn't know.

Once back in her office she phoned the HATP. A stranger's voice answered the call.

'I'd like to speak to Valerie Cosgrove, please. My name's Girvin. I'm from the PSNI. She knows me.'

There was a pause and Gawn began to worry the woman had left her job. She relaxed when Cosgrove's chirpy voice came on the line.

'Chief Inspector. Any news on our break-in?'

'I'm afraid not. That's not why I'm phoning. I have a question for you.'

'Yes?'

'Who prepared the swag bags for the dinner? Did you put them together in-house?' Gawn asked.

'The swag bags? Oh, no. The hotel arranged it for us.'

'They decided what was in the bags and put them together?'

'When I say the hotel, I mean they suggested a company that could do it for us at a good price.'

'And who was that?' Gawn asked.

'Give me a minute.'

Gawn waited impatiently tapping her fingers on the desk. She could hear paper rustling and pages turning before she got her answer.

'They're called Jumping Jacks. I never actually met them. I only spoke to some man on the phone. They gave

us a great price and we were happy to go with what they suggested. Some of our sponsors and clients had donated items and Jumping Jacks provided the rest and put them all together. I checked one or two of them on Saturday afternoon myself and they seemed fine. It was good value for money for us. Was there something wrong with them?'

Gawn ignored her question.

'But you never actually saw who delivered them? They were already in place before you arrived at the hotel on Saturday afternoon?'

'Yes. They were already sitting at the tables. I just had to rearrange a few to make sure they were at the right place with the seating changes.'

'And how did you pay for the bags?'

'Bank transfer to their internet bank account. We always use bank transfer,' came the immediate response.

'I'll need the details.'

The woman gave her the information she wanted.

'Thank you. By the way, Ms Cosgrove, your missing page of names hasn't turned up yet, has it?'

'No, Chief Inspector, it hasn't.'

Chapter 38

No sooner had Gawn replaced the telephone receiver than it rang again.

'Girvin.'

'Chief Inspector.'

She recognised Ferguson's voice immediately and sat forward at her desk. If he was phoning so quickly, she hoped it meant he had found something.

'We've finished checking the air conditioning system.'

'And?'

'We didn't find any trace of K2 or any substance that could have affected the guests. But we've swabbed everything and something might show up in the lab tests.'

Gawn's hopeful expression changed.

'Well, thank you anyway, Mark.'

'That's not all, ma'am.'

'What else?' she asked.

'Both the air conditioning system and the heating system for the annex had been tampered with.'

'Tampered with? How?'

'The air conditioning controls were registering high. But it was actually only running at about thirty per cent capacity or less. And the heating system was turned up almost to its highest setting but it wasn't showing that on the dial. The heat should have been off by the time the dinner was starting. Instead we reckon it would have been almost at full blast.'

Gawn remembered how hot the room had been on Saturday night. It was hot from the moment she had stepped into the reception area but she had put that down to the contrast with the cold winter's night outside and the small space and the number of people all packed in together. She thought of how hot and stuffy it had become as they had been eating their meal. And she remembered how Pepper and Hill had reported that one of the waitresses had collapsed and had to be sent home.

'Can you tell how long it's been like this?' she asked.

She thought someone would have noticed if it had been a serious problem for long.

'Saturday was the first time anyone had remarked on the heat. They had an engineer booked to come on Sunday to look at the system but of course, we'd sealed the place off by then so he didn't get the chance and both the air conditioning and the heating system have been turned off since we started working.'

Gawn was thinking furiously.

'If they hadn't noticed a problem before, then it must have been tampered with sometime between when the last event was held in the annex and Saturday.'

'The last event was on Thursday evening and no one noticed or reported anything then,' Ferguson told her.

'You've already checked?'

'Yes. And I've already asked if anyone had been working on the system and the answer was yes. There was an engineer there on Saturday morning.'

'Who sent for him?' she asked.

'No one seems to know. Everyone just assumed someone else had arranged it. The kitchen staff and maintenance team thought it was the manager and the manager didn't know anything about it. I don't think anyone questioned the engineer too closely either. It was first thing in the morning, early, and they were all busy getting ready for the dinner,' Ferguson explained.

'Did you get a description of the man?'

'Only very general. Average height. Probably dark hair.'

'Probably?' Gawn interrupted.

'He was wearing a beanie. Never took it off. And he wasn't thin or fat. Average build. Not especially tall or small. "Average" was the word that kept coming up all the time.'

'Was he local?' Gawn asked.

'No one mentioned he had any kind of accent so I assume, yes.'

'Let's not assume anything, Mark. I'll send Jamie Grant down to take statements. We might be able to pick him up on CCTV now we have an approximate time when he was there. We should at least be able to spot his van. Can you dust for fingerprints?'

'Of course. We're already on it.'

'Good. Thank you, Mark. Grant should be there within an hour.'

Gawn replaced the receiver. Whatever this was all about and whoever was behind it, it was a very elaborate

plan. The heating and air conditioning systems had been sabotaged. That would have required serious expertise. The sprays had been tampered with. She was sure. Nothing had been left to chance and this couldn't be the work of just one man or one woman. But what was the aim? All this just to kill Randell? Or to grab O'Neill? Or to get whatever was in the missing briefcase? The briefcase. What was in that briefcase?

Chapter 39

Walter Pepper approached Gawn as soon as she walked into the room. He looked even more serious than usual.

'What is it, Walter?'

'I stuffed up, as I believe the young folks today call it, ma'am.'

Gawn couldn't help allowing herself a slight smile. Sometimes he seemed to regard himself as ancient but in truth he was only a couple of months older than Logan.

'How?'

She couldn't think what he might have done. She regarded him as the most dependable member of her team. Brought out of retirement to assist her with admin on a cold case, she had asked him to stay on afterwards. His record, before a serious injury in the line of duty leaving him with a limp, had been exemplary.

'I missed Tracy O'Neill on the CCTV, ma'am.' He spoke without elaboration, not about to offer her any weak excuses. 'Jo spotted her,' he added.

This was good news even if it did mean he was feeling guilty.

'The main thing is we got her, Walter. Where was she?'

She didn't want him fixating on his miss and maybe considering going back into retirement. She knew his wife hadn't been happy when he'd decided to return permanently. It would be easy for him to step back now but she didn't want to lose him.

Gawn followed Pepper to where Hill was sitting at her computer. Maxwell was already standing looking over her shoulder. Hill rotated her screen and showed them a frozen image. It was O'Neill arriving at the hotel.

'Look at the timestamp, ma'am,' Hill said.

It was 7.23pm.

'I thought we had her arriving at 7.45.'

'We did, ma'am, but that was at the entrance to the annex,' Hill explained.

She clicked and the picture changed to the woman entering through the automatic doors into the annex.

She clicked again and changed the photo back.

'Tracy O'Neill arrived at the main hotel entrance twenty minutes before she went into the annex. And she had that carrier bag,' Hill said.

'It doesn't exactly go with her dress,' Maxwell said.

Gawn threw a look in his direction which he didn't notice. She wasn't in the mood for levity.

'There's a camera in reception,' Hill continued. 'You can see her here going towards the restrooms. Then she goes out of shot. She appears again here minus the bag so she must have stashed it somewhere in the ladies' loo. And here she is coming out of the main hotel, and here going into the annex.'

'It wouldn't have taken her twenty minutes to stash a carrier bag, would it?' Maxwell asked. 'Maybe she was doing her make-up,' he suggested but hastily added, 'Sorry,' when he saw the look on Gawn's face.

'Good work, Jo,' Gawn said.

'I was lucky,' she said. 'Walter was looking for someone coming out of the hotel later in the evening not going in,

for we thought we already had everyone arriving at the annex.'

'But we still don't know how she left the hotel,' Maxwell said.

Hill couldn't help looking rather smug.

'Actually we do, sir. Walter had watched all the coverage from all the hotel exits but he was looking for someone dressed like Tracy was when she went in – that bright pink cocktail dress. Really noticeable. I thought, if O'Neill had stashed something in the loo, she might go back for it, so I checked the cameras in reception. Here's Tracy heading towards the ladies' restroom in the main hotel still in the dress just before 10.15pm.'

'That would have been when it was all starting to kick off in the annex,' Maxwell said.

'Yes. And then she emerged dressed like this.' Hill's tone reminded Gawn of a magician unveiling a trick.

Hill froze the image to let them all look at the figure now in a dark coat with a floral scarf on her head.

'She went through to the "staff only" area through that door.'

'Where does that lead?' Maxwell asked.

'To the kitchen, and here's a group of staff leaving out of the staff exit at the back of the kitchen a couple of minutes later.'

They watched a trio of women all dressed in coats against the cold weather conditions, leaving through the staff doorway at the back of the hotel. Two of the women had immediately walked out of shot and presumably gone to a car or walked out to the main road to be picked up. The third woman in the dark coat and scarf had waited until, within seconds, a taxi had pulled up and she got in and was driven away. They had only the briefest glimpse of her face below the scarf but no one was in any doubt it was Tracy O'Neill.

'This was after Ardgeen collapsed, Jo?' Maxwell asked.

'Yes,' Hill answered. 'Look.'

Hill clicked on the mouse again and they watched as O'Neill retreated down the corridor to the kitchens while Maxwell watched himself arriving, leading the first group of diners into the hotel through the other doorway.

'Well spotted, Jo.'

Gawn was pleased. Here was something definite. At last. Tracy O'Neill had been up to something. But what?

'She noticed the feet, ma'am. Even if I'd seen the woman leaving I wouldn't have realised it was her. The feet meant nothing to me.' Pepper spoke almost with the pride of a parent at a clever child.

'The feet?' Maxwell queried.

'How many waitresses have you seen working all night in backless stiletto heels?' Gawn asked. 'She put on a coat to cover her dress but she didn't change her shoes. Do we know where she went after this?'

'Not yet, ma'am. We're trying to trace the taxi that picked her up,' Hill said.

'As soon as you find it, let me know. We need to know where she went. And you can start looking for a heating engineer's van there on Saturday morning too.'

She explained what the CSIs had found.

'Jamie should be able to give you a description of the fake engineer. He's on his way there now to question the staff. In the meantime, we need another forensics team at the main hotel. They need to go over that toilet area. See what they can find. If she hid a coat there, something else could have been hidden there too.'

Maxwell hesitated.

'I thought the ACC didn't want the hotel searched,' he said.

He waited for her reaction and she was aware the others were waiting and listening too. He didn't often question her and certainly never contradicted her in front of anyone.

'That's right, she didn't, when we had no evidence that anything to do with our investigation had happened inside

the hotel. Now we do. But we'll still tread carefully. Inform de Grosse. Let him put an "out of order" sign or "shut for cleaning" or something, and tell our guys not to suit up until they're inside the corridor that leads down to the toilets. Keep the search under the radar.'

'Right. I'll get on to him. Hopefully he'll agree.'

'He'll agree. Tell him the alternative is that we shut off the lobby, go in through the front door all suited up, and tip off the press.'

Maxwell looked shocked.

'I couldn't do that.'

'No. You couldn't, but I could, so tell him that. And can someone trace this bank account, please? And what about that telephone number on Randell's business card? Someone was supposed to trace it. And we need the background info on both the O'Neills. Come on. It's all too slow. Let's move!'

Chapter 40

Gawn and Maxwell were sitting in her office. Most of the team had gone home for the night. It was getting late.

Maxwell was keen to go home too, to spend some time with his family. Gawn realised that but she was in no hurry. There was nothing waiting for her but an empty apartment and a freezer dinner left by her cleaning lady.

'Did you get hold of Goodlife, Paul?'

'No. He's in Canada on some sort of lecture tour. He'll be away for ten days.'

They had still to hear back from the internet bank and they hadn't managed to trace O'Neill's taxi yet either. It hadn't been any of the local firms.

The forensics team hadn't phoned with an update so presumably they were processing the toilet area which would have de Grosse in a state. But at least they now had a name and address for the phone number on the back of Randell's business card. The number belonged to an Ivan Goreski, a new name in the investigation. Goreski had an address in Twickenham. But they knew nothing else about him yet. Maxwell had tried ringing the number but there had been no reply.

'God, I hate this just waiting around,' Gawn said.

It was so frustrating. The more she thought about it, the more Gawn realised Wilkinson would be breathing down her neck very soon and there was always the possibility the ACC would decide to turn the case over to Organised Crime if she reported Tracy's possible link to a smuggling ring.

'Lady Ardgeen suggested that her husband had dealings with Randell when he was on some committee in London. It might all be perfectly innocent as far as Ardgeen was concerned but Randell had criminal contacts.'

'You don't think Ardgeen was involved in anything dodgy, do you, boss?' Maxwell asked.

'Nobody's perfect, Paul. You know that. The judge seems straight enough but who knows what he could have been hiding? I'm keeping an open mind. And I'm not assuming anything about anybody. Let's go back to basics. ABC. Accept nothing, believe nothing, check everything. What about the break-in at the HATP offices? Did we get a report from the Neighbourhood Policing Team?'

'Yes. They had a look at the premises and questioned the staff. They reckoned it happened sometime late on Saturday night. The burglar alarm was disarmed. It was an old-fashioned system installed years ago long before the Trust moved in. Before the ark was what they said. The Trust folk didn't think they had anything very much worth stealing according to Sandford. They don't keep money on the premises so they didn't do anything about updating it.

'The NPT sergeant told Jack they got the impression they mightn't even have bothered to arm it sometimes. They seemed a bit careless about it. But he said a ten-year-old could have dealt with it. It was primitive. The back door was forced and the place was trashed. Three computers were stolen and a small sum of money. Just coffee money basically. Probably kids.'

'But kids with very interesting timing,' Gawn said. 'Then there's O'Neill. We might get a break with the taxi. We need to find where she went after she left the hotel. But that whole scenario at the hotel was well thought out, Paul. It was planned like a military operation. The sprays would have had to be doctored. Who's looking for this Jumping Jacks company? Does it even exist?' Gawn asked.

'Jamie's on it. I told him to have another go at Valerie Cosgrove when he got back from the hotel. I think you intimidate her,' Maxwell told her and smiled.

Gawn's eyebrows rose in mock disbelief.

'I think we'd get more with a gently-gently approach,' he said. 'I told Jamie to use a bit of his boyish charm on her.'

'We're very stretched, Paul. There are so many lines of inquiry. I'm worried we're in danger of overlooking something important. I think we're missing Erin. We may have to pull her off her misper case. I know she'll be disappointed but this is more important.'

Maxwell's mouth drooped. She couldn't miss it. They both knew McKeown would be disappointed.

'Maybe one more day?' he suggested.

'OK. One more day.'

Maxwell stood up, ready to leave. He stretched. He was tired. It had been a long few days. But before he could move, Grant appeared in the open doorway, smiling.

'Did you work your charm on Ms Cosgrove then?' Maxwell asked.

'I can't help it if I have a way with the ladies, sir,' Grant said and grinned ear to ear.

'Well, what did you find out?' Gawn asked.

'She remembered the events company had just started up. The hotel gave her the name but when she spoke to the guy at Jumping Jacks he told her he was one of the people the Trust had helped. He was setting up his own business because of them so Sandford wanted to encourage him and they gave him the contract.'

'So Sandford was involved in the decision too?' Gawn sat up straighter on hearing this. 'And he knew about the bags. He knew this man. Let's bring Sandford in tomorrow, Paul, for an interview.'

'She remembered she had a number for the guy from the events company,' Grant said. 'He'd been hitting on her. I tried ringing the number but no reply, just an answering machine.'

'Did you get a name for this mystery man?' Gawn asked.

'Yes. Arnold.'

'Arnold who?' she asked.

'No. Not Arnold who. Jaxon Arnold. Jumping Jax. J-A-X. Get it?'

She got it alright.

Chapter 41

'You wanted to see me, ma'am?'

Erin McKeown's worried face appeared at the DCI's open door just after eight on Wednesday morning.

'Yes. Nothing to worry about, Erin. How's your misper case going?'

'Jaxon Arnold?'

'Yes. I should confess I have an ulterior motive for asking.'

The young woman looked puzzled.

'It wasn't some kind of test, ma'am? You didn't put Garth up to it?'

'No. Nothing like that. I'm hoping you've made good progress because I think it's connected to my case.'

McKeown looked up, surprised.

'Oh, right. Well, I've checked up on Jaxon. He has a bit of a chequered past. He's been in trouble off and on for years. Nothing too serious. Yet. Just the usual stuff – public order offences round the bonfires at the Twelfth – but it seems he was in danger of getting caught up with some of the local hoods. His father told me that he'd been coming under pressure to peddle drugs for them.

'Then he got some money together and opened a wee business of his own. By all accounts he seemed to be doing quite well. It had only been going for a couple of months but he was working hard at it. All hours. He'd had bookings for a few weddings doing the party favours, some deejaying, arranging a photo booth and a chocolate fountain. That kind of thing.

'What I'm looking into now is how he got the money to start his business. I think maybe some of the hoods helped him to get going and it's time to pay them back. Maybe he couldn't and they either scared him off or beat him up as a warning to others. I think if it was that we would have found him by now so my guess is he's off somewhere hiding from them.'

'Well, I can provide an answer for your question. He got a grant from the HATP to start his business. He was one of their success stories,' Gawn said.

'He was connected to the people in your case?'

'Yes. And we think it's possible that the spray in his swag bags was doctored to deliver a shot of K2.'

'So he might have done that for someone and been paid off. He could be anywhere now on the money,' McKeown said.

'We don't know. It's not even confirmed yet that the K2 was in the spray bottles. That's just my guess until the lab actually finds some. Do you know where Jaxon did his work?' Gawn asked.

'Yes. He has a lease on premises off Ravenhill Road. Just a small warehouse. More of a converted house really. It's where he stores his materials.'

'Have you been there?' Gawn asked.

'I had a look around the outside yesterday. His parents don't have a key. I tried to look through the windows but it's difficult to see anything. I questioned the other businesses but they hadn't heard or seen anything out of the ordinary and they hadn't seen Jaxon since last week either.'

'I think we need Forensics to look it over. See if you can find who the letting agent is and get a spare key. If not, we'll break in.'

'Don't we need a warrant, ma'am?'

'We'll put in a request but it'll take too long, Erin. Evidence could be destroyed while we wait around. Exigent circumstances to find a missing person, either yours or mine. We need to search it. Today.'

Chapter 42

On her way out the door, McKeown almost collided with a jubilant-looking Maxwell. Gawn could see he had news.

'Hot off the presses,' he announced clutching a piece of paper in his hand. 'Ferguson's just emailed an update. The lab found it.'

'The K2?'

'Yep.'

'In a spray?'

He was reading down the page.

'Just in a few of the ones they've tested so far. But they'll keep testing.'

Gawn had jumped up from her seat and moved around the desk to face him.

'At last,' she said. 'Something. And Erin's found our Jumping Jax too. Is it greedy if I ask if you have any more good news?'

'Well, Sandford's coming in at two for an interview if that's good.'

Maxwell stopped reading and looked up at her.

'It is. How did he sound when you phoned him?' she asked.

'You know I'm not good at judging people's voices. I think he sounded a bit worried but it's just my guess.'

Gawn knew Maxwell didn't do the instant character interpretation she did or the "jumping to conclusions" as he called it.

'Let's hope he is worried. It might mean he has something to hide and something we can get out of him.'

Maxwell was looking down at the page again. Gawn saw his brow crease.

'There's something else. Something we hadn't noticed. Well, I hadn't anyway,' he said.

'What?' Gawn asked.

'The names on the bags.'

'What about the names on the bags?'

'I'd assumed they were all named which is stupid when you think about it. Why would anyone take all that extra time to label every bag when everyone was getting the same things?'

Gawn remembered the pretty colourful label with her name on it.

'It would have taken extra time to write them all and then make sure they were at the right seat. It wouldn't make sense. It wouldn't be cost effective,' he finished.

'Maybe Jaxon was trying to give special service to HATP to impress them because they'd helped him,' Gawn said.

Maxwell nodded his head slowly, only half listening.

'No. He wasn't.' His voice had changed. 'They weren't all named. Most of them weren't. Only some, and those were the ones they've been testing first.' His voice had slowed down and when he looked up at her and their eyes met she could see his shock at what he had read.

Gawn thought she knew where he was going with this.

'Only the top table?' she suggested.

'Some of the top table and a few others.'

'Who?' she asked.

'You, me and the super.'

'They targeted us?'

'Yes. Thank God I didn't take my bag home. I'd intended giving it to Kerri. They must have hoped we'd all be out of it and not able to do anything, like McDowell was. Who the hell are these people, Gawn?'

Before she had time to answer, the phone rang to interrupt them.

'I've got hold of the letting agent, ma'am. He's going to meet us at the warehouse with the key,' McKeown informed her.

'When?'

'Half an hour.'

Chapter 43

Police cars were filling the whole alleyway by the time Gawn and Maxwell arrived. But then that wasn't difficult. It was more a back entry than a street. Just off lower Ravenhill Road, the building, now Jumping Jax, had been

part of a row of terraced houses knocked together. Its current facade was just blank grey plaster hiding any traces of its former life. There was no sign above the scuffed reinforced steel door to indicate what was inside.

Their journey from HQ had been completed in silence. Both detectives were stunned by what they had just found out. The idea of a military operation came into Gawn's mind. This had to be the OCG the Met was after, the one Randell was involved with and that would mean involving the Organised Crime Unit. She really didn't want to do that.

'Ma'am, this is Mr Oswald from the letting agents.'

McKeown had led a nervous-looking young man across to them.

'Right. Let's get inside then,' Gawn said. She held out her hand.

'I must insist on accompanying you and noting any damage or anything removed in your search.' The estate agent moved to stand in front of her clutching his clipboard to his chest, like a child with a float in the swimming pool. His words trailed off. Oswald swallowed hard at the look she had turned on him.

'You will stay back, Mr Oswald, until we tell you it is safe for you to go inside. There is no question of going in with us.'

That was all she said. She didn't try to explain or convince him. She didn't raise her voice but Oswald must have realised from her tone and the look on her face that he had no chance of winning any argument so he didn't even try.

Maxwell and McKeown exchanged a knowing look.

Gawn extended her hand further towards Oswald and the letting agent placed a set of keys into her palm then took a step back out of her way. Gawn handed the keys to Maxwell and he unlocked the door. It opened easily. It was dark inside and they were all immediately aware of a damp musty smell.

Dee and Grant went in first using torches until they found a light switch. There was a click and suddenly the inside was flooded with light. Illumination came from a long florescent tube hanging down from the centre of the ceiling on two chains. It exposed the dusty corners of the room and the peeling paint.

They could see that the space was small and cramped. Moats of dust, disturbed by the detectives beginning their searches, swirled in a shaft of weak sunlight coming through the open door behind them. All the walls were filled floor to ceiling with metal shelves. Arnold seemed to be methodical for the shelves were full of plastic storage boxes all neatly labelled.

'This must be the stuff for kids' parties,' Dee called, shining his torch on labels for magic tricks and fizzy bottles.

'Here's spray bottles,' Grant spoke, his voice excited, as he lifted down a transparent plastic box from the top shelf. He set it on the floor and opened it. It was about half full of small plastic bottles, the same type that had been used in the swag bags.

Before Gawn had the chance to lift one, McKeown's urgent call came from upstairs.

'Help! I need paramedics up here. Fast!'

Maxwell led the charge up the stairs, their feet loud on the bare wooden treads. They were met at the top on a narrow landing by three rooms. The door directly opposite them was open and revealed a dingy bathroom, a toilet seat sitting propped against the side of the bath. One of the other doors was still closed but through the third doorway they could see McKeown on her knees leaning over a prone figure. The man was tied to a radiator, his wrists and ankles bound and empty plastic bottles lying all around him. He was breathing and his eyes were open but there was a slash on his temple which had bled profusely, and the blood had spread over the front of his hoodie and formed a congealed pool on the floor beside him.

'OK, Jaxon. We've got you. You're gonna be OK. The ambulance is on its way.' McKeown was trying to reassure him. Maxwell joined her and between them they untied him and helped him sit up. Once he was propped upright, he sucked in a huge mouthful of air and then started coughing.

Jaxon Arnold was deathly pale apart from the deep red slash extending downwards from under his hairline. Gawn was surprised he was still alive if he had been here like this since Saturday. She realised that whoever had done this to him had left him water. The empty bottles scattered around were evidence of that. They had probably expected he would be missed and found within a couple of days at most. But when he wasn't, his meagre supply of liquid had run out. He must be severely dehydrated, and she knew from her experience in Afghanistan the danger of hypovolemic shock.

Gawn had hunkered down in front of Arnold.

'Have you been here since Saturday?' she asked.

Arnold swallowed twice. When he did finally manage to get a word out his voice was hoarse and raspy.

'Yes.'

'Can you tell us what happened, Jaxon?'

It was McKeown who spoke now. She was still on her knees on the dusty floor beside him with an arm around his shoulder helping to keep him upright.

'Water,' he managed to whisper but the effort seemed almost too much for him.

'Just wet his lips. We shouldn't give him anything to drink until the medics check him over,' Gawn said.

Maxwell had taken one of the empty bottles and filled it from the bathroom tap. He handed it to the sergeant. McKeown poured some of the water over her hand and wetted her fingers. Then she gently dabbed the man's lips. Jaxon licked his lips and, after a pause, began speaking, hesitantly, in a weak voice which was at odds with his youthful face and physique.

'Can't remember.' His words came again in a hoarse whisper.

The three detectives waited with greater and lesser degrees of patience as he struggled to answer the question. There was a long pause.

'Hit head.'

Gawn looked at the radiator behind him, at the blood smear on its jagged edge. He must have fallen against it when he was hit and been knocked out.

'Was there just one man?' McKeown asked.

'Two.' Arnold sucked in a great mouthful of air and then continued, 'Torch the place.'

He started crying then. He had had plenty of time to believe he was going to die. He would have been wasting his time shouting for help on Saturday and Sunday. There were no houses nearby, no one would have been about in the other premises. By Monday, he would have been too weak and dehydrated to do much yelling if anyone had even heard him over the sound of the passing traffic on the main road.

'Was it someone you know? Someone from where you live?'

Gawn listened as McKeown probed to get them the information they needed. She was treating him like a child and Gawn realised he was little more than that, not yet twenty, just a boy trying to change his life around who had got caught in the middle of God knows what.

Before Arnold could try to answer, they all heard the thud of heavy footsteps running up the stairs and two paramedics rushed in, one carrying a bulky backpack with all their equipment. Suddenly the room seemed to have shrunk.

'Give us some space, love,' the first one said to Gawn.

She moved quickly out of his way. The man knelt down and took McKeown's place supporting Jaxon. The sergeant stood up then too and the three detectives

retreated to the landing, crushed together on the small square.

'We won't get anything else until they're finished with him. Erin, you stay with him. Go to the hospital in the ambulance. Listen to him. See what else you can find out. If he remembers two men, he might have heard them talking. It must have taken them a while to get the K2 into the bottles. It would have been a fiddly job and they would have had to get the rest of the contents put together too. He may have heard names or details while they were working. Just keep with him.'

'Right, ma'am.' McKeown nodded and turned back to watch as the two paramedics attached monitors to Arnold's arm and chest.

'Paul, we need a CSI team to go over this place. We might get lucky with fingerprints,' Gawn said. 'And see if they can find any evidence of K2 anywhere. Whoever attacked Jaxon must have put it in the bottles here and then delivered them to the hotel.

'We need to see if we can find anybody who saw a van here on Saturday or they might have used Jaxon's own van. We should be able to catch them on traffic cams on the way to Holywood. And the men should appear somewhere on the hotel's CCTV too when they were bringing the bags in. Then keep looking to see where the van went afterwards. It could lead us to whoever is behind all this.'

Gawn didn't think Jaxon Arnold was part of any elaborate plot. He had been a dupe. Someone else had known he had the contract to provide the gift bags. In fact, because of the high degree of organisation behind all of this, she suspected they had probably arranged it that way. Then the men who had attacked Jaxon had filled the bottles and put the bags together before delivering them to the hotel. Were they the same men who had posed as a heating engineer and a taxi driver, she wondered, or were there even more people involved?

The events at the hotel, Joshua Randell's death and Tracy O'Neill's disappearance. She was sure now everything was linked. But who was behind it all? And what was in that briefcase?

Chapter 44

The CSIs were busy at Jumping Jax. Gawn had waited until Damien Lyons and his team had begun their work. She knew he would try to get her answers quickly so she had left them to it. No point in waiting around trying to second-guess anything they might find. Anyway, she had an interview scheduled.

Now she was waiting but this time it was for Adrian Sandford to arrive. He was late. Not a good sign. She was already annoyed. Who were these people who had almost killed Jaxon Arnold, had killed Randell whether intentionally or not, and endangered everyone else at the dinner and targeted her and her colleagues? And possibly, although she wasn't sure about this, abducted Tracy O'Neill? It was possible O'Neill was part of it all, not a victim at all.

Gawn's phone rang.

'He's here.' It was Maxwell with the news.

'Right. I'll meet you down there.'

'He's brought a solicitor with him.'

Gawn had been about to lift her jacket from the back of her chair but stopped mid-movement.

'OK. But you did tell him we only wanted some more information, didn't you? I mean, you made it clear he wasn't under suspicion?'

'Of course. I told him we needed some info on the Trust's involvement with Jaxon Arnold,' Maxwell replied.

'You gave him Arnold's name?' she asked.

'Yes.' Maxwell sounded dubious as he answered. 'Do you think that spooked him?'

'Maybe. But he can't seriously have expected us not to figure out there was some kind of a connection between them, can he? Oh well, let's talk to him and see what he has to say.'

Sandford was dressed more formally today than their first meeting. His dark suit was suitably business-like, less holiday camp vibe than the polo shirt had been. He stood up politely when they entered the room as if this was a social occasion, not a police interview.

'Good afternoon, Mr Sandford,' Gawn said. She didn't smile. If Sandford was spooked by the fact that they were going to talk to him about Jaxon Arnold, she wanted to keep him that way. She was not unfriendly, not aggressive, just cool. That was the approach she had decided on.

'Chief Inspector.' He smiled at her and then moved his head to include Maxwell in his greeting. 'This is the Trust's solicitor, Duncan Herriott,' he continued, indicating a meek-looking little man sitting beside him at the table.

'I'm here to represent the interests of the HATP,' Herriott said. His voice was soft and she almost had to strain to hear what he had said. Gawn had never heard of him and guessed he didn't specialise in criminal law.

'We want to hear about the Trust's support for Jaxon Arnold,' she began getting straight to the point.

Sandford seemed to relax at her question. Whatever he had been expecting to be asked, it seemed he was happy enough to talk about Arnold. That surprised her after what Maxwell had said.

'We support a lot of young people. Hundreds. We finance courses to help them get training in things like financial planning and entrepreneurship,' Sandford said with a touch of pride. Gawn thought he sounded as if he was narrating a promotional video for the Trust. 'We make a difference in young peoples' lives.'

He sat back then and folded his arms with a look of satisfaction on his face. It seemed to challenge her to find something to criticise.

'Indeed. But I'm not talking about hundreds of young people, Mr Sandford. I want to know about just one. Jaxon Arnold. You know Mr Arnold personally,' Gawn persisted, not moving her eyes from his face.

'No. I don't have anything to do with any of the courses. Outside agencies run them. They apply for grants and we assess the scheme and then award the grant to fund them if we think it's worthwhile. Like the PSNI's initiative. We make the courses possible but we don't run them. It's all about helping young people. The courses don't even take place in our premises.'

'So you're telling me you've never met Jaxon Arnold?' Gawn asked, deliberately allowing a sceptical note to creep into her voice.

She tilted her head slightly as she waited for his reply and Maxwell saw her familiar raised eyebrow.

Sandford hesitated and then reluctantly conceded, 'I met him. Once, I think.'

'Where, Mr Sandford?'

'In the office.'

'Your office?' she asked.

'No.' He hurried to make sure she understood. 'No. In the general office. He must have called in to get details of a course or maybe to check something with Val. I think he might be one of the young people she featured in our brochure. In fact, I remember now. He is.'

'He's in your advertising material?'

'Yes. He's one of our success stories. I remember now.' Sandford seemed relieved to be able to agree.

'What about his contract to provide the bags for the dinner? Was that your suggestion?'

'No.' Sandford spoke very decisively, shaking his head at the same time.

'But you knew he'd been awarded the contract?' Gawn asked.

'Is there some suggestion that there was something inappropriate or illegal in the arrangement, Chief Inspector?'

The solicitor had intervened in a gentle voice but with a look on his face which suggested to Gawn he would miss nothing. If he had been appointed by the O'Sullivans, who were by all accounts sharp businessmen, he would be no slouch. He might not be a criminal specialist but he would miss nothing. She realised that now. And she realised it would be a mistake to underestimate him. She imagined he would be reporting back directly to New York.

'We've been led to believe that your client – or rather I suppose I should say Mr Sandford if it's the Trust that's your client – had recommended Mr Arnold for the job.'

'And is there a problem with that?' the solicitor persisted.

'It seems a bit strange if Mr Sandford claims he didn't even know him.'

'I didn't say that,' Sandford interrupted, his voice loud in comparison to Herriott's.

'When asked by the chief inspector if you knew Mr Arnold you replied' – Maxwell read from his notebook – '"No. I don't have anything to do with the courses," didn't you?'

'Yes but I'd forgotten then. I told you that I met him in the office. It was no big deal. I walked into the general office and he was there for something. Nothing to do with me but I probably said hello. That was it.'

'And you're still telling us that you didn't suggest him as suitable to provide the bags?' Gawn asked.

'No. I didn't. Definitely not.'

'But you told us you didn't know Joshua Randell either, that you'd never met him. And that was a lie, wasn't it?' she persisted.

As Gawn spoke, she slid the photograph of the four men posing for an official picture at the dinner across the table towards him.

He picked it up and looked at it. When he set it down again, he looked up at her. Gawn noticed a bead of sweat on his brow. It wasn't particularly warm in the room.

'Is that Randell? No one introduced us. I didn't know his name. The photographer just put us together and took the photo.'

* * *

Gawn and Maxwell watched Sandford's and Herriott's backs as they walked away down the corridor.

'He was able to explain the photo, wasn't he?'

'And you believed him, Paul?' Gawn asked.

'Well, he seems very definite that he didn't recommend Jaxon for the goody bag gig.'

'"Goody bag gig", have you been watching American TV cop shows again, Inspector?'

'You know what I mean, boss.' Maxwell smiled.

'Yes. I do. But then he started off by telling us that he didn't even know Arnold until he couldn't deny it any longer. So, either he's lying about recommending him or Valerie Cosgrove is.'

'Not necessarily.'

She turned to look at him.

'Cosgrove told us the hotel had suggested Jaxon and then Sandford had supported the suggestion. She didn't say it came from him first. It might just be what he said, that he wanted to support one of their protégés.'

'Who at the hotel, Paul?' Gawn asked.

He looked back at her blankly.

'Phone de Grosse. We need that information for tomorrow's briefing. Right now I don't believe a word that comes out of Mr Sandford's mouth.'

Chapter 45

The sound of a phone ringing somewhere in the distance gradually infiltrated Gawn's dream, dragging her back to reality. She turned over in bed and reached out for her mobile.

It was Maxwell.

'I hope I didn't wake you, ma'am.'

He had. And he knew it. She could almost hear a smile in his voice.

'What time is it?' she heard her own sleepy voice ask in response.

'Just after five.'

She ran her hand through her hair and sat up blinking her eyes open and shut, trying to get herself awake.

'My alarm would have been going off soon anyway. I take it you've something important to tell me. Are you in the office now? At this time?'

'No. I got a call-out. To a house fire.'

'A house fire?'

'Yes.' He paused. 'In Killinchy,' he added. And waited for her reaction.

Gawn was wide awake now.

'Sandford?'

'Yes.'

'Is he alright?' she asked.

'They'd already taken him to hospital before I got here. I didn't get to see him.'

'But why did they call you, Paul?'

'Valerie Cosgrove was here with him. She was in hysterics but they managed to get enough sense out of her to know she wanted police protection and she kept

mentioning your name. The local sergeant didn't want to call you.' He paused knowing he didn't need to explain why. 'So, they got me instead.'

Gawn was already out of bed and had discarded Seb's T-shirt which she liked to sleep in.

'It should take me about forty minutes to get there. The traffic shouldn't be too bad at this time of the morning.'

'There isn't much to see here, boss. They're dampening down the site and then they'll need to check it over. No one will be able to get inside for a while. Sandford's been taken to the Burns Unit at the Royal. A constable went with him and I'll phone Jack now and get him to take over. I was just about to take Cosgrove to Belfast so we could question her. I don't think she'll talk to us until she's safely away from here. She's a wreck.'

'Right. I'll meet you at the office then.'

'Don't break any speed limits, boss. This is one witness who doesn't want to be leaving our custody. She'll wait for you.'

Chapter 46

Gawn had a quick shower, ran a comb through her wet hair and brushed her teeth. That was all she had taken time for. No make-up. At least, following her usual routine of leaving her clothes out ready in the evening for any emergency call-out, she was wearing something different from yesterday. If anyone even noticed.

As she hurried up the empty corridor, she was aware of her stiletto heels clicking loudly on the tiled floor. This had to be a breakthrough. She had always suspected that Sandford was involved in something. And her hunch that he and Valerie Cosgrove were in some sort of relationship

was correct too. Whatever had happened at his home confirmed that.

'Where is she?' Gawn asked as she pushed open the door and strode into the office.

It was still dark outside and Maxwell had only switched on a couple of desk lights so the room was in semi-darkness with gloomy spaces where detectives were normally busy at their desks. The place looked eerily empty, so different to its usual buzz and bustle.

'Interview suite 3.'

He was standing waiting for her, a steaming cup of coffee held out at the ready.

'I didn't think you'd take time to make any at home,' he explained.

'Thanks, Paul. I didn't.'

She took a mouthful of the coffee as she sat down at the nearest desk. She couldn't help pulling a face. He saw it.

'Only instant. Sorry, boss, it was all there was.'

'Beggars can't be choosers. Right, tell me. What happened at Killinchy?'

'All I could get out of Cosgrove was that she and Sandford were in bed when three men suddenly appeared out of nowhere. They dragged Sandford out and told her to stay put. Which she did. Then after about five minutes – her timings, which I wouldn't put a lot of faith in cos she's all over the place, could be two minutes, could be ten. Anyway, she smelt smoke and when she worked herself up to opening the bedroom door the hall was on fire. She got out the back way and phoned for help.'

'Leaving Sandford inside?' Gawn asked.

He nodded. They exchanged a look.

'And the men were gone by then?' she asked.

'She didn't say she saw them again, but I don't think she would have been looking.'

'Did she tell you why she feels she needs police protection? It could just have been someone breaking in.

It's an isolated house. Sandford drives a big expensive car. Thieves would assume he probably has expensive electronic equipment, computers, TVs, maybe an expensive watch or two and they could have set the fire just to cover their tracks. No reason why they should come back.'

'She's clammed up now until she gets to speak to you. So I don't know.'

'Right. Then we'd better grant her wish.'

Gawn took another mouthful of coffee and stood up. She ran her hand through her still-damp hair, pushing it back off her face, straightened her jacket and pulled the sleeves down.

'Right. Let's go.'

Chapter 47

Valerie Cosgrove was almost unrecognisable. The perky young woman they had met on Sunday morning, even though she had been hung-over then, was gone. Then she had seemed blasé about everything that had happened, not really concerned about anything, not even the possibility of losing her job. Now she sat looking dejected and anxious, glancing around sharply at any loud noise, jittery.

She was dressed in pyjamas again with a plaid blanket wrapped around her waist and Gawn thought she seemed doomed to always be interviewing her in nightwear. But this time it was a man's pyjama jacket she was wearing. She had been given some tea and Gawn saw her hand shaking as she lifted the cup to her mouth.

'Ms Cosgrove, how are you?' Gawn asked as she walked in oozing a concern she didn't entirely feel. The truth was, much as she had disliked the woman from their

first meeting and had been annoyed by her behaviour when she could have been helping them and didn't, and by the fact that she had left her boyfriend to burn to death, she did feel rather sorry for her now. To have your home invaded by masked strangers and to have to escape being burned alive was enough to unnerve anyone. Gawn was beginning to see beyond the typical Gen Z-er whose life revolved around her social media accounts and realised she was just a scared young woman, not much older than Jaxon Arnold and perhaps caught up in this as he had been.

'Do you have a fag?' Valerie Cosgrove looked up hopefully, her lips trembling.

'I'm sorry, I don't smoke.'

Gawn thought for one moment Cosgrove was going to burst into tears at her reply.

'Shit. I need a cigarette.' She cupped her face in her hands, elbows on the desk, and bit her lip. Gawn could see her eyelashes were heavy from her tears.

'Have you been checked over by a doctor?' Gawn asked, looking at Maxwell for confirmation.

'Yes. He arranged that.' Cosgrove looked towards Maxwell who had taken a seat beside his boss. 'Anyway the firemen had already checked me over.'

Cosgrove couldn't prevent a smirk passing fleetingly across her face. Gawn realised some of her perkiness was beginning to return now she felt safe with them. Some of her sympathy for the woman dissipated now too.

'Can you tell us exactly what happened this evening, Valerie? In your own words. No rush.'

'We'd gone to bed.'

'You and Sandford?' Maxwell asked.

'Yes.'

'You're in a relationship?'

'We're friends. With benefits. Nothing serious.' Valerie Cosgrove dismissed the idea of a relationship with a casual flick of her hand and a shrug.

'But he's your boss. Doesn't that make it difficult?' Maxwell asked, his voice betraying his lack of understanding.

Gawn realised Maxwell wouldn't understand the couple's tangled arrangements. He was a one-woman man. He had met his wife when they were at school and married her before they were twenty.

'Would you have trouble having sex with your boss?' the young woman asked, her eyes flicking from Maxwell to Gawn and back again. She seemed to enjoy the look which crossed Maxwell's face.

Gawn said nothing. She ignored the sly look the younger woman gave her.

'Anyway, Adie didn't seduce me or anything. I seduced him and he's not forcing me to have sex if that's what you're thinking. It's not in my contract.' She laughed. 'It's a mutual thing. I just like older men.'

Cosgrove smirked at Maxwell again and Gawn realised the woman was enjoying making him feel uncomfortable with her revelations. She could sense him shuffling his feet beside her.

'And how long has this mutually beneficial sex been going on?' Gawn asked, her voice hard now, sympathy gone.

'Ever since I came to work for the Trust.'

'And you were staying over last night?'

'Yes.'

'Was that usual? Did you stay over often?'

Gawn thought of the arrangement she and Sebastian had had when they first met. He had called it bed ping-pong, sometimes her apartment, sometimes his house.

'Maybe once or twice a week. Sometimes Adrian stayed with me, sometimes I stayed with him. It just depended on where we'd been or what was happening the next day.'

'So last night it was Adrian's house,' Gawn said for confirmation.

'Yes.'

'And nothing happened earlier in the evening? Nothing out of the ordinary?'

Valerie Cosgrove seemed to consider before she answered. She took another slow sip of her tea. Gawn recognised the tactic of playing for time. The woman was deciding how much she needed to tell them to get what she wanted.

'Adie was a bit hyper. You'd interviewed him yesterday afternoon and he thought you suspected him of something. He talked to someone for a long time on the phone last night.'

'Do you know who he was talking to?' Gawn interrupted.

'No.'

'Did they phone him or did he phone them?'

'He phoned them.'

'On his mobile?' Gawn asked.

'No. On the phone line. He was charging his mobile. It'd died.'

'Did you hear what he was talking about?' Gawn asked hopefully.

'No. I couldn't hear. He was in his study. He didn't tell me but whoever it was, it upset him. Scared him. And he'd had quite a bit to drink. More than usual. We went to bed and he fell asleep almost immediately. I'm not sure how long I was asleep but next thing I knew the room was full of men.'

'How many?' Gawn asked.

'Three.'

'Are you sure?'

She paused and shuddered at the memory.

'Yes.'

Her eyes widened as she thought of it. As she lifted the disposable cup to her lips her hand was shaking so much this time that some of the brown liquid spilled over the side and down onto the table just missing Maxwell's notebook. Gawn lifted a paper towel and wiped the tea away.

The break let Maxwell ask, 'Would you recognise them again?'

'No. It was dark and they were all in black and had those balaclava things on. I could only see their eyes.'

She shivered.

'What did they say?' Gawn asked.

'There was a lot of shouting. They said something like he should have kept his mouth shut or he needed to keep his mouth shut or something and then they dragged him out. I was screaming and one of them grabbed me and shoved me up against the wall and said if I didn't shut up he'd cut my fucking throat so I'd never be able to scream again. I thought they were going to kill me.'

She started crying. Not loudly, just a gentle stream of tears trickling down her pale face. Gawn pushed the box of paper hankies across the table to her and they waited until her tears had eased and she had wiped her eyes and blown her nose.

'OK to go on?' Gawn asked.

Cosgrove nodded.

'Did the men have accents? Were they local?'

'No. They were English. I think. I was terrified. I'm not sure of anything.'

'What happened then?' Gawn asked.

'I don't know how long I waited. I thought if I went out into the hall they'd still be there and they'd kill me. I could hear more shouting and…' She stopped and gulped. 'I could hear Adie screaming. Then I heard a door bang. I thought it was the front door and then there was silence.'

'You didn't hear a vehicle, a car or motorbikes?' Gawn asked.

There was a pause while the woman was thinking.

'Yes. Yes I did. There was a car. That was why I thought they'd left so I could go and see if Adie was alright but then I smelt the smoke. I opened the door and I could see flames coming from down the hall. I ran out the back way.'

Valerie Cosgrove had started to sob, really sob this time, taking great gulps of air, unable to speak, her shoulders heaving.

'Take your time, Valerie.' Gawn waited while the woman took another wodge of paper hankies and wiped her face. 'Is there anything you can tell us about the men to help us identify them?'

She waited. They waited. Until eventually the woman shook her head.

'No. I wouldn't know them again if they came in here now.'

'What about anything else they said to Mr… to Adie?' Gawn asked.

'Only that he knew too much for his own good. He needed to keep his mouth shut.'

Valerie Cosgrove was sobbing gently now trying to get her breathing under control. Now for the $64,000 question, Gawn thought to herself.

'Why do you think you need police protection, Valerie?'

'They might come back. For me. I did everything he asked me to. I arranged the seating like he told me and gave him the plan. If he told them I knew all about it, then they'll be after me too.'

Chapter 48

'We need to know who Sandford was talking to last night, Paul. He was obviously following someone else's instructions about the dinner. He's not the brains behind this.'

The two were standing outside the door of the interview room. No one else was in the corridor. They had decided Cosgrove needed a break – well, Maxwell had

thought it was a good idea and convinced Gawn. She thought he was too soft and would probably have kept at the woman if he hadn't insisted.

'Whoever it was either arranged for the men to attack Sandford or told someone else that he'd become a liability and needed dealing with. Get in touch with his phone provider and find out who he was talking to. Top priority. Don't let them mess you about.'

'On it. What are you going to do?'

'I'm going to try the Met again. We need more information about Randell's activities and this OCG he was involved with.'

Phoning someone at the Met was what she had intended when she went into her own office. But the more Gawn thought about it, the more convinced she was that something was going on and she was being kept out of the loop. Deliberately. For whatever reason. Asking questions directly would get her nowhere. She needed to get the information another way. And she knew how. Mike Lee was a security expert. He knew all about the London crime scene but he was her ex-lover too and they hadn't parted on the best of terms.

Gawn sat there staring at the phone in front of her for what seemed like a long time. She was aware of the second hand on her wall clock moving round the dial and the noise as two men walked past in the corridor talking loudly and laughing.

She reached out and her hand was almost on the receiver when she hastily withdrew it again as if it might burn her. She pushed her hair off her face brushing against the scar on her temple without registering it. She closed her eyes and took a deep breath. If anyone had been in the room watching her, they would have had no doubt she was debating with herself what she should do. This phone call was not going to be easy to make.

Gawn clenched her teeth as if she had suddenly made up her mind. Then instead of picking up the receiver she

took her personal mobile from her pocket. Better leave no trace on any official phone. She punched in the number. It was a number she was dredging from the back of her mind but a number she would never ever forget.

The call connected quickly and only rang twice before a voice answered, a surprisingly alert voice for this time of the morning.

'Hello.'

A male voice. He sounded wary.

'Who is it?'

Gawn hesitated and when she spoke it was in almost a whisper. She said only one word.

'Gawn.'

There was silence. She could hear breathing so she knew the call was still connected; he was still there. But there was no other sound. She expected he might hang up on her now. She wouldn't have been surprised if he had. But then he spoke.

'Quite a blast from the past. I certainly wasn't expecting to hear from you. To what do I owe the pleasure? Or maybe I should ask, how do you want to fuck with me this time?' His voice was cold, bitter. 'Oh no. Of course, you don't want to fuck with me, wasn't that it? It was over between us. You needed space.'

'Mike, I told you—'

He interrupted her before she could say anything more.

'Right. It wasn't me. It was you. Isn't that right, Gawn? I wasn't good enough for you,' he sneered.

'I never said that, Mike. I said you weren't good for me. We weren't good for each other. I needed to get my head together. After Max I needed to get away. From everything and everybody and start again.'

'So, you ran home to Belfast.'

She was shocked. She hadn't realised that he knew where she had gone. But, of course, he was a security expert. He had his investigators and his informants. He would have ways of keeping track of her if he wanted to.

She was just surprised that he had bothered and wondered what else he knew about her life now.

'How do you manage without my little pills, my darling? Or are you still popping them?'

'No. No pills,' Gawn answered.

'So, if you don't want pills from me, what do you want?'

'Information.'

He laughed.

'I'm not your CI, you know,' he said, sounding angrier now.

'But nobody knows the London gangs like you do, Mike.'

'Don't try to flatter me. And don't tell me Gawn Girvin is thinking of taking on one of the London mobs. You're liable to get your fingers burned, pilgrim.' He put on a John Wayne accent as he spoke. She remembered how much he liked Wayne's films and how they had cuddled up and watched them together. 'Or maybe some other part of your anatomy,' he added and laughed.

Gawn shivered. She remembered one particular gang who had liked to burn their rivals or anyone who stood up to them. She had seen the pictures of their handiwork, a girlfriend of one of the gang, who had given information to the police. She had been tied to the steering wheel of her car which was set on fire. She had to be identified by her dental records.

'I need to know if any of the OCGs are moving into Belfast port. A gang which has links to Tilbury and a brief called Joshua Randell.'

'What's in it for me, darling? You're not here to do me any favours anymore.'

'But I'm a DCI now. I still have links at the Met and access to national databases.'

'If that was true about the Met, my darling, you'd be tapping them for this information. Not coming to me. But at least you're not asking me to do it for old times' sake.'

He laughed again but there was no warmth or mirth in the sound.

'I'll think about it.'

The line went dead.

Chapter 49

As soon as Gawn saw Maxwell's face, she knew they'd got lucky. She had waited in her office until her heart had stopped pounding in her chest and she thought she could disguise her feelings after the phone call. Anyway she had wanted to give Maxwell time to contact the phone people and convince them to give up the information they needed. If they knew who Sandford had been speaking to it could crack the case. But she knew it might take a court order to get what they wanted.

The incident room was filling up now. The others had begun arriving. Grant was perched on the end of Logan's desk chatting. The older detective was biting into a croissant and Gawn saw the pastry flakes falling down over his computer keyboard. Normally she would have been annoyed and made some comment to him but this morning her priorities were elsewhere.

There was a buzz in the room not just the usual banter. It was an expectation of something about to break in the case. Gawn sensed it and she thought the others did too. The attack on Sandford meant they must be getting closer but she still didn't know to what or whom.

'Good morning, everyone. There's been a development.'

Gawn gave them details about the intruders and the fire at Sandford's home. It was clear from their reactions that

they had already heard something about it. News travels fast in a police station.

'Cosgrove told us Sandford had been speaking to someone on the phone earlier in the evening.' Gawn turned to Maxwell before she asked, 'Did the providers give you the details of the call?'

'Yes. It's a number we know.'

Gawn could see the others exchanging looks. They were wondering who he meant. So was she.

'It belongs to Ivan Goreski. The call only lasted a few seconds. But he must have given Sandford a mobile number to use instead and the man was stupid enough to use it right away so we've got it too. They spoke for about twenty minutes then.'

'So we have Goreski's mobile number now?' Gawn asked.

'We do indeed. It's switched off but any time it's back on we'll know.'

'Great. Now we need to know everything there is to know about this Goreski character. Anything else?' Gawn asked.

'We found CCTV footage of the two men delivering the bags on Saturday afternoon. They used Jumping Jax's own van. But I'm sure they'll have dumped it long ago. If it turns up, we might get something, but I wouldn't hold my breath. They're professionals. They knew where the cameras were and kept out of their way as much as possible,' Maxwell said.

'Jo, you and Walter go back to the hotel after we finish here. See if you can get a better description of the two men who brought the bags and ask especially if either of them bore any resemblance to the heating engineer who'd been there earlier.'

'Right, ma'am.' It was Hill who responded.

'Any luck tracing the taxi that picked O'Neill up?' Gawn asked turning round to the rest of the detectives.

'It was a black Mercedes. Maybe. That's as much as I could get from the two women who walked out with O'Neill. They were sure of the colour, not sure of the make. They don't know a lot about cars,' Logan said and shrugged.

They had already identified it on CCTV as a Mercedes so this was not new information and the number plate had been covered in mud, so they couldn't use ANPR. They had only been able to follow the car on camera until it had turned off the main road to Belfast and headed into the Holywood Hills. There they lost it.

'No description of the driver?' Maxwell asked.

'No. They just wanted to get home. They didn't look at the driver.'

'Could they tell you anything about O'Neill? They walked out with her. Didn't they talk to her?' Gawn asked.

'It was the end of their shift. They were tired. They said they didn't know her, just assumed she was one of the casual staff too who'd been employed for the night. They said hello. She said hello back. That was about it.'

'What about Jumping Jax? Do we know who at the hotel recommended them?' Gawn asked.

'Yes, ma'am. But I don't think it has anything to do with what happened,' Jo Hill said tentatively.

Gawn was going to pull her up for her assumption but decided to hear her out.

'It was one of the waitresses. Her name's Angela Fraser and she went to school with Arnold. I think she's a bit sweet on him and she was just trying to help him get some business.'

'We have no other connection between Fraser and anyone else in our case?' she asked.

'No, ma'am.'

Gawn was disappointed. She had hoped that finding the person who had recommended Jaxon would link with Sandford too.

'OK. We'll leave her for now. Who's been getting background on the O'Neills?' Gawn asked.

'Me, ma'am.' It was Walter Pepper and she was glad to hear his voice. Now they might find something to link this all together.

Chapter 50

Pepper liked to keep in the background and get on quietly with anything he was asked to do so Gawn was surprised when he stood up now and walked across and positioned himself beside her. He was carrying a sheet of paper and he pinned it up alongside the photograph of Tracy O'Neill, which they had got from her husband when she was first reported missing. It was a photograph of a man and Gawn had never seen him before. Fighting the urge to ask who he was, she decided to let Pepper reveal what he had found at his own pace.

'I checked into the couple's background as you asked, ma'am. There wasn't too much to find out about Gary O'Neill. He's a local boy from North Belfast. Brought up off Cavehill Road. Left school at eighteen and got a job with the Harbour Commissioners. He has no criminal record. Not so much as a speeding ticket. He and Tracy married two years ago. They're buying their house on a mortgage and he's still working at the harbour office.'

Gawn's ears had pricked up at the news that Gary O'Neill had a connection to the harbour too. But she supposed it was not so very surprising. It might be how the two had met, nothing more suspicious than that. But it was interesting.

'What about Tracy?' she asked.

'Tracy Morrison, as was, is English. She was born in London and lived there until she married Gary.'

'They didn't meet in Belfast?'

'No, ma'am. He was on some kind of training course in London and they met and clicked. She followed him back here, moved in with him and they were married within a couple of months.'

'And who is this?' Gawn pointed now to the man in the new photograph, not willing to wait any longer.

'That's Tracy's father – Morris Morrison or Little Mo.'

'His parents didn't have much of an imagination, did they?' Grant stage-whispered to Dee. The snigger faded from his face at the look Gawn turned on him.

'Little Mo Morrison is the son of Big Mo, as you might expect, and Big Mo was the top man in one of the main OCGs in London until last year.'

Gawn realised she had heard of him.

'He's well known to the Met. He's done time for robbery with violence but that was a while ago and his son, Little Mo, Tracy's dad, seems to have taken over running things recently now granddad's getting on a bit. Little Mo's managed to keep out of prison. So far. Organised Crime Command are keen to get him. My source says he's a vicious bastard but he's clever and he's feared. No one will grass him up. They're too afraid. They've thought they had him a couple of times but ended up having to make do with lesser fry. And he uses top briefs to tie the police up in knots.'

'Like Joshua Randell,' said Gawn and smiled.

Chapter 51

At last they had connections. Gawn still had no idea why Randell had come all the way to Belfast to attend the dinner or why Tracy had disappeared on Saturday night. Had she gone off voluntarily, part of some plan of her

father's? Because Gawn was convinced Morrison was involved in this, probably the brains behind it all.

Or had Tracy been abducted? Gary had said they had no money so it wouldn't be worth anyone's time to kidnap Tracy, but what about her father? He would have money. Perhaps they were expecting him to pay a ransom.

The door opened and Mark Ferguson walked in.

'Sorry I'm late, ma'am. I was waiting for some results.'

'That's alright. We're on a roll here. I hope you can add to it.'

'Well, we didn't get any fingerprints from the heating or air conditioning systems. Our man wore gloves. Which you would expect. He's a pro. The equipment was very sophisticated. We've removed it but I don't think it'll tell us much. They could control both systems from anywhere. It meant everything could be normal and then, whenever he wanted to turn the heat up, so to speak, he could do it remotely and switch off the air conditioning too.'

'So how does that help us, Mark? Can you trace the signal?' Maxwell asked.

'No. It's turned off. It's served its purpose. But he'd scraped himself on a piece of rough metal. Well, someone had and we hoped it was him. He'd bled. Not much. Just a smear but enough for us to get a DNA profile and that was what held me up. I was waiting to see if we could get a match.'

Neither Gawn nor Maxwell asked the obvious question.

'The blood belongs to a Reggie Weatherup. He's got a record. He's an electronics expert. Not long out of prison. He was serving time for his part in a big robbery in the north of England where some Russian oligarch lost a lot of jewellery. No one's sure exactly how much. He only admitted to losing about five million.'

Grant gave a low whistle. 'Only five,' he said sarcastically.

'Northumbria Police reckoned he'd lost a lot more but some of it he couldn't admit to.'

'You mean he'd got it illegally?' Maxwell asked.

'That's what they suspected.'

'And this Weatherup was caught for it?'

'He was actually caught trying to fence a bracelet from the robbery which must have been his cut. He wouldn't name any of the rest of the crew. He got five years. Out in three.' Ferguson paused and then added, 'And we found Randell's briefcase in the toilets. Empty.'

'Why didn't someone find it before and hand it in?' Maxwell asked.

'Because it was in a locked cupboard, not just stuffed down behind a cistern or anything. There's a corridor with the ladies and gents and a disabled toilet off it. There's a cupboard there with supplies, toilet rolls and cleaning materials and so on.'

'Had it been broken into?' Gawn asked.

'No. It's not usually kept locked during the day. The housekeeper says there's always a number of keys on the go anyway but it's not as if they keep anything very valuable in it.'

'Any sign of what had been in the briefcase, Mark?' Maxwell asked.

'No. We've swabbed it for trace and they'll take it apart in the lab and see if they can get anything useful. It tested negative for any drug residue so it's not that.'

'No sign of an inhaler?' Gawn asked.

'No. No inhaler.'

She smiled at the CSM. They were making progress. At last. Tracy O'Neill had been there to get something from Randell, either with or without his knowledge. She'd got it but what had happened to it and to her afterwards? Where were they now?

'One other thing, ma'am.' Everyone turned to look at Ferguson. 'We've gone over O'Neill's car. Nothing very interesting apart from a cup.'

'A cup?' Maxwell echoed.

'Yes. One of those cups from a drive-thru.'

'And this is interesting why?' Gawn asked.

'Because they contain a mine of information if you look for it. Next time you get one, have a wee look, ma'am. The sticker on the side tells you not only what you ordered but also the number of items ordered so you can tell if the person was alone or with others. It also tells you which outlet the drink was bought at and the precise time to the second. And when you have that information you can get the CCTV from the drive-thru and see who was in the car.'

'Who?' Maxwell asked eagerly.

'O'Neill, of course, and a man,' Ferguson said. 'And before you ask, we ran his image through facial rec. He doesn't have a criminal record but we did a wider check and found him on a watch list. He's Russian. His name's Ivan Goreski.'

Chapter 52

Gawn had been called to Wilkinson's office. She'd been expecting the call.

'You're confident now it's nothing to do with Goodlife?'

'There's nothing to link him with the attack, ma'am. I don't think he was the target and I don't think there's anything political about what happened last Saturday but I have arranged to interview him again over videolink when he gets back from Canada. He told us that he hadn't spoken to Randell but he was in a photograph with him. It may just be he'd forgotten but I'll check. But I think now these are criminals pure and simple.'

'Good. That should get him off my back,' the ACC said and then added, 'but from what you say I doubt very much they're pure and their plan certainly wasn't simple.'

'No. It wasn't. It was like a military operation,' Gawn said.

Somewhere, in the back of her mind, a warning bell rang. She chose to ignore it.

'Do you think there could be some paramilitary involvement?' Wilkinson asked. 'They would have the capability for this, wouldn't they?'

'They would in terms of manpower. But I'm not so sure about the technical side and I doubt they'd use an English criminal like Weatherup to work with them. Plus, I don't think they've been operating on the mainland robbing oligarchs, but I'll check with Intel. There should have been some chatter if they are involved.'

'So what now?'

'We're still looking for Tracy O'Neill. We've upped the checks on the ports and airports. If she wasn't abducted she may be trying to get out of the country or she could be hiding till everything calms down a bit. And we'll need to speak to Sandford as soon as he's in a fit state to be questioned.'

'Any idea when that might be?' Wilkinson asked.

'He's in a medically induced coma and the doctors won't say when they'll try to bring him out of it. I don't think they know themselves,' Gawn admitted. 'I have a guard at the hospital to protect him and to let us know when he's conscious.'

'Good.'

'We'll try Valerie Cosgrove again. We're letting her stew at the minute. I think she has more to tell us. And someone needs to talk to the O'Sullivans. Sandford told us on Sunday that one of them was hoping to come over but there's been no sign of him. He hasn't been in touch. We'll contact him.'

'That would be good. I think Finance would have a fit if you had to go to New York for an interview,' Wilkinson

joked but the concern behind her eyes showed there was little to joke about. She must be coming under a lot of pressure to get this cleared up.

The press was still featuring the story every day. There had been eye-witness accounts and wild speculation in the papers and one of the nationals was running an interview with an actress who had been there under the title, "My brush with death". It was to be the main feature in their weekend colour supplement. Gawn could only guess what the journalists would make of it if they found out about the K2 and the sprays.

'We need to know about their connection with Randell and why they were so keen to have him at the dinner.'

Wilkinson had been nodding her agreement as the DCI had been speaking. 'Anything else?'

'My team are still trying to trace Randell's and O'Neill's movements on Saturday. We know now that at one point O'Neill met with this Russian, Goreski, at a drive-thru at Connswater. And we should find out some more about the man who smuggled clothes in for her although that might be irrelevant. Just her little sideline scam.'

'You have your hands full. You'll be glad to have McKeown back.'

'I am, ma'am, but at the minute she's still with Jaxon Arnold. I'm hoping he may have heard something to help us while the two men were packing the swag bags. We have lots of pieces but I can't quite see how they all fit together. Yet.'

'What about involving Organised Crime?'

That was the elephant in the room. Gawn had been bracing herself for Wilkinson to bring it up. It was obvious to her and to Wilkinson too that this was a well-organised gang and she knew the Organised Crime Unit would want to take over.

'I'll brief DCI Maitland, of course. They may have some ideas but this gang hasn't had a base here before. I'm sure of that. And I don't think they're trying to set one up

now. I think we were just a route they were using for this exchange. A one-off. I'd like my team to work at this a little longer, ma'am. They've been flat out on it and we have made progress.'

Gawn heard her own voice and thought of McKeown's request to investigate Arnold's disappearance. Wilkinson could order her to hand everything over. She examined the woman's face closely in the seconds of silence that followed. She couldn't read which way she would jump.

'OK. Let them know. Everything. Share all you have. Keep them in the loop. Use their contacts but you can keep charge of the investigation. For now.'

As Gawn made her way back to her office she was mulling over some of the things she had said to Wilkinson. She didn't think there was a paramilitary element. She certainly hoped not. That would complicate matters even more. She needed more information about organised gangs in London and she needed it urgently, but she knew there was no point in asking anyone at the Met. She was depending on Mike Lee coming through for her.

Chapter 53

Gawn hadn't had a chance to speak to Valerie Cosgrove again on Thursday. The woman had said she was feeling ill and a doctor had been called to check her over. He had admitted her to hospital for observation. She was under police guard and Gawn knew she wasn't going anywhere. But not to be able to question her was frustrating. Cosgrove had to know more. The fact that she had passed the seating plan to Sandford was hardly enough to be a threat to these people unless Sandford had told her who they were. She could be the

key to this and now Gawn couldn't question her until the doctors said so.

She had spent the afternoon, after her meeting with Wilkinson, with DCI Davy Maitland of the Organised Crime Unit. The two were old sparing partners, often butting heads for resources and because of his opinion of women police officers. He never made any direct comments or criticisms of course. He would never get away with that, but his patronising attitude was clear. She felt the meeting had been rather one-way. Maitland had claimed to have no knowledge of any OCG muscling into the Northern Ireland crime scene. He denied all knowledge of Ivan Goreski too. The name was new to him, or so he claimed. She seemed to be giving out all the information and getting none in return.

It was so frustrating. She needed to know what Mike Lee could tell her. Now.

Before she left on Thursday evening she explained to Maxwell she had some meetings planned for Friday. She would not be in the office but he could contact her if anything happened or O'Neill turned up and she would see him on Saturday morning.

She had been relieved to get away. But she didn't know what lay ahead. If she had, she would never had set foot on the plane.

Chapter 54

Gawn realised it was a mistake as soon as she walked into the hotel lobby. Lee had insisted they meet in person. He refused to tell her anything over the phone. So here she was.

The hotel had barely changed. A new paint colour, some new curtains but still the same hotel where they had spent that one mad weekend. She couldn't have forgotten. And he wouldn't have forgotten either. It must have been buried somewhere deep in her memory, leading her to choose this hotel for her overnight stay.

As Gawn freshened up after her flight, she mulled over where they were in the investigation. They seemed to have reached an impasse. She was waiting for other people to come up with answers. McKeown had got nothing more from Jaxon Arnold. He hadn't remembered anything new but at least he had been discharged from hospital and was going to make a full recovery. That was some good news.

Sandford was still unconscious and it seemed likely he would remain so for at least a few more days if not longer. The Intelligence Branch was now sniffing around the case. And Organised Crime was trying to muscle in as well. They were itching to take over and Maitland would be in Wilkinson's ear.

She needed answers and progress quickly. The pressure on her was mounting. Not least the pressure she was putting on herself. She didn't want to let Wilkinson down or the victims, or O'Neill if she was innocent and being held somewhere against her will. Approaching Lee was risky for all sorts of reasons but she needed information and he was her best way to get it.

She had brought only a carry-on bag with the barest essentials for an overnight stay. She was wearing jeans and a polo-neck jumper and, as she looked at herself in the mirror, she realised the only parts of her skin visible were her face and hands. Everything else was covered up. Quite a contrast to her appearance at the Trust dinner less than a week ago.

There was a knock on the door. She hadn't ordered anything from room service. She planned to get something to eat in one of the local restaurants after her meeting with

Lee. She'd even selected which one, a little trattoria which she remembered served delicious fettuccine.

From long habit, Gawn checked through the peephole. Lee stood there just inches away from her on the other side of the door. If the hotel had changed only a little, he had changed even less. He was still one of the most handsome men she had ever met. His eyes were a soulful dark brown. Looking into them could be mesmerising. He exuded an animal magnetism that she had not been able to resist then. She could now.

Gawn was used to acting quickly, sometimes a little too quickly. Without thinking through any implications, she yanked the door open to face him.

'What the hell are you doing here?'

'We're meeting. Remember?'

A smile played across his face.

'In the Red Lion. Not here. I'll not even ask how you knew where I was staying.'

'Aren't you going to invite me in?' Lee asked.

'No. Wait here. I'll get my coat.'

'You want' – he raised his voice – 'to discuss the Morrison gang out here in the middle of the corridor?'

At the mention of the name, Morrison, Gawn reacted. She hadn't said anything about the Morrisons to anyone outside her team except Wilkinson and Maitland. As far as Lee was concerned she wanted to pick his brains about gangs. She certainly hadn't mentioned the Morrisons to him. In fact, when she'd been speaking to him at first, she hadn't even heard of the Morrisons. Now here was Lee coming up with the name himself. She knew she was on the right track.

Gawn realised there were other people in the corridor. A door had opened directly across from them and a man standing in the doorway was watching them with interest. A family had just emerged from the elevator. She saw their curious glances too.

Gawn reacted spontaneously. She grabbed Lee by the lapel to drag him into the room where no one would hear what he might say next. She had expected to meet some resistance and had used a degree of force. Lee was a big man, but he didn't resist her at all so their momentum had carried them both back into the room.

The door closed behind him with a clunk and she found herself pinned back against the wall unable to extricate herself from under him. She could smell his aftershave, the same brand he had used when they were together. His face was just inches from hers. She felt his breath hot on her skin. Then he pulled back and walked further into the room.

'This isn't the room we had that weekend, is it?' he asked as he looked around.

'No. It isn't.'

She spoke more forcefully than she had intended. She mustn't let him get to her. She needed to keep control of the meeting and keep control of herself. Somehow he had always brought out the worst in her.

'I thought maybe you'd chosen it for old times' sake, darling.'

She didn't reply.

'Aren't you going to invite me to sit down? Forget your manners, darling?'

'I think we'd be better off talking in the pub,' Gawn said trying to keep her voice steady.

'Well, I don't. If I'm going to risk my neck talking about these villains I don't want to be doing it in a packed pub where someone could overhear. Fair enough?'

He had a point, she supposed. Anyway, she didn't want to waste time arguing. She wanted to hear what he had to say and get rid of him as quickly as possible.

'OK. Sit down. Now, what can you tell me?' she asked.

'Always in a rush, darling. I remember how you couldn't wait to get me into bed. There was that time in Southend–'

She cut in. 'I didn't come here to reminisce, Mike. If you're going to help me, then give me the information I want. Otherwise, piss off.'

'Tut! Tut! Manners!'

He was playing with her now. She knew it but she needed to hear what he could tell her.

'Well, at least offer me a drink first, darling.'

He was stalling. She wasn't sure why. Was he trying to keep her here for some reason? Or did he think if he stayed long enough he could charm her into bed? It would be just like him to see her as a challenge. Or was he just enjoying making her suffer before telling her what she wanted to know?

He'd always had a callous streak and he'd had a reputation as a ladies' man even when they were together. She hadn't minded then. She'd been under no illusions about him or about their relationship. She didn't love him, he didn't love her. But they had needed each other. Her life had been a mess; her head all over the place. Lee had offered some comfort, some sense of physical closeness, and of course he had provided those little pills which helped her get through every day.

She would give him a drink, listen to him and then get rid of him as quickly as possible. Even being in the same room as him now made her feel compromised, as if she was cheating on Sebastian.

Chapter 55

Gawn opened one of the tiny bottles from the minibar and emptied its contents into a glass then poured herself some orange juice.

'You remembered. I'm touched,' he said mockingly as she handed him the whisky.

'Now. Who are the Morrisons?' she demanded.

Gawn turned away and sat down on the edge of the bed as far away from him as she could get. She took a sip of her orange juice as Lee started talking.

'They're one of the new mobs that have crawled to the top of the pile of shite over the last few years since you left us. You wouldn't know most of them. They're the next generation. Sons and grandsons, some of them, and some new players too. The hope for the future,' he added sarcastically and smiled before swirling the golden liquid in his glass and taking a sip. 'They're all expensive designer suits and tame lawyers. Manicured fingernails, no dirt on their hands.

'Most of their activities are internet-based – scams, frauds, blackmail – although they do have a nice sideline in trafficked women and prostitution. They have victims all over the world. They run scams on an industrial scale and most of their victims don't even complain, too embarrassed that they've been taken in. But the family does have legitimate businesses as well. They're into shipping and security.'

Gawn wondered how Lee had found out so much about them so quickly. Then she realised, if they were involved in security, they would be his competitors. Had he been investigating them already? She would ask him later. She didn't want to stop the flow of information now but she was struck by his use of the term "the family", just as Sandford had referred to the O'Sullivans as "the family" and Maxwell's jokey reference to the Mafia. But then, the O'Sullivans were family. But so were the Morrisons and Tracy O'Neill was one of them.

Lee was talking again, his eyes never leaving her face. She realised he was gauging her reaction to the information he was giving her. Why? What was he expecting?

'They do carry out some more traditional crimes too. Hijacking, heists. Nothing piddling. It has to be worth their while. Really worth their while. And they use Tilbury as their exit point for any stuff, mostly into Europe but across the pond as well.'

Gawn wondered if it was just coincidental that Lee had chosen to refer to the Atlantic as "the pond". Or was he dropping her a clue?

'Anything recent?' she asked.

'That's the beauty of having a business with no cash flow problems, no investors looking for a dividend, and no accountants going over the books for the taxman. They don't need to rush to get rid of their loot. They can afford to wait until some of the heat's gone off and they can shop around for a buyer with the best price.

'The last really big heist that your erstwhile mates at the Met fancied them for was a big jewellery robbery at a private house in Northumberland over three years ago.'

Gawn thought of Weatherup and his three-year stretch for handling a bracelet from that heist. She knew she was on the right track. The Morrisons were behind what had happened at the hotel last Saturday.

'How big?' she asked.

'The insurance on it was five million plus but the word on the street was that one piece was practically priceless. If they could find the right buyer, it could reach that figure and more by itself.'

'What was it?'

'A tiara belonging to Grand Duchess Olga, daughter of Czar Nicholas II of Russia.'

'The one who was murdered during the Russian Revolution?'

'Yes.'

With one of those light-bulb moments her former boss at the Met had always laughed at her for, she remembered the book lying on the bed in Goodlife's hotel room. What

were the chances he was reading a book about the Romanovs? Was he involved in all this somehow?

'The imperial family took their possessions with them including their jewellery to Yekaterinburg and the story goes that this particular piece had been entrusted to a footman, Alexei Sverlov, who managed to get it out to relatives before they were all killed,' Lee continued speaking like a teacher to a particularly slow student. 'It turned up years later in the possession of a Russian émigré in Paris. When it was stolen it was in the private collection of a Russian oligarch at his country estate in England. Sort of full circle, you might say.'

Lee gave a laugh and took a slug of his whisky, finishing the last of the liquid. He set the glass down.

'And they fancied the Morrisons for it?' Gawn asked.

'Yes. There was a lot of sophisticated security, which is what you would expect with the value of the jewellery, but the thieves managed to bypass it – high tech, which is very much their style. They don't see themselves as thugs unless they absolutely have to be. But when they have to be they can be as brutal as any old-school East End gang. Little Mo Morrison, the boss, is as nasty a piece of work as you're ever likely to come across. Not too many would have had the balls to meddle with this particular Russian. He's regarded as a mobster himself in his own country. And not too many would have the contacts to get a buyer and a good price for the haul. They do.

'But the Met's playing it very close. The Morrisons are a real pain in their arse and they've been trying for years to get something on them. They suspect there's a mole inside the Organised Crime Unit, someone feeding the gang information. They always seem to be one step ahead no matter what they do. They almost got them a couple of weeks back when they were trying to get something, presumably this tiara, out of the country.'

'And they use Tilbury,' she said.

'Sometimes. Yes.'

'And Joshua Randell was their barrister?'

'One of them. He'd represented them a few times. Now what's your interest in this?' Lee asked her.

She wondered, if he knew so much, why he didn't know it was her case.

'Joshua Randell was murdered in Belfast last weekend.'

'That dinner thing?' he asked. So, he had heard of it.

'Yes. He was carrying something with him which went missing in all the confusion. From what you've just told me, it could have been the tiara, although, it could be anything really. Unless you know anything else,' she added hopefully.

'All I know is the word on the street was that the tiara would be out of the country soon but I never heard any details. But if it was the tiara and someone's taken it then the Morrisons will want it back. They'll be after whoever killed your lawyer to get it. You could end up with more dead bodies.'

Gawn wondered about Tracy O'Neill's fate. She believed now that Randell must have been bringing the tiara to pass to Tracy at the dinner. But then why had she gone missing? Was she hiding somewhere or had someone grabbed her? And how did Goreski factor into her disappearance? Was Tracy working with him? Did he have the tiara now and was Tracy dead? Questions. Questions. And more bloody questions. She was more confused than ever.

'Look. I'm hungry. Do you fancy a meal in the hotel restaurant? For old times' sake?' Lee saw her expression and added mockingly, 'Or just because even the great Gawn Girvin needs to eat sometimes?'

He had stood up and so had she. He smiled. He was smooth and he was used to getting his own way. She knew he was trying to be charming. She was long past falling for his charms but she realised she was hungry and she did need to eat. She'd had nothing to eat all day, too wound up about her meeting with him. And he might have more to

tell her, maybe about Goreski. Anyway it would be a good way to get him out of the bedroom.

The door knocked and without thinking, she swung round and opened it.

That was the last thing she remembered.

Chapter 56

Gawn opened her eyes and closed them again instantly. The light was so bright and her head felt as if someone was hitting it with a hammer but from the inside. She opened her eyes again, more slowly this time, and waited until she'd grown accustomed to the bright light. As her eyes focused, she realised she was in her hotel bedroom. She recognised the stripped wallpaper and saw her overnight bag sitting on the floor beside the bed. But it was morning. And she was in bed with no recollection of how she had got here.

Gawn felt a movement behind her and turned round sharply. A stab of pain shot across her forehead when she moved. Mike Lee was lying there, beside her, his bare chest rising and falling gently. He was snoring.

'You bastard.'

She sat up in the bed.

'What did you do?' she yelled.

Gawn punched him on the shoulder. He opened his eyes and looked at her. He seemed to take a moment to focus. Then she remembered opening the hotel room door and she thought she could remember a sickly smell and then nothingness.

Lee had managed to half sit up and was propped up on his elbow rubbing his shoulder with his other hand.

'What did I do for Christ's sake? Why'd you hit me?'

She turned to face him and knelt up on the bed, then realised she was naked and pulled the sheet up to cover herself.

'What do you remember?' she demanded.

He didn't answer right away. Then his eyes opened wider.

'Two men. And a gun.'

Gawn realised they must have been drugged. But why? What was the point? If it wasn't to overpower them to be able to kill them – and it couldn't have been for they were still alive – then why do it? She had no memory of having been questioned if that had been their plan. But who were "they"?

'Did they ask you anything?'

Lee shook his head. He groaned with the effort.

'I don't think so. I don't remember. God, my head hurts.'

He sat up and put his head in his hands.

'Can I have a glass of water?'

Wrapping the sheet around herself, Gawn walked to the minibar. She lifted out a bottle of water and poured it into a glass, all the time thinking furiously. What had happened? She held the glass out to him. She was expecting him to take it but instead he made a grab for her wrist. She reacted and jerked her hand away just in time spilling most of the water over him.

'What the hell are you playing at?' she demanded.

'I thought it was a pity to waste all this. You, me, naked, a bed. For old times' sake.' He smiled.

'There are no old times for us, Mike.'

Her mobile buzzed. It was sitting by the side of the bed and she moved round to pick it up.

'Saved by the buzzer, eh, Gawn.' He joked and took a drink of what was left of the water. He seemed to be finding their situation amusing.

Gawn picked up her mobile and looked at the screen.

'Bad news?' Lee asked when he saw her expression.

'I don't recognise the number.'

'Probably just spam. Or maybe it's something important to do with your case. Read it and see,' he suggested.

She scrolled down the text.

'Funny time…' But she didn't finish what she was going to say. Her eyes had opened wide in horror. The colour had drained from her face. She dropped the phone on the bed and ran to the bathroom.

By the time she'd finished throwing up and made her way back, Lee was sitting on the side of the bed scrolling through the pictures on her phone.

'They did quite a job on us, didn't they?' he said.

'Who would do this?'

'Your husband isn't looking for a cheap divorce, is he?'

Gawn was so surprised at his comment that she didn't even question how he knew she was married.

'No.'

'Then my guess would be it's the Morrisons warning you off,' he said.

'But how would they know about me? Did you tell anyone?' she demanded angrily.

'I'm a professional. Of course I didn't, but I did have to ask around to get the info about Randell for you. Someone might have put two and two together. That's all I can suggest. But maybe the leak came from your side.'

'I didn't tell anyone I was meeting you.'

'I'll bet you didn't,' Lee said snidely. 'Well, however they found out, the message is obvious. Back off. They couldn't put it any more clearly.'

'God, this is like some bad B-movie from the 1950s,' Gawn said and put her head in her hands.

'I think something like this did happen in a film I saw once,' Lee said. 'Torrid stuff but if I remember correctly the woman in the movie woke up beside a stiff. At least they didn't follow that script too closely. Thank God.

They're not very original, are they?' Lee asked. He almost seemed to be enjoying himself.

'I'm glad you can joke about this, Mike. It won't do your reputation any harm if these pictures get out. But it's no joking matter to me. What if they send them to Sebastian?'

'Your husband?'

She nodded.

'Wouldn't he believe you if you told him what happened?'

'Yes, of course he would. But what if they sent them to my bosses or the newspapers?' she asked.

'Do many chief inspectors get the boot for having extramarital sex these days even if it is a little kinky? I would have thought with all the pressures in policing, it's practically part of the job description now. Professional Standards must see this sort of stuff all the time. They can't dismiss someone for this, otherwise they'd have no staff left.'

'Well, the papers then?' she asked not comforted by his reply.

'I don't know what your rags are like in Belfast but you're hardly front-page news and I'm certainly not. Now if you were a princess or I was a famous footballer it might be different.'

She knew he was trying to be consoling. At least she thought he was but it wasn't really helping.

'Let's just count our blessings, Gawn. If we'd been a problem to these guys twenty years ago they'd have been dredging us out of the Thames this morning with a bullet in the back of our head.'

Chapter 57

Gawn spent the whole flight across the Irish Sea lost in thought, staring out of the cabin window but seeing nothing.

She sat silent, but inside she was screaming with rage. She had dug her nails so hard into the palms of her hands to control her emotions that she had drawn blood. She felt violated but, most of all, she was angry. With Mike Lee. With the Morrisons. With herself.

She walked back to her car where she had left it in the long-stay car park less than twenty-four hours before. She took out her mobile phone and made two calls. Then she set off, her wheels spinning on the loose surface of the car park.

* * *

'My God, Gawn, you look awful. Come in.'

Anne Wilkinson stood back to let Gawn walk past her. They were not at police headquarters but in Wilkinson's home. Her apartment, on the site of a former convent overlooking playing fields in South Belfast, had earned her the nickname, among the ranks, of "Mother Superior".

'Sit down. Let me get you a drink.'

Wilkinson hurried out of the room and came back with a glass half full of liquid.

'I don't know if I should, ma'am. I'm driving.'

Gawn was perched on the edge of an armchair in Wilkinson's living room. She looked up at her boss as she spoke. There were tears in her eyes.

'No, you're not, my dear. You're staying right here. I have a spare room. Quite apart from any alcohol I might give you, you're not in a fit state to drive.'

Gawn took a sip of what she quickly realised was brandy. She could feel it warming the back of her throat as she swallowed. She allowed herself to sink back into the armchair and closed her eyes for a moment as the liquid began to work its magic, or maybe it was just the sense of relief and safety she was feeling.

'You don't have to tell me anything, Gawn. I won't pry but, if you want to, I'm a good listener and I can keep secrets, so long as it's nothing illegal, of course,' Wilkinson added and smiled keen to lighten the mood.

Gawn looked up at her boss again and smiled back. Her second phone call had been to Wilkinson. She had simply said the words, 'I'm in trouble.' Just that. But the reaction had been immediate. Without hesitation, Wilkinson had told her to come to her home. She was off duty. They could meet there. No one else needed to know. She gave her the address. Gawn already knew she lived alone. Her family had never relocated since her appointment as ACC. She travelled back to England once or twice a month to see them. Gawn was just grateful this wasn't one of the weekends she was away.

She took another slow sip of the brandy, her hand shaking as she raised the chunky glass to her mouth.

'I was in London. And this happened.'

She set the glass down very deliberately and reached into her pocket and lifted out her mobile. She glanced down and saw how much the hand holding the phone was shaking. With difficulty she selected a text, then held the phone out to the ACC and watched her face carefully as Wilkinson looked first at the screen and then back at her.

'Keep going. There's more,' Gawn said.

Wilkinson breathed in sharply as she scrolled through the pictures.

'Dear God. Is this some kind of revenge porn? Have you just split up with this man?' Wilkinson asked.

'No. No. This happened last night. I haven't seen Mike for years and we never took any pictures like that. This wasn't consensual. I'd been drugged.'

The look of concern on Wilkinson's face deepened.

'Who is he?' she asked.

'His name's Mike Lee. We were lovers. A long time ago.'

'And you were meeting him in London this weekend?'

'Yes. But not for sex. Not to rekindle our relationship.'

In different circumstances that thought would have made Gawn laugh. She had no feelings for Mike Lee now. Perhaps she never really had.

'Then, why meet him?' Wilkinson asked.

'To get information. For the HATP case.'

Wilkinson sighed and sat back in her chair still holding Gawn's phone.

'Mike runs his own security business. He was Military Intelligence. That's how we met. We were both going through rehab after Afghanistan. He always had contacts. He used to know all the villains when I was at the Met. He mixed in their circles. He could always get information for me.

'I wanted him to suss out if anyone could be planning to use Belfast to move stolen goods abroad and who would be crazy enough to risk killing so many people so randomly. The Met has been stonewalling me, ma'am. I thought at first it was just that they didn't want to deal with a junior officer because I'd asked Grant to phone them. But Pepper and Logan got nowhere with them either.'

Wilkinson handed the phone back. She was obviously considering what she should ask next.

'You met this man in a hotel room?'

'Not by choice. I'd arranged to meet him in a pub but he turned up at my door.'

'And the handcuffs? Are they yours?' Wilkinson asked.

'No. I didn't take anything with me, no handcuffs, no gun, nothing.'

'What do you remember, Gawn?' the ACC asked.

Gawn didn't have to think about what to say. She had been going over and over it in her mind already.

'We were talking. He'd told me about the Morrisons. He brought up the name. I hadn't mentioned anything about them so it was confirmation that that is who's involved. I think I was insisting we go downstairs to finish off our chat and then the door knocked and after that it's just a blank.'

'What about Lee? Was he still there with you this morning?'

'Yes. He couldn't remember anything either.'

'Could it have been someone targeting him rather than you? Maybe someone he'd crossed in his line of work?' the ACC suggested.

'Why would they send the pictures to my phone? They would have sent them to him. Anyhow, he more or less shrugged it off. It didn't worry him. He seemed to think it had to be the Morrisons and that I was the target.'

'Would they really go after a police officer like this?' Wilkinson asked.

'They went after us all at the hotel. The swag bags, yours, mine, the others' all had K2 in the spray bottles. Mike's take on last night was they were trying to be more subtle than putting a bullet in the back of our skulls like the good old days.'

Wilkinson sucked in her breath sharply.

'That would have attracted too much attention,' Gawn added.

Wilkinson stayed silent for a minute thinking about what Gawn had just said.

'I take it you haven't reported any of this to the police in London?'

'No.'

'And you don't want to report it now?'

'No. I don't think it would do any good. Whoever drugged us and took the pictures was paid. It wasn't personal.'

'These people, whoever they are, haven't demanded anything?' Wilkinson asked.

'The only message I got is what you see. "Stay out of it."'

'The hotel must have CCTV. We could get it checked,' the ACC suggested.

'I already checked. Their security system was down last night.'

'Very convenient.'

'But not surprising. From what Mike told me it seems the robberies the Morrisons carry out are very high tech. Bit like last weekend. Disabling a hotel CCTV would be child's play to them. I only wonder why they didn't do that at the Royal Holywood as well. If what I suspect is correct and they took the Romanov Tiara, then they had to bypass an oligarch's top-notch security system to get it. The hotel in London would have been a piece of cake in comparison.'

'The Romanov Tiara?' Wilkinson frowned. 'That rings a bell. I remember something about that from before I came here. I wasn't involved in the investigation but I remember it was big news and my colleagues couldn't get anywhere with it.'

Gawn recounted what Lee had told her about the robbery and the provenance of the tiara and its value.

Wilkinson listened carefully. When she spoke next, it was to change the subject completely.

'What about seeing a doctor, Gawn?'

'I already have. I phoned Jenny Norris and saw her before I came here.'

Dr Jenny Norris was her friend and the assistant chief pathologist.

'She did a rape kit and she'll keep it safe if I need it for evidence. And she took a blood sample. It was recent enough that there might still be traces of whatever they used in my bloodstream. Worth a try anyway. She's going to run that for me under a false name just in case someone puts two and two together. And she prescribed the morning-after pill for me.'

Seeing the look on Wilkinson's face, Gawn added, 'Seb and I have been trying to start a family. I'd stopped using any contraception. It would be the worst of ironies if I happened to get pregnant now, like this. I wouldn't be sure who the father…' Gawn's voice trailed off.

'Don't even think about that, Gawn. What you need now is a good night's sleep. Another couple of brandies should help. Tomorrow, you can start to figure out what you want to do. No need to make any hasty decisions tonight. If you decide you'd like someone else to take over the case and have some time off, I'll understand. Organised Crime could step in. There'll be no questions asked and no comeback. I'll see to it.'

Gawn was sure Davy Maitland would be only too happy to take over. At that moment she realised Anne Wilkinson really didn't know her very well at all. Only a bullet in the back of her skull would be likely to stop her now.

This was personal.

Chapter 58

Gawn had slept well. The brandy had worked its magic. The ACC had spoken to her before she left in the morning and ordered her to take the day off. The PSNI wasn't going to grind to a halt if she wasn't there for a day.

She had taken a long time standing in her rainforest shower as soon as she got home, enjoying the water cascading over her face and body, trying to feel clean again. She wanted to wash away any sign of what had been done to her. But in spite of her best efforts, her tears had mingled with the gushing water and coursed down her face unchecked.

And she hadn't been able to forget about the case. Of course. Exactly the opposite. The break from the office, the ringing phones and the conversation of the other detectives, had allowed her to concentrate on it without interruption. She had arranged all the facts they'd established along with everything she suspected on stickies and put them all over the wall in her spare bedroom. She created a timeline of events which extended back to the jewel robbery in Northumberland. As she stepped back and surveyed the colourful squares of paper dotted over the wall like a multi-coloured rash, she saw so many question marks.

How much did Valerie Cosgrove really know? She was obviously terrified but Gawn suspected that was because she knew more, more than she'd told them. Could someone be afraid she could name them? Was she really in danger? Or was she taking them for fools?

The attack on Sandford suggested he was involved, but how exactly? Who was he working for, other than the HATP? The Morrisons? How had he got involved with them? And how did Goreski fit in to it all?

And the big questions. Where was Tracy O'Neill? Was she dead or alive? And who had killed Joshua Randell?

Questions, questions and more questions. As she stood and surveyed the wall, Gawn thought she was beginning to see some pattern. But then she doubted herself. She thought she had rushed to wild leaps of conjecture. And she began to doubt everything. She even doubted her ability to lead her team. How had she allowed herself to be compromised like that in London? What happened to her

should never have happened. She should have seen it coming. She shouldn't have allowed the pressure she was under make her take rash decisions.

But she was convinced of one thing, the missing woman was central to it all. They had nothing to link O'Neill with anything other than her strange behaviour in disguising herself to leave the dinner and her subsequent disappearance. Except of course her family connections. Perhaps she had been running away. Perhaps she had planned to leave her husband. Perhaps Randell and she had been lovers. Perhaps. Perhaps. Gawn hated that word.

And none of it explained the briefcase. They needed to know for sure what had been in that briefcase. Was it the tiara? And, whatever it was, where was it now?

Gawn glanced out of the window and was surprised to see it was getting dark outside. She had been mulling over everything for hours and getting nowhere. She realised she was hungry. She made herself an omelette and carried it and a glass of wine into the living room. Sebastian would be pleased that she had cooked something for herself, she thought. He normally did the cooking for them. She existed on takeaways and food from the freezer prepared by Martha, their cleaning lady. Thinking of Sebastian brought a frown to her face. She would have to tell him.

She was about to take a bite of the omelette when her phone rang. No one had rung all day. She imagined Wilkinson had warned Maxwell not to disturb her and Jenny would be giving her space, knowing she would be in touch if she wanted to talk. She jumped when it rang and sat looking at it suspiciously as if it might explode.

She picked it up and looked at the caller ID. It was Mike Lee.

'What do you want?'

'And good evening to you too, darling.' His voice was cheery. 'I just thought I'd check how you're doing.'

'How do you think I'm doing? I was raped.'

'Are you sure? I don't think I raped you. Looked like you were the one taking the lead in the photos I saw.'

'I was raped,' she shouted down the phone.

A suspicion flitted through her mind. Did Lee seem almost too pleased with himself? He seemed to be enjoying her distress and for one second she wondered if he could have been involved. She only had his word for it that he couldn't remember anything. He could have arranged it. But did he really hate her that much? She remembered Wilkinson's immediate reaction that the photographs were revenge porn.

'I thought you'd like to know I did a bit of digging today.'

In spite of herself, she couldn't help asking, 'What did you find?'

'The Morrisons were definitely planning to move something out of the country and my informant assures me it was the Romanov Tiara. They needed a new route and a new courier. All their usual people were being watched and all the ports and airports they'd used in the past. They'd tried a couple of weeks ago to do the exchange and nearly got caught. Word was they were going to use a brief to handle the exchange this time and some new route.'

'Randell?' she asked.

'He didn't have a name for me but I found out that Randell had a drug problem. He was in to the Morrisons for a lot of money and they would expect to be paid off one way or another.'

'What about Morrison's daughter?'

'Daughter?'

'Tracy. She disappeared at the hotel last Saturday. You didn't hear anything about her?' Gawn asked.

There was a very slight hesitation before Lee answered.

'No. Nothing. But, if I hear anything, I'll let you know.'

He rang off and Gawn found herself wondering why he'd really phoned. Why had he told her about Randell and

the Morrisons? And how come he didn't know anything about Tracy when he knew so much about everything else?

More questions.

Chapter 59

Gawn poured herself another glass of wine. She thought she might need it. She was sitting on a cushion in front of the fire, her arms around her drawn-up knees losing herself in the flickering flames, thinking of anything but what she had to do next.

The darkness outside was comforting, almost as if she was alone in a world asleep. She hadn't drawn the curtains, preferring to let the lamps along the marina walkway provide some dim illumination. She didn't want bright light. Darkness was her friend.

She set her laptop carefully on the table. Her actions were slow and deliberate. She knew she couldn't put off the call much longer. Seb would be waiting and he was already suspicious. He had commented during their last phone call on Thursday, just after she'd booked her flight to London, that she seemed distracted and he thought her voice sounded a bit strange. He had asked several times if she was OK until she had snapped back at him, which had put an end to his questions and their conversation.

But she couldn't put off calling him. She didn't know how he would react when she told him what had happened. She hoped he wouldn't be angry and blame her for putting herself in danger. But what if he didn't believe her? Then a thought struck her. What if he already knew; if they had already sent the photographs to him?

Her fingers felt leaden as she held them over the keyboard. She was just about to type her password when a

scuffling, scraping sound outside her door stopped her hand in mid-air.

Security in the apartment block was tight. It was one of the reasons she had chosen to live here. It must be her neighbour, Rhoda. She and her husband, Billy, were moving to live in a granny flat. Billy had already put a note under her door earlier in the week to invite her to drop by for a farewell drink tonight. She had made a vague promise to herself to try to get over. They were nice people. Now Rhoda was probably here in person to repeat the invitation.

Gawn crossed to the door glad of any excuse to defer the video call. She checked through the peephole. She wasn't going to be caught out again. She froze. Sebastian was standing there searching through his pockets. Almost unwillingly, on some sort of automatic pilot, she opened the door.

He looked up.

'Surprise!' he shouted.

He flung his arms open, took a step into the room and enfolded her, pulling her tightly into his body. Gawn inhaled the so-familiar smell of black pepper and coriander from his favourite aftershave and for a few seconds forgot everything else as she allowed herself to feel secure in his arms.

'What the hell are you doing here?'

She hadn't meant to sound so angry but was aware she did as she pushed him away.

'Not exactly the welcome I was expecting, babe.'

He moved forward again and went to kiss her but she sidestepped him.

'What's going on, Gawn? And don't tell me "nothing".' He had a worried frown on his face. 'Because I know there is. Do you have someone else here with you?'

She almost laughed at the idea.

'I know there's something you're not telling me.' He paused a beat. 'Is this about the baby? Are you having doubts again?'

'No. Of course not.'

There had been a time when she had been reluctant to consider having a child with him and its effect on her career but not now.

'Before I tell you, I need to ask you something. Do you love me?'

His face creased in surprise.

'You have to ask? Seriously, Gawn? Of course I love you, babe. I've just flown six thousand miles to see you because I'm worried about you. That must tell you something about how I feel.'

'It's not just sex, Seb, is it? You love me for more than that?'

'What? Of course, it's not just sex. I love you, all of you. You're a complicated crazy woman who drives me mad worrying about what you'll get yourself into next. If it was just sex I could have got some blonde model who would sit at home fawning over me, not prefer chasing after criminals than being with me.'

'And nothing will ever change that, Seb?'

'Now you have me really worried, Gawn. Nothing will ever change how I feel about you. I'll love you no matter what, remember? I promised you that.'

He hadn't taken his eyes off her face.

'Then there is something you need to know.'

Chapter 60

Gawn told him everything, showed him the photographs and waited for his reaction.

He had been silent for what seemed like a long time. Shock and anger and distress, waves of emotion passed across his normally sunny features. His eyes had welled up and he had punched the sofa they were sitting on

repeatedly, more angry than she had ever seen him. And then he had just reached out and held her, tightly, for a long time as if he never wanted to let her go again. She wasn't sure if it was to comfort her or himself.

He had made no move to initiate intimacy between them when they had gone to bed. Just a chaste goodnight kiss on the cheek, almost like strangers, and she wondered what that meant. In one way she had been relieved. She wasn't sure how she would feel if he had tried to make love to her. She hoped it meant he was being considerate of her, giving her time to come to terms with her ordeal. She had slept fitfully and been aware he was tossing and turning too.

When she woke, Seb was sitting with his back to her on the side of the bed scrolling through her phone. She slipped out of the sheets and moved to sit beside him. She reached out and put her hand on his arm.

'Please, don't look at them anymore. Please, darling. We need to forget it. Put it behind us,' she pleaded.

'No. I think I've found something,' Seb said and turned to face her. 'Look.'

He held the phone out and waited. In the picture Gawn's face was hidden behind a sheet of auburn hair falling forward as she straddled a man handcuffed to a bed. But her naked body was all too visible.

Gawn didn't want to take the phone from him; didn't want to look at it again.

'I know every inch of your body, babe.'

He put his hand on her leg and ran his thumb gently over the scar on her knee, the scar she had got from being run off the road on a case in the Netherlands. Her stomach flipped at his familiar action.

'No scar,' he said simply.

Gawn sat up and grabbed the phone from his hand. She enlarged the image. There was no scar on the naked figure's knee.

'What does it mean?'

'You're the detective, not me, babe. But I don't think that's you. In fact, I'm sure it's not. It's someone in a wig. You can't see a face, can you? In any of the pictures?'

'What would they gain from doing this?' she asked of no one.

Suddenly she threw the phone aside and put her arms around him pulling his face close to hers. Then she kissed him. Gently at first but then with an increasing hunger as she felt him respond. Their tongues touched. It felt like her memories from childhood, that first fizzle of sherbet in her mouth, her senses exploding.

'Don't you have to go to work this morning?'

He was only half-smiling as he spoke. She knew he must be thinking of all the times he had tried to cajole her to stay with him when she had been rushing away to work, prioritising her job over him.

'Perhaps I could be a little late, just this once.'

* * *

'I'll make us some breakfast,' Seb said and kissed her before sliding out of bed.

Gawn lay back and smiled contentedly. Everything was alright. More than alright.

She didn't know what the posed pictures meant but she couldn't help feeling relieved that she hadn't done those things even in a drugged condition. Now all she had to do was find Tracy O'Neill and whoever had killed Randell and tried to compromise her and then get this case closed. As soon as possible. It had thrown up too many old memories for her. These were dangerous people who would stop at nothing.

She listened to the sounds coming from the kitchen. Normal sounds. Comforting sounds. Far away from murder and vicious criminal gangs. Seb was opening cupboards and clinking cups as he made them coffee. Then his voice came from the other room and his question surprised her.

'What were you doing with my books, babe?'

He didn't sound angry, just surprised. She never interfered with his books.

'Your books?'

'Yes. Why did you move them?'

He had lots of books so they had overflowed from the spare bedroom and were all around the living room in low bookcases which didn't match her décor. It was a temporary arrangement. But she didn't mind. They were a comforting reminder of him when he wasn't there, something solid and real.

Gawn was standing in the doorway watching him now. She couldn't help smiling at the care he was taking to get his books in just the right order.

'Are you sure you didn't move them?' he asked again looking over his shoulder at her.

'I swear I never moved any of them, darling. Honest. It must have been Martha.' She held up her right hand as if she was taking an oath in court.

'No. It wouldn't be Martha. She knows better than to mess with my books.'

She saw him picking something up and looking at it.

'What's this?'

He was holding out a tiny piece of black plastic to her. Gawn walked across and knelt down beside him. She looked at the tiny object lying in the palm of his hand.

'Is it part of our TV system? Did you get something new added to our satellite package?' Seb asked.

She hadn't had anything done to the electrics or any of the systems in the apartment. She was thinking furiously. Then she stood up and put her hand on his shoulder and applied just a little pressure, just enough to get his attention. When he looked up at her, she shook her head and put her finger to her lips warning him to say nothing.

Chapter 61

Gawn led Seb into the bathroom and turned the shower and taps on full. Once the sound of rushing water was drowning out other noises, she put her mouth close to his ear and explained what she suspected. She borrowed his mobile phone then and went out onto the balcony to make a call.

Within thirty minutes a team had arrived from Seapark, the PSNI forensic facility just outside Carrickfergus. Both Gawn and Seb had dressed hastily awaiting their arrival. They planned to have breakfast at a nearby restaurant while the technicians checked the apartment.

Before they left the building, Gawn had knocked on her neighbour's door. Billy opened it. He looked a little harassed and Gawn remembered this was the day the couple were moving.

'Sorry to interrupt you, Billy.'

'No problem. I'm glad to get the chance to say goodbye. You didn't get over last night.' Then he noticed Seb standing in the corridor. 'Seb. You're back home. Good to see you.'

They refused an offer of coffee. Gawn wanted to get away and anyway, the couple would have plenty to do.

'You didn't see anybody around my apartment in the last couple of days, did you?' Gawn asked. Rhoda had joined her husband at the door.

'No. I don't think so. When do you mean exactly?' the woman asked.

'I'm not really sure,' Gawn had to admit. She had no idea how long the bug, if that was what it was, had been in position.

'We made ourselves scarce on Friday when the work was being done,' Billy told them. 'We didn't want to be in the way so maybe someone could have been around then.'

'Were you getting some work done for the move?' Seb asked.

'No, the maintenance work,' Billy told them as if he expected them to know what he was talking about.

'What maintenance work? Was there a problem in your apartment?' Gawn asked.

'No. You know. The work the management company arranged.' Billy saw the puzzled look on Gawn's face and added, 'You know, the letter.'

'What letter?'

Billy walked back into the apartment and emerged with a single sheet of paper in his hand.

'I assumed we'd all got them,' he said.

Gawn read the letter, with Seb peering over her shoulder. They could see from the letterhead that it purported to be from the management company and warned that a crew would be working updating security arrangements because of an attempted break-in at one of the other apartment blocks in the area. As a result, all burglar alarms would be off for a period of time on Friday and the crew might need access to some of the apartments.

'I didn't get this letter. May I keep your copy?' Gawn asked.

'Of course, my dear. We don't need it.'

Gawn and Seb said their goodbyes to their neighbours and promised to keep in touch. Then, clutching the letter, they made their way to Grandpapa Joe's for breakfast.

Chapter 62

It hadn't taken long for the technicians to confirm Gawn's suspicion. The little black box was a listening device. Sweeping the whole apartment had taken a little longer so they weren't quite finished by the time Gawn and Seb arrived back.

Inspector Curtis Allen of the Security Branch met them at the front door.

'It's what you thought, ma'am.'

'Have they found others?' she asked.

'One in the bedroom and the phone was bugged. They're just doing a final sweep now to make sure nothing's been missed.'

'No cameras?' Gawn asked hesitantly. She was aware her voice sounded forced. She could see a look of concern cross Seb's face. The thought that someone had been listening to them last night as she had confessed everything to him and this morning in bed was bad enough, but after her experience in London, she worried that they might have been filmed and someone had watched them as well.

'No. No cameras, ma'am,' Allen assured her.

A white-suited figure emerged from the doorway behind him.

'That's us finished inside now, sir. Just the three.'

'Do you know who was listening?' Gawn couldn't help asking although she knew they would have a lot of work to do to identify the technology and try to find the source.

'Too early to know, I'm afraid. We'll take them apart. They're very sophisticated, I can tell you that. Must be absolutely the latest model. I haven't seen any like them before. Foreign. Probably Russian or Chinese. They're the

masters at this sort of thing. A quick job once it was all set up and ready to go, you just needed someone to be able to get inside and leave it somewhere unobtrusive.'

As the technician spoke Gawn heard echoes of Mike Lee's words to her about the Morrisons and their high-tech crimes. Was it them again? Could they have set up the bugs as a backup if their threat in London didn't work? Only Seb's meticulous system with his books, which made no sense to her but perfect sense to him, had given them away. If he had not returned home this weekend to check on her, she would have been oblivious and someone would have heard everything she said in the apartment or on the phone. But what she didn't understand was what they hoped to learn from bugging her.

'We did a quick check of your car too,' the technician informed her. 'There was another of the wee buggers there, if you'll excuse the expression, ma'am, and a tracking device as well. We're just going to remove them now.'

'No. Don't.'

Chapter 63

No one looked up as Gawn walked into the noisy incident room. Everyone was busy.

Maxwell noticed her.

'Morning, boss.'

He sounded just the same as always, but normally when she'd had a day off he would ask if she'd had a good time. She waited, expecting it. The question didn't come. She was confident Wilkinson wouldn't have told him anything about London but she must have said enough to warn him questions were off limits.

'Good morning, Paul. Sorry. It's almost good afternoon, isn't it? Seb was over for a quick visit.' She wouldn't normally have offered an explanation but she thought it might stave off any speculation.

And it did.

'Oh, that's what you were doing,' Maxwell said and smiled.

She didn't contradict his assumption.

'Bring me up to speed on the case please, Inspector.'

Even to her own ears she sounded abrupt like the Ice Queen of her early months in the job when her demeanour had been designed to keep everyone at bay. It had earned her the reputation as a cold bitch. She hadn't sought friendship nor understanding then; she certainly wasn't now.

'There've been quite a few developments. We've found the taxi that picked up O'Neill.'

'Did the driver tell us where he'd taken her?'

'We only found the taxi. It was burned out at the back of Cave Hill. They're trying to get the VIN number but I would guess it was stolen and even kids on the street know about fire destroying evidence. But Walter took it on himself to have a look at traffic cameras in the area. I think he's still trying to make up for missing O'Neill at the hotel. He reckoned whoever dumped the taxi would either have been picked up or would have walked somewhere and there wouldn't be too many about up there in the middle of the night.'

Gawn wasn't hopeful they'd get anything from the burned-out taxi. This gang left nothing to chance. No easy clues. But her ears had picked up as she listened to Maxwell.

'And did he spot anyone?' she asked.

'Yes. Gary O'Neill walking down Antrim Road.'

'Gary O'Neill! He picked his wife up from the hotel? He was involved?'

Before she could say anything else, Maxwell was speaking again.

'But there's a bit of bad news, I'm afraid. O'Neill did a runner.'

'What!' Her single-word response sounded angry. She was angry and she didn't care who knew it. 'How? Didn't we have someone with him? Didn't you bring him in when Walter identified him?'

'He'd asked the FLO to leave. It wasn't her fault. He told her he wanted to visit his sister in Bangor.'

All this had been happening while she had been distracted by events in London and wallowing in self-pity, she realised.

'And we just let him walk away?'

'No. I wasn't sure whether you'd want him picked up or followed. Wilkinson had told me you weren't to be disturbed under any circumstances so I went to her and told her what we'd found and she approved a surveillance team. We just missed him according to his neighbours.'

'How long has he been in the wind?'

'Not long. Just a couple of hours. We found him quickly. We'd been monitoring his phone in case of a ransom demand. He's holed up in a guest house on Ormeau Road. He'll not be going anywhere without us knowing. Wilkinson said to wait until you were back to decide what to do about him.'

'Have we traced his recent calls?'

'Yes. He had one incoming and then he made one. First was a two-minute call from Ivan Goreski's burner phone.'

'Goreski again! How's he connected to Gary O'Neill? He can't have been delivering a ransom message if she wasn't kidnapped.'

'They were able to trace Goreski's phone and we've been tracking him every time it's been turned on. He's been in Belfast. We got him on CCTV near the Big Fish.'

Maxwell stepped aside then. He had been blocking her view of the incident board. Now she saw a new photograph on it. It was of two men standing by the colourful fish sculpture along the bank of the River Lagan. One was Goreski.

'We haven't been able to identify who he was meeting yet. Are you alright?' Maxwell had broken off what he was saying as he saw Gawn's expression.

For an instant she had thought she was going to faint. She knew Maxwell had noticed her reaction.

'I can. His name is Mike Lee.'

Chapter 64

Maxwell had insisted on bringing Gawn into his office and getting her a glass of water. She realised he'd noticed her reaction to the photograph. He couldn't have missed it.

She quickly pulled herself together.

'What about O'Neill's other call?' she asked, keen to gloss over what had just nearly happened.

'A burner.'

'Did they trace where it was?'

'Somewhere around the dock area,' Maxwell answered.

'Yessss! Near McKinty, I bet.'

She didn't quite punch the air, but she felt like it. Now it was all coming together. And it all centred on McKinty.

'I bet he was phoning his wife. I think it's time to pull O'Neill in now. He has a lot of questions to answer.'

* * *

Gary O'Neill sat staring at the door. His face was even more ashen than when Gawn had met him before. If that was possible. She knew he had no criminal record. He had

probably never been inside a police station before, never mind spent time sitting in a holding cell contemplating his fate. She reckoned he would be easy meat.

'Good cop, bad cop, boss?' Maxwell asked.

'I don't think that'll be necessary. He'll be falling over himself to help us.'

'Even if it means giving up his wife?'

'He's not a hardened criminal, Paul. Tracy was brought up in that life. She'll have been the driving force in their little plan. Whatever it was. I expect him to be glad to talk. He's been sitting for over a week with nothing else to think about. He's been in over his head,' Gawn assured him.

'Remember me, Mr O'Neill?' Gawn asked as she sat down opposite him.

It was clear from the man's expression that he did.

'You've been lying to us from day one, haven't you, Gary? So, no more messing me around. We've wasted enough time on you. Where's your wife?'

'I don't know.'

His head was down. He didn't look at her but Gawn could see a line of sweat sitting on his upper lip like a liquid moustache.

'Really? Let me put it another way. Where did you leave her after you'd picked her up at the hotel? And don't say you didn't, for we have you on CCTV dumping the car.'

He looked up and met her eyes for the first time then. She read defeat and fear in them.

'It wasn't my idea.'

'What wasn't, Gary?' Maxwell asked.

'Any of it. That friggin' tiara. I didn't want anything to do with it. I wish we'd never agreed.'

'Start at the beginning, Gary. How did you know about the tiara in the first place?' Gawn asked.

'Tracy's dad. He phoned her. Out of the blue. Said he needed her help. He had something worth a lot of money and he wanted it picked up and delivered. He said he

didn't have anyone else he could trust. He offered her £50,000. Easy money, he said.' There was a sneer in his voice.

'Who did she have to pick it up from?' Maxwell asked.

'Some man at that dinner. She'd been given his name.'

'Joshua Randell?' Maxwell said.

'Yes.'

'Why there, Gary? Why not somewhere else, somewhere private?' Gawn asked.

That question had been annoying her all along. They could have met in a car park, somewhere away from everything and everyone to pass the stolen goods on. Why choose a high-profile public dinner?

'For safety. Mo thought out in public, lots of people around, was safer. He knew all his usual people were being watched. The police in London were onto him and some Russian is after him too. One of his gang was beaten up a couple of weeks ago. Nearly died. Mo wanted it done here so no one would know who'd got it or where it was going to be delivered. And he didn't trust that man either.'

'Randell?' Maxwell asked.

'Yeh, him. He thought he was going to shop them all. Mo had it all arranged for the hotel. Some old pal planned the handover for him so no one would know when it took place or who got it. There was to be some kind of a diversion and that would let Tracy get the tiara and get out.'

Gawn knew exactly who "the old pal" was.

'Wasn't he going to just give it to her?' Gawn asked, puzzled.

'That was the original plan but Mo thought he'd got cold feet. They'd been listening in to his phone calls. Randell had been in touch with some old friend and Mo said he was planning to hand himself in. He thought it could be a trap. Then some scary Russian turned up on Saturday afternoon. He picked Tracy up in the street on

her way back from the hairdresser's and made her an offer she couldn't refuse.'

He gave no indication of the irony of the phrase he had used.

'Goreski?' Maxwell said.

Gary looked surprised that they knew about the Russian.

'Yes. Him. He knew she was getting the tiara. He wanted her to pass it to him when she got it. What were we supposed to do? If she did what Mo wanted, the Russian said he'd kill her and take it anyway. If she didn't do what Mo wanted, Mo would go crazy and she'd seen what he could do to people who crossed him. She didn't think being family would save her. And we were worried you lot could be watching too.'

'So, what did you decide to do?' Gawn asked.

O'Neill looked her straight in the eye for the first time and said, 'We decided we might as well double-cross everybody.'

She was stunned at his words. She and Maxwell exchanged a look.

'Take us through what happened at the hotel, Gary,' Maxwell asked.

'Tracy said it seemed to go OK. At first. She lifted Randell's briefcase when he was being photographed as arranged and hid it in a cupboard. She knew there was going to be some kind of a diversion but she didn't know what it was. When it started she was to get the tiara and get out. When people started collapsing, she realised that was it. She went to the cupboard but the briefcase was empty. The tiara wasn't in it. Someone else must have taken it.'

'So what did she do?' Gawn asked.

'She followed the plan. She dumped the briefcase and came out to me.'

Gawn believed him. He had fooled them when he reported his wife missing but she didn't think he was lying now. He was shaking as he sat in front of them.

'We were fucked every which way. We didn't have the tiara. We couldn't give it to Goreski or pass it on to the buyer or even give it back to Mo. None of them would believe us. So we followed our original plan.'

'Which was?' Gawn asked.

'Hide. Until the handover to the buyer. Only now it was hide until we could think of what to do next.'

'Where's Tracy been hiding, Gary?' Gawn asked.

'She's on a yacht in the marina at the SSE.'

Gawn realised the missing woman was within view of Herdman Channel. She could even be watching the comings and goings at McKinty.

'Goreski contacted me yesterday and gave me an ultimatum. His boss is tired of waiting for the tiara. We have two days to hand it over. But we haven't got it.'

He put his head down on his arms on the table and sobbed.

Chapter 65

'They're either the stupidest criminals we've ever come across or the most ballsy,' Maxwell said as they stood outside the interview room.

'A bit of both and a big dose of panic and greed thrown in, I think,' Gawn agreed. 'And bad luck too.'

Suddenly Gawn had one of her light-bulb moments.

'Tracy wasn't in the restroom for twenty minutes. There must be another exit from it into the main hotel. She got hold of the briefcase when Randell and the others were being photographed and she hid it in some cupboard or other but, a bit like the kids' nursery rhyme, when she got there to pick it up the cupboard was bare. Someone else had taken it. Well, taken the tiara out of it.'

'She would have known straight away they were in big trouble. Remember, Tracy knows who the buyer is. Her father might think she was double-crossing him, cutting him out of the deal. She could go straight to the buyer, get the big money and she and Gary could head off into the sunset with what? A million? Two million? Maybe more.'

'But with her da and half the Russian Mafia after her and of course she doesn't have it, if we believe Gary,' Maxwell said.

'I do believe him this time. He's terrified. But you do realise what he told us means Cosgrove and Sandford are in this up to their necks?'

He looked puzzled.

'Think about it, Paul. O'Neill was told to take the briefcase when Randell was being photographed. How did they know he was going to be photographed? Who arranged it? And where it would be done? In that room just off the foyer.'

'Cosgrove,' he answered.

'On Sandford's orders, I'm sure. Now, if Tracy really hasn't got it and, I don't think she has, then someone else took it out of Randell's briefcase before she got back to it. Sandford? Cosgrove? They might both have known where it was going to be hidden. Or someone else we don't know about yet? And where is it now?'

Of course, with what they knew now, Gawn had to update Wilkinson.

The ACC made no mention of London or Gawn's night in her spare bedroom. She focused her comments and questions on the case.

'So it is this Russian tiara that everyone's been after all along?' Wilkinson asked.

'Yes. It's worth the kind of money which makes all this effort worthwhile. Someone's gone to a hell of a lot of trouble. And Gary O'Neill has admitted his wife was picking it up from Randell.'

'By the way, I contacted the Met,' the ACC told her.

Gawn knew Wilkinson would notice her consternation. She couldn't hide it.

'Not about what happened to you. I went over the head of the officers your men had been talking to. And you were right. They were stonewalling you.'

'Why?' Gawn asked genuinely puzzled. She knew her last few months at the Met had been difficult. Some parts of it she could barely remember. She'd been suffering from depression after her daughter was killed and some of her actions had been a bit out of control but she couldn't think why anyone would hold that against her now. Nor why they would jeopardise an active investigation by holding back information just to spite her.

'It seems they've been after this Morrison mob for a very long time. They'd love to pin something on them but so far they haven't been able to make anything stick and that's made them a bit paranoid, I think. They suspect they've got a mole in the department.'

Gawn's eyebrows rose.

'It could just be a handy excuse to explain shoddy work on their part or, of course, they could be right. Someone in Organised Crime could be on the Morrisons' payroll,' Wilkinson added.

'But what's that got to do with me, ma'am?'

'They've closed ranks. They're using "need to know" for everything. Apparently, the Morrisons have worked closely in the past with an old friend of yours. And that means they see you as a liability. They don't want you knowing what they know.'

'Mike Lee.'

'Lee. Yes. And apparently your relationship with Lee is well known among your former colleagues,' Wilkinson added.

'I never hid it. Mike was on the right side of the law as far as I knew. Then. He was getting started in the security business and he had to mix with some crooks but that made him useful to know. And lots of coppers mix with

criminals. You know that, ma'am. Some of the pubs in the East End were practically the local for both police and villains. Some of them were far closer to the mobs than Mike ever was… at least as far as I knew.'

'Well, it seems he's moved on a bit since you knew him. In fact, they suspect that Lee's set-up could be challenging the Morrisons, which means it would be worth his while to point you in their direction and away from him.'

Gawn didn't react. She wasn't going to defend Lee. She realised now he was involved. She told Wilkinson about the surveillance photograph of Lee and Goreski in Belfast.

'I think you need to be very careful as far as Lee's concerned,' Wilkinson advised.

Gawn bit her lip and nodded. She had no intention of ever seeing Lee again. But she suspected now that he had set her up for the Morrisons and been part of the blackmail attempt to get her to back off.

'And I see what you mean about the lengths these people will go to.' Wilkinson sounded bemused. 'The gift bags, the heating and air conditioning systems, all that took time and planning. What happened to you in London as well. But if Randell was bringing this tiara to Belfast to hand it to Tracy, who stole it before she got it away?'

Gawn suspected she knew but she wasn't about to share her suspicions with Wilkinson. She simply repeated what Gary O'Neill had told them.

'So where's Tracy now?' Wilkinson asked.

'Gary's told us she's hiding on a yacht at the marina beside the SSE.'

'And you believe him?'

'Yes. He's been sitting at home worrying about her and worrying about someone coming after him. But now that we know where she is and that she doesn't have the tiara, I have a plan.' Gawn paused and looked directly at her boss.

Anne Wilkinson's head jerked up at Gawn's words. The chief inspector had a reputation for unorthodox and

sometimes downright dangerous methods. What was she hatching now?

Gawn explained how Sebastian had found the listening device. She explained that she had told the technicians to leave the one in her car and the tracker too.

'This could be our chance to be proactive, ma'am. So far, all we've been able to do is react to what they've done. Play their game. Chase after them. Mostly in the dark, not even knowing who or what we're looking for. But for some reason they seem to need to know what we're doing. So, here's what I think.'

Gawn was aware of Wilkinson leaning forward slightly at her desk. At least the woman was prepared to hear her out. She had feared the suggestion she was going to make might be rejected as too outlandish. Gawn knew she was doing a lot of guessing, putting two and two together and maybe making more than four.

'The Morrisons want the tiara. They still have a deal to do but they don't have the resources or the experience we have in finding missing persons and they're not on their own patch. They need us to find Tracy for them. They may suspect she's double-crossed them, or they may think she was grabbed and is being held somewhere until she gives up the identity of the buyer so someone else can make the exchange and walk away with the money. But I think they still expect her to have the tiara. They'll be ready to swoop in to get it back.'

'But I don't understand how you intend to use the bug,' Wilkinson said.

'We can feed them duff information and set them up so we can arrest them. At the minute we have no idea who their buyer is. If we let them think we've found Tracy and we're going to pick her up, then they'll have to try to get ahead of us. And we can be ready and waiting for them. And hopefully we can get Goreski too if Gary cooperates. He can phone the Russian and give him the same information.'

The idea had come to her almost as soon as she had heard about the bug and tracker. These people were audacious going after a chief inspector in her own home but it meant they must also be increasingly desperate. If Randell had come to Belfast bringing the tiara to deliver to a buyer, then somewhere that buyer was waiting and he wouldn't wait forever. The Morrisons would want to find the tiara as quickly as possible and exchange it for a big pay day. They'd already waited three years.

Gawn watched her boss's face carefully. She found Wilkinson hard to read. She wouldn't have been surprised if she'd laughed at her suggestion. But she seemed to be considering it carefully.

'It's the best I can come up with, ma'am,' Gawn said apologetically. 'If they thought it was worth their while bugging my place, they must have hoped to hear something important and something about Tracy is all I can think of. There's no other case I've been working on that would merit that sort of intrusion or any perp who would have that know-how and the brass neck to go after a chief inspector.

'They took a lot of risks. They'd done their homework. They knew I was going to London which is another reason why I think it's the Morrisons. I wasn't going to be around but they'd researched the management company and delivered the letters and went through a whole charade with the entire apartment block. It was like one of those films of Las Vegas heists or something.'

'I'm sure your neighbours wish Brad Pitt had been part of the plan.'

Wilkinson smiled. Gawn didn't. She knew exactly who had been part of it.

Chapter 66

As Gawn walked back to the Serious Crimes suite, she was thinking over exactly how they would set their trap. But when she walked in, before she got the chance to say anything at all, Maxwell handed her a piece of paper.

'Background on the O'Sullivans' businesses.'

'They've fingers in a lot of pies, haven't they?' Gawn said as she scanned the list of companies and investments. Then her eyes widened. 'They own warehouses at Tilbury.'

'Uh-huh,' Maxwell said. 'Read on.'

Her eyes moved down the page and then up at Maxwell's face.

'And they bought an interest in McKinty at the beginning of the year and installed Gunning as CEO.'

'They could be in bed with the Morrisons, couldn't they? They would have the resources to provide routes out of the country for stolen goods,' Maxwell suggested.

'A bit of a leap. I must be rubbing off on you.' Gawn smiled at him. 'That could explain how Randell was at the dinner. The Morrisons could have bought him a ticket easily enough but they wouldn't have been able to make sure where he would be sitting or the whole business with the photograph.' Then she looked up from the page at her inspector. 'But do we really think multimillionaire American businessmen like these are going to get involved with someone like Mo Morrison?'

'Maybe not for the money. They don't seem to need it but Walter checked into Tyrone O'Sullivan. And guess what?'

His face showed he couldn't wait to tell her. 'Tyrone is a well-known art collector. He's even employed our old

friend, Goodlife, to curate a collection for him. He's spent vast amounts of money over the years on paintings and jewellery.'

Gawn remembered the book in Goodlife's hotel room so she wasn't surprised when Maxwell added, 'And apparently his particular interest is in Russian and Slavic artefacts.'

Chapter 67

Now Gawn wanted to talk to Valerie Cosgrove again.

'Has Cosgrove been released from hospital yet, Paul?'

'Yes. They only kept her twenty-four hours for observation.'

'And where is she now?'

'Well, we couldn't arrest her. We didn't have anything to charge her with but we've put her in protective custody. After all that was what she was asking for.'

* * *

Some of the woman's confidence had obviously returned since their meeting in the early hours of Thursday morning. She was looking almost chirpy again as she walked into the interview room. The two detectives were already there, sitting at the table.

'Ms Cosgrove,' Gawn greeted her.

'Hello there, Chief Inspector.'

No hint of nerves.

Gawn opened a folder sitting in front of her and lifted out some photographs. She placed them one by one on the table in front of Cosgrove.

'Ivan Goreski. Mo Morrison. Mike Lee. Gary O'Neill. Sergei Federov. Donald Gunning. Tyrone O'Sullivan.'

Gawn had paused between each name and watched the woman's face closely as she looked at the pictures. There had been a flicker of recognition at Gunning's name but then she had relaxed and smiled as she admitted, 'Tyrone O'Sullivan, that's the man who owns the Trust, well, not owns it of course. But he's the boss, isn't he?'

'Have you ever met him?'

'No. Adie always deals with him.'

'What about any of these other men? Have you ever met them? Or heard Adie talking about them?' Gawn asked.

Even Maxwell noticed the hesitation before Valerie Cosgrove answered.

'Well, he talks about Mr O'Sullivan of course.'

'Any of the others?' Gawn persisted. 'How about this man? Donald Gunning.'

Gawn pushed Gunning's picture closer to her.

Valerie Cosgrove bit her lip.

'I've never seen him but Adie knows him. He was out of the room one night and his mobile rang. I lifted it to answer it and that was the name on the screen. I didn't get the chance to speak to him. When Adie came back into the room he snatched the phone off me.' She looked from Gawn to Maxwell and back again anxiously. 'Do you think he's the one who attacked Adie?'

'We don't know who that was yet. But I still don't understand why you think you might be a target. You told us you'd given Adie the seating plan and he was passing it on to someone. But that's hardly enough to make you a target for anyone,' Gawn said, and waited to hear what Cosgrove would offer in reply. Would she admit to arranging the photograph for Sandford? And to anything else?

'I did a little more.' Cosgrove swallowed hard. 'I arranged with the press photographer to do a group photo for our publicity material. Adie wanted it and he told me who he wanted in it.'

'Lord Ardgeen and Randell,' Maxwell said.

'Yes. And that MP too.'

'He specifically wanted Goodlife in the picture too?' Gawn asked.

'Yes.'

The two detectives exchanged a look.

'Do you know why?' Gawn asked.

'No. He just wanted them together and he wanted me to give them cigars to thank them.'

'Cigars?'

'Yes. Expensive Cuban ones he'd been sent.'

'By whom?' Gawn asked.

'I don't know.'

'And did you give them the cigars?' Maxwell asked.

'Lord Ardgeen refused his. He didn't smoke so he didn't take one but the other two did. The last time I saw them they were going out onto the terrace to have a quick smoke before the meal. I was tempted to join them. I could have done with a fag myself but there were still some things I had to sort so I didn't go with them. Oh, that wasn't the last time,' she suddenly added. 'The MP guy passed me in the corridor on my way back. He'd changed his mind. He made some comment about needing another drink before all the fun started. That's what he said. He was going to save the cigar for later.'

'But Randell went out to smoke?' Gawn asked.

'As far as I know.'

'And you think this might get you in trouble with someone?' Maxwell asked.

'Well, Ardgeen and Randell both died and afterwards Adie told me I mustn't tell anyone about the cigars. That seemed weird to me. They only cigars but when Adie heard Randell was dead he was bricking it so I thought maybe something was wrong with the cigar and I was the one who had given it to him.'

Valerie Cosgrove paused and looked from Gawn to Maxwell and back again before asking, 'Do I need a lawyer?'

Chapter 68

'What do you make of what she said?' Maxwell asked Gawn. 'Do you think she really is in danger?'

'She thinks she is, doesn't she? Munroe suggested right from the start that smoking could be how the K2 got into Randell's system. We were sure, well I was sure, Randell hadn't been smoking but now it seems he was, just immediately before the dinner. And what did you tell me that doctor who was sitting beside him said?'

'Dr Maven? She said she thought he'd been drinking. He was a bit slurry and not very communicative.'

'That would have been the K2 starting to affect him.'

'You think there was something in the cigar,' Maxwell said.

'I'm guessing, of course, but I'd love to have the stub to prove it. Get a search of the grounds organised.'

'Boss, be reasonable. It's been more than a week. We've had rain and it's been windy. And I'm sure the hotel empties its bins regularly. It would be a miracle if there was anything left to find.'

'I know, Paul, but we have to give it a try. If we could find the stub and get DNA from any saliva on it and K2 in the tobacco, we'd have a slam dunk. Pull up CCTV if there is any of the exterior so you can see where he was standing.

'And we need to get someone from the Met to contact Goodlife to get his cigar as soon as he gets back from Canada if he still has it and hasn't smoked it yet. It could be

spiked too and we could end up with another death. Maybe he was right. Maybe he was a target. If we can get his, then we can test it. Although they may only have spiked the one for Randell. Whoever "they" are,' Gawn added.

'I always wondered how they could be sure Randell would spray the K2 on himself and whether his death was only accidental because of his drug habit,' she continued. 'Now it seems they didn't take any chances. They targeted Randell with the cigar and, if it was the Morrisons, which I'm sure now it was, they knew all about his drug taking. It was deliberate. It was murder.'

The two had made their way back to her office. Now she needed to explain her plan to Maxwell. She needed him to be part of it.

She started by telling him about finding the listening devices in her apartment and car.

'Shit!' Maxwell's face and voice showed how shocked he was. 'They bugged you?'

You don't know the half of it, Gawn was thinking to herself.

'We're going to use it against them. If they're listening, we'll give them something worth listening to. We're going to set them up so we can nab them. And we want to do it as soon as possible. Time is running out for us and for Tracy. The more time goes by, the more chance there is that whoever really has the tiara will get it out of the country to the buyer and they find that out. Then she'll be expendable. Worse than that really. She could be seen as a liability,' Gawn said and took a sip of her coffee.

'But it's her own father!' Maxwell looked shocked.

'It's business, Paul. To them. Family loyalty doesn't come into it. And she's between a rock and a hard place. Tracy followed the plan. But she didn't get the tiara. At least according to Gary and I don't think he's lying,' Gawn said. 'Someone else got to the tiara before her. So where is it? Hell!' Gawn ran her hands distractedly through her hair. 'Someone else must have known about their plan.'

'Goreski?' Maxwell suggested.

'I don't think so. He's forcing Gary to go after Tracy now. He must still think she has it and he doesn't know where she is. He needs Gary to flush her out. And either bring her and the tiara to him or else he'll follow Gary in case they decide to double-cross him.'

'And the Morrisons don't know either?' Maxwell asked.

'She's hiding from everybody.'

'What about this Lee guy?'

'He's a fixer. I've heard of him in London. He'll have been arranging an escape route or something for Goreski. I imagine he'll be safely back in London by now. He won't be getting involved. He's not violent. That's not his style.'

She was trying to sound reassuring but she didn't believe a word she was saying.

'So how do we set them up then, boss?'

'We know where Tracy's hiding. The Morrisons might suspect she'd use somewhere near the docks but they don't know exactly where. She could be lying low on one of the ships docked in the port. Or she could be anywhere for all they know.'

'Why didn't Goreski just beat it out of O'Neill?' Maxwell asked.

'Because we had a FLO there with him from after the dinner until Friday, and once Goreski got in touch with him O'Neill went to ground so the Russian doesn't know where he is now either. Remember Goreski and the Morrisons and Lee' – if she had paused slightly before saying Lee's name, she hoped Maxwell hadn't noticed – 'aren't on their home turf. They don't know Belfast. They don't have connections here. And they don't have any informants here feeding them information about what we're doing. That's our big advantage. Maybe our only one.'

'So they need us to lead them to her,' Maxwell said, his face lighting up.

'Yes. You and I are going to go out in my car. We'll go to the hotel. It won't hurt to have a word with de Grosse

and unruffle some of his feathers anyway, but while we're driving there, we'll have a conversation about having found out where Tracy's hiding and how we're planning to arrest her tomorrow morning. We'll be excited that we have a fix on her hiding place and our team is moving in down at the McKinty offices first thing in the morning. If I'm right, someone will be listening and that should force them to act tonight and we'll get Gary to phone Goreski and tell him the same thing. And we can be ready for them.'

'What about Tracy? Are we going to pull her in today?'

'Not us. Just in case we're being watched. We can't chance it. I'm going to ask Chief Inspector Boyd to get a couple of his men to do it very quietly and hold her in a safe house until this is over.'

Gawn had named a colleague from the Public Protection Branch whom she had worked with on a previous case.

'Do you think it'll work, boss?'

'I don't know but for all our sakes I hope it does. And that we can do it without a firefight. Now, come on, Paul. Here's your chance to channel your inner Tom Cruise and put in an Oscar-winning performance.'

Chapter 69

Gawn was sitting on the edge of her seat in the back of an unmarked van in the car park at the Victoria Ferry Terminal. Her knees were starting to ache from her cramped position but she barely noticed. She was going over in her mind all the possible outcomes of the night.

They had spent the rest of the day, after she and Maxwell had returned from placating de Grosse at the

hotel, getting their plans together. Her team had taken up position mingling with the passengers arriving for the final ferry crossing of the evening. A handful of cars, left by travellers making the crossing as foot passengers, sat parked around the van. It was close to the perimeter fence adjacent to the McKinty compound, giving them a clear view of the office building.

McKeown and Hill were with Gawn in the van monitoring a bank of screens. It was nearly 1am. The late ferry had left on time at 11.30pm and the lights in the terminal had quickly dimmed. The wait started. But by now everyone was on edge. The next ferry was due to leave at 3.30am. The gates would open an hour before and vehicles could start arriving soon.

Gawn hoped Morrison and Goreski had checked the timetable and would choose to come in the brief period between the last crossing of the night and the one in the early hours of the morning. If they left it until later, there was a danger that innocent travellers could be caught up in the sting operation and she would have to call it off for fear of endangering the public. The men waiting in the dark outside were cold and no doubt fed up. The ARU team hidden in a lorry across the road would be getting restive.

Would anyone take the bait? Had they been talking into the ether, no one listening in? It could all be a waste of time and it was expensive and costly in manpower. Gawn knew they would only get one chance at this.

She had enlisted the support of the Harbour Police, ready to approach the compound from the water and prevent any getaway by sea. Wilkinson had insisted she inform the Organised Crime Unit and involve them too. She'd had no choice but really she was glad of the extra manpower. Maitland and his team were positioned at the junction of West Bank Road, hidden between the rows of containers of another logistics firm, watching the approach from that direction.

Traffic was light. Maitland's men were ready to intercept any suspicious vehicles. No doubt they were cursing that they weren't at the McKinty offices but Wilkinson had said it was Gawn's show. She had overall control.

Two snipers were in position at McKinty, another two with the Organised Crime Unit and all officers were armed. The Morrisons and Goreski would use violence without hesitation, she knew.

Outside, only weak street lighting illuminated the broad roadway. But a huge floodlight high over the terminal car park bathed the immediate area underneath in bright light.

Time was running out for her plan to work. Morrison and Goreski must use the cover of night. They mustn't wait until the terminal was filled with cars and lorries. They must come soon. She was willing them to come.

The moon was hiding behind clouds. Blackout covered the windows of the van but inside the light was bright and harsh. A bank of screens filled one side. The team waiting outside in the cold and dark of the night were wearing body cameras, so Gawn could see what was happening. They were all in position and she had radio contact with Maitland and a screen showing what was happening at West Bank Road too. It wasn't ideal. She would have liked to be there for both Morrison and Goreski but she knew Maitland would do a good job. She had to trust him.

'Nothing happening out here.' Dee's voice hissed softly over the radio. He was hidden in the shadows between rows of tall containers reaching up into a starless sky. It was cold and he could make out his own breath hanging in the air in front of his face as he spoke.

'Shit!' Logan said.

'What happened?' Maxwell's anxious voice asked from his position to the side of the office building which afforded him some protection from the chill coming off the water.

'A bloody great rat just ran across my foot,' Logan replied.

'Control, I have a visual. Light-coloured saloon car heading your way.' It was Pepper reporting in. He was sitting crouched down on the floor in the usually empty port security box at the southern end of the road, well hidden in its dark recesses.

'Do you think that's them, boss? We were expecting Goreski to come from the north, from the M2 direction, weren't we? That was where we had the last fix on his phone,' McKeown said. 'Maybe it's the Morrisons.'

'Just wait.' Gawn's voice was tense.

'The car's pulled in near the bird sanctuary,' Pepper said. 'There's two people inside.'

They all waited for his next words.

'They're getting into the back seat.'

'It's a freakin' mobile passion wagon,' Grant joked.

Before Gawn could remonstrate with him, she was interrupted by Hill's excited voice. 'Ma'am, we've got a car approaching from the M2 roundabout.'

They were linked into the motorway traffic cameras. There were so few vehicles on the road, she couldn't have missed it.

'Is it our target?' Gawn asked.

Hill waited until she could get a clear view of the occupants.

'Two men. Affirmative. The passenger's Morrison.'

Gawn had hoped but not expected Morrison might come himself.

'Everyone, hold position. Keep your chatter for later,' Gawn ordered.

They were linked to the terminal's CCTV feed too and had a view of the approach road and the car park. Gawn and the two detectives watched as a dark car drew slowly through the open gateway, pulled up outside the McKinty office building and stopped.

All three watched as two dark figures climbed out and pulled balaclavas down over their heads. They stood beside the car looking around and listening. One man reached back into the car and then straightened up. Gawn saw a rucksack in his hand. It seemed heavy from the way he was holding it. The two moved off heading towards the mountains of containers where Dee and the others were hidden in the shadows.

Suddenly the figure in front stopped and held out his hand in warning. He froze. He was listening. Had someone made a noise? Coughed? Shuffled their feet? Endless seconds passed. He seemed satisfied and set off again, followed by his companion. Dee flattened himself even further against the cold metal of the container trying to blend into its dark grey side. He hoped they didn't have torches. That would make him a sitting target for them.

The shadowy figures walked past the row where Dee was waiting, only metres away from him, holding his breath as he sensed, rather than heard, them passing. They reached the next row and then switched on head torches. The torches provided just enough light to let them enter the utter blackness of the narrow alley between the lines of containers.

Dee had moved out of his hiding place and stationed himself at the top of the row while the men were making their way towards the water's edge. He had watched the light from the torches dancing in the darkness like tiny magic moonbeams leading the figures on. They must stop soon. There were only a few containers left. They would be running out of possibilities.

'Where are they going?' McKeown's whisper echoed Gawn's thought.

The figures stopped again. Dee shrank quickly back into the blackness flattening himself against the corrugated metal. Had they heard him? He waited and then looked around the end of the container.

'Where the hell are they? I can't see them.' Dee's whisper sounded panicky and much too loud.

'Maybe they've extinguished the torches,' suggested Gawn. 'Or broken into the container as we planned.'

But Gawn realised the figures could be doubling back and might be with Dee in an instant, without warning, out of the blackness.

But no figures appeared.

'They must have fallen for it. They didn't come out this end,' Maxwell reported.

'OK, Inspector. You're green to go.'

Now it was down to Maxwell and the others who had been waiting to make the arrest.

Chapter 70

Gawn could only sit back and wait and she hated it. The inactivity was like a burning pain in her stomach. She wanted to hear they had Morrison in custody. She wanted to hear Maitland's voice reporting that he had made an arrest too.

She could make out vague shapes on the monitors. No one had spoken on the radio other than Maxwell to give the order to move in. They wanted the element of surprise.

Maitland's voice came over the radio. 'We've got a car just turned into West Bank Road. Can we intercept?'

'You're good to go,' she said.

Her stomach lurched. It seemed both Goreski and Morrison had chosen 1am for their approach. It was all happening at once.

Suddenly an explosion reverberated through the silence and raised clouds of dust and smoke into the air about halfway down the alleyway of containers where Dee had

been following the dark figures. The noise was thunderous in the silence of the night. A burglar alarm on a nearby car was set off by the soundwave and sent out a wail like a screaming child frightened by a bad dream.

Some of the team had been making their way down that row. Had Maxwell or Dee been caught in the explosion? Had they somehow triggered a booby trap?

'Officer down. Officer down.' Maxwell's voice came through on the radio.

She watched as Maxwell ran towards the seat of the explosion. She wanted to order him to stay back. There could be more traps waiting but she knew all the men would want to help their colleague.

Had the figures realised they were being followed and set a trap for them? Then Hill spoke, interrupting her thoughts.

'Look, ma'am. There's someone moving inside the building. I saw a light. On the second floor.'

How was this possible? How had someone made their way from the container area and got inside the building so quickly without anyone seeing him? How had he got past Maxwell? The answer was easy. There had to have been three men. One must have hidden in the car and slipped out of it and across to the building while they had been concentrating on the figures in the car park. But what was he looking for inside the building?

'Jamie, meet me at the main door to the offices. Jo, come with me.'

Gawn was already on her feet and opening the back door of the van before she had finished issuing her orders. She jumped down and ran across the open ground towards the building keeping low, trying to avoid any patches of light.

Grant was waiting for her, weapon drawn, when she and Hill reached the front of the building.

Just then a message came through on the radio.

'We stopped the car. It was Goreski. He was armed but he gave up without a fight. He surrendered when he heard the explosion.' Maitland sounded disappointed to have made such an easy arrest.

'Well done. Take him back to Ladas Drive but don't start questioning him until I get there, please, Chief Inspector. We'll let him stew for a bit.'

She turned her attention back to the man inside the McKinty offices. She spoke quietly to Grant and Hill. She could see, even in the low light, that their eyes were sparkling. They were excited. She knew neither of them had come under fire before so they would be frightened too. That was OK. It meant they would be careful. She didn't want any dead heroes under her command.

'There's someone inside. On the second floor. Jo, I want you to wait here in case he comes out this way. On no account are you to enter the building. Wait here. Jamie, go round the back. I think that's the most likely way he'll try to get out. Don't take any chances with him. He'll be dangerous if he feels trapped and we've already seen they have explosives and will use force. I'm going inside.'

She spoke into her radio.

'Inspector, sitrep.'

'One officer down. Minor injuries. The targets are holed up inside a container. There's nowhere for them to go.'

'Don't take any chances. They might choose to try to shoot their way out or they might have more surprises planned. There's another one inside the main building. I'm going in.'

She didn't wait for Maxwell's response. She knew he would try to convince her to hold back and wait for reinforcements. She switched her radio off. She didn't want any message revealing her position to whoever was inside.

Chapter 71

Gawn pushed against the door. It opened easily. Why wasn't it locked? Why hadn't the burglar alarm gone off? Was this a set-up, another trap like the explosion?

She became aware of the sound of approaching emergency vehicles. Someone had summoned the Fire Service. Of course. There could be volatile substances in some of the containers, she supposed. They would have called the paramedics too. No one had thought to tell them to approach without sirens blaring, slicing through the silence.

She stepped inside and everything was suddenly quieter. She had lost any light coming from the moon which had been casting intermittent silver streaks across the container park or from the flames rising into the sky, no doubt visible across Belfast. The press would be onto this soon. She could hear the sirens coming closer, almost here. Whoever was inside would be panicking, aware time was running out.

Gawn paused. There was no point dashing forward into the unknown. What she did know was these people were ruthless. She tried to visualise the reception area from her one visit. She could remember a counter facing them when they had walked in. Somewhere along its length was the opening to allow access to the staff area. She walked forward until she felt the ledge at waist height and then ran her hands along searching for a break in its surface. Her fingers found an opening. She reached down and pulled the section up so she could walk through.

Gawn remembered the stairs to the second floor, to Gunning's office. They had been straight ahead but she couldn't be sure there weren't obstacles in her way. Her eyes had grown accustomed to the deeper darkness but

only sufficiently to let her make out vague shapes. Her foot hit against something metallic, probably a waste basket. The noise sounded loud to her ears. She stopped and waited, listening for any movement, any reaction to the sound. Nothing. Only her own ragged breathing.

Inch by inch she moved forward holding her hands out in front of her like a blind man. Suddenly her way ahead was blocked. This must be the doorway to the stairs. She pushed against it. It opened noiselessly. Moonlight flooded the stairwell through the huge window overlooking the dockside. Now she could see where she was. Was the intruder still on the second floor? Or had she already missed him in the dark?

She took the stairs slowly and carefully keeping tightly to the outer wall. It felt cold to her touch and damp, the dampness of night with the heating switched off. Then she realised it was her own hands that were damp. The rubber treads and metal-tipped edges of the stairs were solid. She didn't have to fear the noise of squeaking treads revealing her approach.

Now which way? On Tuesday they had visited Gunning's office and then his secretary's, Sylvia Newton. They had had a brief look around O'Neill's office too but now she was aware there were three other rooms on this floor, three other closed doors. Behind one of these doors there could be a man with a gun. Waiting for her.

Chapter 72

Gawn reached out and gripped the sturdy door handle, the metal icy cold to her fingers. She had no idea what might face her on the other side of this door. These people had already set off one booby trap tonight. She realised the

explosion would have been part of their escape plan to cause confusion and let them get away, another diversionary tactic. There could be more.

She had her gun clutched tightly in her hand. The familiar shape and weight gave her a sense of comfort. She had used it before. She would use it again if she had to.

Slowly Gawn turned the handle and pushed the door open. A tall figure was silhouetted against the light coming in through the wraparound windows. He hadn't heard her or, if he had, he had ignored the sound. He was bending over the desk at a computer, its screen casting a ghostly green glow unto his features. She wasn't surprised to see him. She had known who it would be.

'PSNI. Put your hands up where I can see them!'

The figure turned towards her. Then, instead of raising his hands, he reached across and turned on the desk lamp almost casually. Mike Lee's smiling face was illuminated now.

'I said put your hands up, Mike.'

'You're not going to shoot me,' he said confidently. 'I'm not armed, darling. You can't go around shooting an unarmed man. It'd be the end of your career.'

'I will if I have to. To stop you getting away. Now put your bloody hands up. Now!'

She took a step towards him. At the same time, she reached to switch her radio on again to summon Grant to help her handcuff Lee. Her attention was divided for just a split second but that was more than enough for the trained soldier Lee had been.

He dropped to one knee and then lunged at her from a crouching position. The gun was forced from her hand as his body hit against hers. It skittered away across the floor, out of reach.

He was on top of her now, pinning her down.

'You're not going to ruin everything, Gawn. I tried to warn you off. I didn't want to hurt you. I could have let them kill you.'

His voice was coming in bursts as he tried to subdue her but she was fighting back, struggling against his superior strength. They were rolling around the floor like two kids play fighting. Only this was no game. He hadn't tried to hit her but then her head connected with something hard – the leg of Gunning's desk, she thought – and for a second she lost her grip on him.

Gawn was clutching at his wrists, digging her nails into his skin, trying to force him to release his hold on her but she didn't think she could resist him much longer. Just then she heard loud voices and Lee collapsed on top of her as someone hit him hard from behind and hands pulled him off her. It was Grant and Maxwell.

In spite of Lee's struggles, the two officers quickly subdued him. Grant searched him but he wasn't armed. They handcuffed him and dumped him unceremoniously onto Gunning's chair.

'Sit there. Don't move,' Maxwell ordered him.

Gawn was standing up now.

'Are you OK, ma'am?' Grant's voice was tinged with concern.

'Yes. I'm fine.'

'We'll get this one down to the car. We've got Morrison and his henchman. They gave up when they saw they had nowhere to go. They had a RIB standing by, but the Harbour Police picked it up and arrested the man in it. The Organised Crime guys got Goreski but there's no sign of the tiara anywhere.' Maxwell paused and then asked, 'Do you want him taken to Musgrave or Ladas Drive, or where, ma'am?'

'Give me a minute,' Gawn said.

'Ma'am?' Maxwell didn't know what she meant.

'Grant, you go ahead. Get Morrison to Ladas Drive,' she added. She waited until Grant had left and then turned to Maxwell. 'Send two PCs up here, Paul, and tell them to guard this door until I bring Mr Lee out. I want to speak to

him before we arrest him. You go with the others and set up the interviews. I won't be far behind you.'

'Are you sure, ma'am?'

'Just do it, Inspector.'

Gawn knew what she was suggesting was very irregular and she knew Maxwell knew it too. He gave her a questioning look but said nothing more and followed Grant out of the office.

Chapter 73

'Breaking the rules again, Gawn. Tut! Tut! Tut!'

'Never mind the bloody rules. Where's the tiara, Mike?'

'You have no idea what's going on, have you? Going to threaten me?' he added as she took a step towards him.

'Go on then. Tell me, if you're so clever,' she taunted him. 'When did you start working for the Morrisons?'

'The Morrisons? Me? Working for the Morrisons? Give me a bit of credit, darling. They're just a bunch of thugs. I have more brain cells in my little finger than Mo Morrison and all his crew have between them. They couldn't mount an exercise like any of this.'

And suddenly it was clear to her. That was what had been niggling away at the back of her mind. The organisation, the planning, the execution of the diversion at the hotel. It all shouted military and she'd ignored it.

'They had enough brains to steal the tiara,' she taunted him again.

'Stealing the tiara didn't show they had brains. That was the dumbest part of the whole thing. They might have had the technical know-how to circumvent the security system, but crossing Federov? Just bloody crazy. He was never going to let them get away with it.'

'So, you're working for him?'

Lee didn't answer.

'And the whole episode in London. Was that the Morrisons or the Russians?' she asked. 'Or just you?'

She saw the smile that flickered across his face, a smile of self-satisfaction. And then she knew.

'You weren't drugged, were you? You set me up.'

'Come on. Don't tell me you didn't enjoy it.'

'I was drugged,' she yelled at him.

'Believe me, darling, you were enjoying yourself.'

Gawn took a step towards him and slapped him.

'Shit. You still pack quite a punch, don't you, darling? Should I call your PC plods in to rescue me?'

'You heard my orders. They won't come in unless I call them.'

'And I saw how your tame inspector looked at you too. He won't hold back forever. He'll be checking what you're up to if only to cover his own arse. And you won't do anything to me. You're too by the book, Gawn, when it comes down to it. Miss Goody Two Shoes of the Met.' Lee laughed.

Gawn took out her baton and extended it.

'One of these could make quite a mess of you, Mike.'

She took a step closer to him and he kicked out at her to keep her back.

'I could break both your kneecaps,' she said. 'No problem. Then I could go to town on you, make sure you'd never be able to get it up again.'

Lee's expression changed. She realised then she had him.

'Was London just your revenge or were you seriously trying to warn me off?'

But as she asked the question, she realised she already knew the answer. He had known it wouldn't stop her. Wilkinson had asked if she wanted to give up the case after what had happened but the woman didn't know her at all.

Lee did. He knew it would make her even more determined to keep going.

'I want to know it all. From the beginning, Mike.'

He seemed to consider whether he should answer. She waited. If he refused, she would have no choice but to take him into custody and question him under caution, in a taped interview with Maxwell or even Maitland with her, and she didn't want that. She wanted to get the information she needed and then keep all mention of what had happened in London out of it.

'OK. I'll talk but off the record and I want a deal.'

She stepped back and pulled up a chair opposite him.

'I can't make any promises. You know that.'

He sat still, thinking. She didn't say anything. He knew she was his best chance to get out of this.

He started talking.

Chapter 74

'You're right. About some of it anyway. The Morrisons stole the tiara. They've been sitting on the cache, getting rid of a few smaller bits and pieces but waiting for a buyer for the tiara and last month they found someone with deep pockets. The transfer was going to take place. But they had a problem. The first time they tried to move it, they nearly got caught. They were being watched. All their usual routes and associates were under surveillance and they couldn't trust the tiara to just anybody. So they got their brief to carry it to Belfast to pass it to Mo's daughter. He owed them and they were blackmailing him. They thought the cops wouldn't be onto him. Dumb move. Anyway they should never have trusted a mouthpiece.'

'Randell was double-crossing them?' Gawn asked.

'He'd got cold feet or a guilty conscience. He'd contacted that old judge to hand himself and the tiara in and give them all up. Mo had been monitoring his phone so when he heard that, he contacted me for help. He needed to make the exchange on Saturday night. It needed to go ahead. On time. So he wanted a diversion.'

'But I don't understand what happened at the Royal Holywood. That was your plan?'

'Yeh. But Morrison's goons went too far. On his orders. He decided he wanted Randell dead. That wasn't any part of my plan. It was meant to be just a few people getting a bit woozy and happy on K2, nothing too harmful. You believe me?'

For the first time he sounded uncertain. She nodded. She didn't think he was a killer.

'Meantime, Goreski had contacted Tracy. He'd already been to me and we'd done a deal. What none of them knew was I had my own plan. I nabbed the tiara before Tracy could do anything with it or Randell could tell his old judge buddy about it. I'd arranged for Tracy to hide the briefcase in a cupboard but I went and got the tiara while you were all enjoying your chocolate ganache.'

'You were there? At the hotel? But you weren't that clever. Your plan wasn't perfect, was it?' She couldn't resist the comment.

'It was a bit too successful. I didn't know the old bloke was going to croak it or people were going to panic like that. I thought it'd only be a couple of people fainting, enough to be a small distraction; to let Tracy get away.'

'What about the K2 in my spray and my colleagues'?'

'Just the luck of the draw.' Then his expression changed and he added, 'Unless it was Mo's idea again. But it wasn't me.'

'And Sandford?'

Lee looked genuinely puzzled.

'What about Sandford?' he asked.

'The fire at his house.'

'Nothing to do with me.'

'The Morrisons then?' she suggested.

'I doubt it. They didn't know anything about Sandford.'

'So, who then?' Gawn asked.

She didn't realise she had spoken her thoughts aloud.

'Probably the buyer, I would think. Covering his tracks. Sandford could identify him.'

'Do you know who it is?' she asked.

'I think we both do, don't we?'

Chapter 75

Gawn and Maxwell were watching Ivan Goreski. He was sitting in an interview room looking supremely relaxed.

'He's claiming diplomatic immunity. Apparently he's some sort of attaché at some embassy. He's refusing to answer questions and demanding to be released,' Maxwell informed her.

Gawn swivelled in her chair to look at the other screens. Mike Lee was sitting in one room. Tracy O'Neill and her husband were in two others. Gary O'Neill especially looked nervous glancing around at the slightest noise.

'Still no tiara?' she asked.

'No tiara. We've searched the yacht, the O'Neills' house, the McKinty offices and every container that wasn't already sealed by the customs people. I don't think there's a snowball's chance in hell anyone'll implicate O'Sullivan.'

Gawn had told Maxwell her suspicions about the American. She hadn't explained how she knew.

A door opened behind them and they turned to see Wilkinson walking in.

'Congratulations. Quite a haul.'

The ACC looked pleased.

'It's going to be a bit of a nightmare, ma'am,' Gawn told her.

'You think they won't talk?' Wilkinson asked.

'Some of them won't. Goreski and Morrison for sure. And Lee too.'

A look passed between the two women. Maxwell was oblivious to it.

'The tiara isn't officially stolen property. It doesn't exist. It wasn't listed at the time of the original robbery and I doubt Federov will want to claim it back now with all the questions that would raise about where he got it.'

'But you have the attack on Jaxon Arnold and the hotel to charge someone with. People were injured there.'

'Yes. But Arnold can't describe his attackers and none of this lot are going to give us any names. As for the hotel, we have to presume the Morrisons organised that to get the tiara to their buyer. But Morrison and his man, Deakin, aren't talking. Organised Crime have them but I'd be surprised if they admit anything. The most we'll get them for is possession of explosives and firearms, which is something, and breaking into the McKinty offices and damaging a container of course.'

'But you can tie Tracy O'Neill and her husband into it all, can't you?' the ACC asked.

'If we can't prove the tiara was stolen or even exists, then we can't charge them with handling stolen property except possibly Tracy for the clothes I saw at her house. And she'd already left the hotel before anyone collapsed so how can we prove she had any involvement with what went on? Her actions changing her clothes and leaving out the back way are suspicious but not illegal. All we have them for is wasting police time searching for her.'

'She didn't have the tiara?'

'No. She's denying any knowledge of it. A load of bullshit, ma'am. Either someone took it off her or she

managed to get it to the buyer but she's not going to tell us.'

Wilkinson was beginning to look more and more perplexed.

'What about Randell?'

'The PPS will have to decide about that one,' Gawn said. 'His death was the outcome of multiple drug use according to Munroe. The K2 contributed but I'm sure the lawyers will have a field day arguing about it. Cosgrove told us Sandford gave her the cigar to pass on but she insists she didn't know it was anything other than an ordinary cigar and we couldn't find any trace of it so there's no proof it was the cause of his death. And we can't even prove he smoked it. We couldn't find anything on CCTV.

'Sandford still hasn't regained consciousness, but I doubt he'll be forthcoming when he does. He'll lawyer up and it'll be a top-notch barrister paid for by whoever he was working for, I imagine.

'I have a warrant out for Weatherup. His blood was found on the ventilation system so he was there and he was part of the plot. They might be able to charge him for the hotel business.

'The CSIs are going back over Arnold's warehouse. They might get fingerprints there. If they don't, I wouldn't expect Weatherup to give up any names. He's a pro and he served three years before he would grass on the Morrisons last time.'

'Not very much to show for all the effort. Rather unsatisfactory.'

It was as close as Wilkinson was going to come to criticising the investigation. Then, almost as an afterthought, she asked, 'What about Lee? What was he doing searching Gunning's office?'

'His story is Tyrone O'Sullivan was suspicious about discrepancies since Gunning took over as CEO. He employed Lee's security company to investigate. Lee was

searching through Gunning's computer for evidence of embezzlement.'

'And O'Sullivan will back his story up? That he had permission to be there? In the middle of the night?'

'Apparently so, ma'am. I know it's suspicious. More than suspicious, but if he had permission to be there, what can we do? Lee seems pretty confident about it. I've a call booked to O'Sullivan in New York later but Lee's not dumb. He wouldn't be telling us this if he wasn't sure O'Sullivan would back him up. And Gunning's left the country. We traced him on a flight out of Dublin to New York yesterday.'

'And what about Lee attacking you?' Wilkinson asked.

'He says I surprised him. I didn't identify myself. He thought it was Gunning and he was being attacked. He was defending himself. That's what he's saying anyway.'

'And did you identify yourself?' the ACC asked.

'Yes, of course I did, but I suppose it's possible he didn't hear me with the noise outside.'

Gawn was aware Wilkinson was looking at her closely. The woman was suspicious. And rightly so.

'So it's really only the small fry we've any chance of getting and some more serious charges for Morrison.'

'Unless we can get Tracy to roll on her dad. I'm working on that, ma'am.'

Epilogue

Gawn was wrapping an early Christmas present, a colourful book about dinosaurs, for Seb's nephew, Murphy. She wanted to be prepared for Christmas. She was counting down the days. Sebastian would be home.

Her mobile rang. She sighed. Please, don't let it be a new case, she thought to herself. They seemed to have spent weeks interviewing the suspects in the Randell case. Clams were more open than some of the accused. Most of them had been released on bail pending further inquiries. Goreski had been escorted back to London and then deported.

The one good thing to come out of it all was that she seemed to be back in favour at the Met. She'd helped them get the Morrisons. Tracy had eventually agreed to give evidence against her father. She didn't know everything about his business but enough that he would face some serious charges.

Gawn glanced down at the caller ID. Mike Lee. She was tempted to reject it but she knew they had unfinished business.

'Mike.'

'Hi, darling.'

He sounded pleased with himself.

'Where are you?' she asked.

'Just doing a bit of Christmas shopping in New York. I had some business to do so I thought I'd take the opportunity to get a start on my present buying.'

'Business? What sort of business?'

'The sort they say are a girl's best friend.'

She knew what he meant. He'd been delivering the Romanov Tiara to O'Sullivan. Federov would have been well paid for it. He would be happy not to lose face and it would have been too hot for him to hold on to anyway. O'Sullivan had got what he had coveted for years, his dream to own part of the Russian imperial jewels. He would have been happy to pay the price Federov demanded and Lee's fee too. Morrison was the big loser in it all. He had lost the tiara and his expected big payoff and now he was facing prison.

'Tell me this, Mike, why did you have such an elaborate plan at the hotel? Once Tracy had grabbed Randell's bag, why didn't she just leave?'

'I convinced them she needed to wait, make sure no one was watching her and would follow, use the cover of the diversion. Smoke and mirrors.'

'But it was really to give you the chance to take the tiara yourself, wasn't it?' she said. She had worked it out.

'I had a lovely stay at the hotel. I would recommend it and they're very accommodating about keeping luggage for their guests.'

The tiara had been there all the time they were there. If Wilkinson had let them search the hotel from the beginning and question the guests she would have seen him; she would have known.

'Anyway, I just wanted to wish you an early Merry Christmas. I've sent you a present just to say sorry and thanks for the memories, darling. You should get it tomorrow.'

Then his voice changed. He sounded serious.

'I really am sorry, Gawn. The Morrisons wanted to waste you. I convinced them it was better to do it my way, less heat, more effective. I'd never have let them hurt you. Anyway, I knew doing it my way would only make you more determined to get them.

'I've destroyed the photos. It was a set-up. Of course. We took the pictures in the same room the night before. The model who stood in for you was a stunner and very compliant, if you know what I mean. We didn't want photos of you just lying unconscious. To get to you, it needed to look as if you were enjoying yourself. But your husband had already worked all that out, hadn't he?'

She realised then that it wasn't only the Morrisons who had been listening in to her. Lee had been too. She had suspected that when he had turned up at the McKinty offices at the same time as her operation.

'It was a stupid mistake on my part. Careless. I knew about your scars from Afghanistan, of course, darling, but you've managed to pick up another one. You need to be more careful mixing with dangerous types.

'Sebastian really loves you, doesn't he? Poor bastard. You build walls around yourself and close people out, Gawn. Don't do that to him. Don't stuff it up this time.'

She found herself standing looking down at the phone in her hand, not believing what he had just said. She wasn't going to take relationship advice from him but she knew he was right. She had. Even with Sebastian at first. But not now. He rang off before she could react.

She jumped up and ran to her computer. She called up her case notes and looked at the hotel guest list for the night of the dinner. They had never examined it, never questioned the residents nor searched rooms just as Wilkinson had insisted from the beginning. Her eyes scanned down the list until it came to E.G. Girvin, the unusual spelling of her surname jumping out at her.

His idea of a joke to use her name. Elizabeth Gawn Girvin. Lee knew that. If she had seen it, she would have realised.

* * *

Next morning she waited impatiently in the lobby for the postman. Among the junk mail and the bills, there was a small white envelope with her name and address on it. She didn't bother about fingerprints. Mike was too canny for that. She ripped it open and took out a flash drive. There was nothing else. No accompanying message. But she didn't need one. Whatever was on this was his present to her.

Back in the apartment, she booted up her computer and inserted the drive. Two folders appeared. One marked "Morrison", one "Federov".

She opened the Federov one first and saw lists of transactions with details of names and dates and amounts of money. There were photographs too. She recognised Federov and Goreski in one and she was sure the National Crime Agency investigators would be able to identify the others.

The Morrison folder had details of their activities, a bank robbery, the hijacking of an arms shipment to some Middle Eastern country, a list of addresses of their associates and of some of the premises they used. The Met would have a field day with this information. It was a gold mine.

There was no file on O'Sullivan but Gawn knew the PSNI's Criminal Investigations Branch had already got a team checking in to the HATP's finances. She suspected that the Trust could be used for money laundering. Forensic accountants would be going through everything but somehow she thought they wouldn't find anything.

Lee had had plenty of time when they were busy arresting Goreski and the Morrisons and she and Lee had been struggling on the floor to make sure anything incriminating on Gunning's computer was destroyed, and he must have been behind the break-in at the Trust's offices too when the computers were stolen. That hadn't been to protect Cosgrove's list. It had been to protect the Trust's records.

She had wondered that night why Lee hadn't just surrendered to her straight away. He would have known he couldn't get away but he had been buying time. Tech support had already told her that a virus had corrupted all the files on Gunning's computer and they weren't hopeful of being able to retrieve anything useful at all. She wondered if Gunning had really been involved or if he was a handy scapegoat paid to make himself scarce.

But now Lee had given her Federov and Mo Morrison. They were his present to her.

Maybe he really had cared, once. And maybe he really did still want to be on the side of the white hats. But she couldn't help thinking he just wanted to be on the winning side and maybe to get rid of the Morrisons if they were his rivals as the Met suspected. He had always wanted to come out on top.

'Merry Christmas, Mike. Until our paths cross again.'

If you enjoyed this book, please let others know by leaving a quick review on Amazon. Also, if you spot anything untoward in the paperback, get in touch. We strive for the best quality and appreciate reader feedback.

editor@thebookfolks.com

MORE IN THIS SERIES

All free with Kindle Unlimited and available in paperback.

THE PERFUME KILLER (Book 1)

Stumped in a multiple murder investigation, with the only clue being a perfume bottle top left at a crime scene, DCI Gawn Girvin must wait for a serial killer to make a wrong move. Unless she puts herself in the firing line.

MURDER SKY HIGH (Book 2)

When a plane passenger fails to reach his destination alive, Belfast police detective Gawn Girvin is tasked with understanding how he died. But determining who killed him begs the bigger question of why, and answering this leads the police to a dangerous encounter with a deadly foe.

A FORCE TO BE RECKONED WITH (Book 3)

Investigating a cold case about a missing person, DCI Gawn Girvin stumbles upon another unsolved crime. A murder. But that is just the start of her problems. The clues point to powerful people who will stop at nothing to protect themselves, and some look like they're dangerously close to home.

KILLING THE VIBE (Book 4)

After a man's body is found with strange markings on his back, DCI Girvin and her team try to establish his identity. Convinced they are dealing with a personally motivated crime, the trail leads them to a group of people involved in a pop band during their youth. Will the killer face the music or get off scot-free?

THAT MUCH SHE KNEW (Book 5)

A woman is found murdered. The same night, the office pathologist Jenny Norris goes missing. Worried that her colleague might be implicated, DCI Gawn Girvin in secret investigates the connection between the women. But Jenny has left few clues to go on, and before long Girvin's solo tactics risk muddling the murder investigation and putting her in danger.

OTHER TITLES OF INTEREST

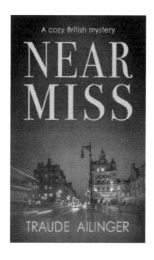

NEAR MISS by Traude Ailinger

After being nearly hit by a car, fashion journalist Amy Thornton decides to visit the driver, who ends up in hospital after evading her. Curious about this strange man she becomes convinced she's unveiled a murder plot. But it won't be so easy to persuade Scottish detective DI Russell McCord.

Available free with Kindle Unlimited and in paperback!

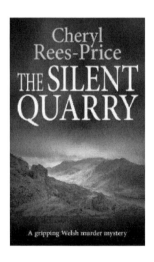

THE SILENT QUARRY by Cheryl Rees-Price

Following a fall and a bang to the head, a woman's
memories come flooding back about an incident that
occurred twenty years ago in which her friend was
murdered. As she pieces together the events and tells the
police, she begins to fear repercussions. DI Winter
Meadows must work out the identity of the killer before
they strike again.

Available free with Kindle Unlimited and in paperback!

www.thebookfolks.com